Apelles
The Alexander Mosaic

Paolo Moreno

Apelles
The Alexander Mosaic

Translation by David Stanton

Design
Marcello Francone

Editing
Emma Cavazzini

Layout
Eliana Gelati

First published in Italy in 2001
by Skira Editore S.p.A.
Palazzo Casati Stampa
via Torino 61
20123 Milano
Italy

Printed and bound in Italy. First
edition

ISBN 88-8118-864-3

Distributed in North America and
Latin America by Abbeville Publishing
Group, 22 Cortlandt Street,
New York, NY 10007, USA.
Distributed elsewhere in the world
by Thames and Hudson Ltd., 181a
High Holborn, London WC1V 7QX,
United Kingdom.

Grandi Libri Skira

*This series has been created with the ambitious aim
of presenting a detailed account of the greatest works
of art of all time with reproductions of the highest quality
that can be offered in book form.
This quality regards not only the illustrations, which
reflect Skira's best tradition, but also the interpretation
— involving an examination of the work at close
quarters, with special attention being paid to its materials
and aesthetic qualities and, last but not least, academic
excellence. This means constant care over the choice
of authors, as well as historical materials and documents,
in order to satisfy the increasingly exacting demands
of international scholarship.
Each volume is devoted to a single work, a cycle
or a series of works linked by the artist who made them
or else their theme, period or location. In each case,
the masterpieces in question are ones that have had
a profound influence both on the history of art and
on culture in a more general sense. However celebrated
or obscure they may be, they are revealed in a new
light, offering the experts food for thought and bringing
them to the attention of a broader public.*

Contents

Introduction

When Neapolitans speak of 'the museum', they are almost certainly referring to the Museo Archeologico Nazionale. Among the marvels that make it the world's greatest collection of classical art, the Alexander mosaic, which comes from the House of the Faun at Pompeii, was, from the moment it was brought to the museum in 1843, the 'great mosaic', a vibrant work of art composed of two million tesserae.

Although it has been demonstrated that it is a Hellenistic work reproducing a painting, while the original was being reproduced in a different medium some of the details were misinterpreted. In antiquity, restoration work was necessary to eliminate the damage suffered by the floor when it was detached from its first site and reused in Pompeii around 100 B.C.

Nevertheless, the result justified the amazement of the archaeologists and the enthusiasm of the travellers who saw the floor *in situ* in the House of the Faun: the sense of rediscovery of ancient painting was born here rather than in the frescoes that continually emerged from the lapilli and volcanic ash with their brilliant colours. Compared to the decorative exuberance and the contrasts of the wall-paintings, it was the intensity of the story and the magnificent orchestration of the tones, where the medium values function as dark colours and the subdued passages render the scene with authenticity, that most struck observers. The year after the discovery of the mosaic in 1831, Goethe wrote: 'The present and the future will not succeed in commenting correctly on this artistic marvel, and we must always return, after having studied and explained it, to simple, pure wonder'.

Two centuries of archaeological inquiry have not exhausted the profundity of the picture — the mosaic version still bears comparison with the originals that have appeared at Paestum, Ruvo di Puglia and in Macedonia — and have not given wholly satisfactory replies to the principal questions regarding it, namely, which episode is being represented here, whether the painting was executed during Alexander's reign or later, and to whom it should be attributed.

The battle is not that of Issus in 333 B.C., as is usually maintained, but rather the subsequent rout of the Persians at Gaugamela in 331, which will be described later; far from the site of this event is Arbela, a common, but incorrect, alternative to the historical designation of the victory, as Plutarch had already observed (*Alexander*, 31. 6), in conformity with the writings of Ptolemy I Soter and Aristobulus of Cassandreia.

The exclusion of the first battle with Darius makes it less probable that the work may be ascribed to Helen, the daughter of Timon, an Alexandrian woman artist who had celebrated 'the battle at Issus' with a painting that was then brought to Rome (Ptolemy, the son of Hephaestion, in Photius, *Bibliotheca*, p. 482). However, the most widely accepted theory now is that the painting may be identified with what Pliny the Elder referred to as 'the battle of Alexander and Darius' (*Naturalis Historia*, 35. 110), executed by Philoxenus of Eretria for King Cassander (305–297 B.C.). But the discovery of two paintings in Macedonia has, in recent years, given rise to an unexpected argument against the current attribution. Examination of the marble Dionysiac frieze from a tomb at Cassandreia (formerly Potidaea), in Chalcidice, and the fresco depicting the rape of Persephone at Aegae (fig. 22) — now Vergina, one of the capitals of the kingdom — has finally revealed exactly what Pliny meant when he mentioned the rapid

procedures that Philoxenus introduced to the court of Cassander. This is, in fact, a style that, as a result of these archaeological finds, must be regarded as incompatible with the introspective detail found in the mosaic.

Elements contained in the scene represented that tend to favour the dating of the painting to a period earlier than Philoxenus's career — that of Alexander's military victories, in other words — have revived suggestions that it was the work of Apelles, a painter whose name had already been proposed by some scholars.

On the one hand, our knowledge of the painter has increased, with the identification of additional works and a different critical approach, which tends to seek out all the details regarding the places and circumstances involved. On the other hand, we are able to observe the mosaic with the simplicity of its first admirers, which is the same as that with which the Greek artists were accustomed to expressing themselves. From the historical correction (Gaugamela instead of Issus) to the reconstruction of the artistic procedure, the theoretical justification of the sequence thus reconquered identifies in the original painting the nascent state of Aristotle's optical theories: the 'transparent medium', in this case the dust that the painter has taken into account with the rapid softening of the tones in the distance. The articulation of the perspective with its various vanishing points, superb draughtsmanship, the limit of four colours (white, yellow, red, black), graduated chiaroscuro and the highlights reflecting the glare of the sun are the results of Apelles' composing his work immersed in the atmosphere of the event. Thanks to the wholly rational perceptiveness of this remarkable witness — who portrays himself mirrored in a shield — the picture becomes the transparency of actuality, a flurry of wind and dust raised by the passage of history.

The 'Battle'

The Mosaic

The present and the future will not succeed
in commenting correctly on this artistic marvel,
and we must always return, after having studied
and explained it, to simple, pure wonder.
Johann Wolfgang von Goethe

The mosaic floor depicting Alexander the Great in battle was brought to light on 24 October 1831 in the House of the Faun, the most magnificent residence in Pompeii (fig. 1). It consisted of a complex, similar to the houses built around courts with peristyle at Pella, which were adorned with mosaics representing scenes from Alexander's youth; one of these was a stag-hunt with Hephaestion, possibly deriving from an original by Melanthius or Apelles, as we shall see later (figs. 48, 49).

The House of the Faun covered a whole block in Pompeii, an area of three thousand square metres: the Alexander mosaic decorated an exedra, a room used for conversation and the reception of guests.[1] The illusionistic architectural structure painted on the walls (in the so-called first style), comprised fictive drapery on the podium;[2] the stucco frieze reproduced the Centaurs at Pirithous's wedding-feast after a painting by the Athenian Hippys, dating from the late fourth century B.C.[3] The floor of the doorway, flanked by two Corinthian columns, was embellished with Nilotic scenes, which are also now in the Museo Archeologico Nazionale in Naples.[4] From here one proceeded to the first of the two peristyles of the house. The battle scene measures 5.12 metres by 2.71; with the frame it reaches 5.82 by 3.13.

The mosaic floor of the exedra was constituted by two different surfaces resulting from the size of the tesserae.

Cubes of a centimetre square were used in the perimetric area (now destroyed), conceived as a link between the pictorial mosaic and the space to which it had been adapted. This external border was formed by a white band, just over a metre in width in proximity to the three walls and approximately thirty centimetres wide by the doorway leading to the peristyle: the pattern was oblique with undulating rows.

The same large tesserae have been used in the frame composed of dentils enclosing the picture, although the rows of tesserae are straight, evidently because of the need to be consistent with the dense segmentation of the motif (fig. 2). The battle scene and the four fictive bosses adorned with floral motifs that appear to hold together the corners of the frame are, however, executed with minute tesserae — on average, each one is three millimetres square — in *opus vermiculatum*, a technique known to have existed by the second century B.C., the period from which the work dates. This procedure differs from simple tessellated mosaic (*opus tessellatum*) because of the very precise arrangement of the tesserae in undulating or circular patterns, following the forms of the figures in a wormlike manner, from which its name derives (*vermis* is Latin for worm). It has been calculated that, in this mosaic, there are four million tesserae, all made of limestone, the colour of which is the result of natural mineralization.

The very small size of the tesserae and the way they are fitted closely together produces an imitation of a painted surface: viewed from a distance the effects of an irregular surface and fragmentation of the colours — which we consider to be typical features of the art of mosaic — are reduced, while the impression of a smooth brushstroke is created.

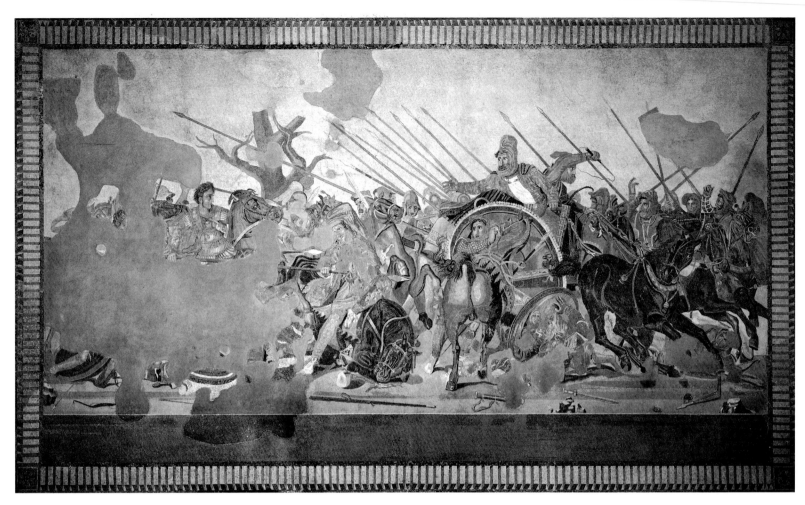

1. Alexander mosaic, from
the House of the Faun, Pompeii.
Museo Archeologico Nazionale,
Naples

The remarkable technical skill, the acute perception of the smallest details and the capacity to preserve the magnificence of the original are not always matched by the attention paid to the underlying meaning of the images. The long, tiring work of reproduction — just think of the noisy fragmentation of the small slabs of stone into minute pieces in order to obtain the tesserae — did not take place before the original picture, which adorned a palace, but rather with the aid of a copy, which may have led to the misinterpretations. Naturally, this regards the initial execution of the mosaic, in a totally different environment from the Pompeian house.

The strangeness of the severed horse's hoof, lying next to the Oriental transfixed by Alexander's lance, and some incongruity in the quadriga (figs. 7, 9, plate XVIII) — where the only part of the white horse's body that has any appearance of solidity is its legs — reveal the difficulty of making an indirect copy of such a great work of art in the analytical process that required the mosaic to be built up piece by piece: directly onto the fresh mortar, or on the back of 'cartoons' that were then turned over and placed on the prepared surface.

In antiquity restoration work was carried out to the mosaic following the damage caused by its detachment from its original site, transport and reinstallation in Pompeii. To facilitate matters, the mosaic was cut into two equal parts along a line passing between the speared Oriental and Darius's chariot (figs. 6, 7). So that the line of junction would be as invisible as possible, the division was made along the outlines of the figures, as may be deduced from the left edge of the cut.

The procedure was successful for the left half, while, in the other piece, the edge eaten into by the zigzagged fissure had crumbled away. The work was patched up with the original tesserae, but without there being access to the lost drawing. Revealing a notable difference from the splendid workmanship of the original floor, the inaccurate reconstruction of the picture causes confusion about what is happening near Darius's chariot. Entering the picture-space from the foreground, in this problematic section we find an ownerless leg; a partial copy of the hindquarters of the horse in front of the left part of Darius's chariot; lastly the head of a helmeted rider with a bizarre facial expression.

The situation is similar in another two small passages, one below, in front of the wheel of Darius's chariot, the other on the far right of the mosaic, where the damaged areas have been filled in with the original tesserae, but in a very naive manner (plate I).[5] In the first case, the lacuna regarded a part of the shield of a dead Greek mercenary (as we shall see). The surface of the shield reflects the face of an Oriental (nearer to the spectator, because he has fallen off the horse seen from behind in the foreground) who holds it off with his right hand. The metal disc has been very clearly depicted in all its brilliance and the reflection of the face and the shadow under the hand pushing away the shield are rendered with great optical skill. In comparison with this, the substitute filling-in is all the more woeful. The Oriental's face — of which the reflected image was visible — could not be seen in the representation of the man himself, who is seen *profil perdu* with his back turned to the spectator. The amateurish restorer, however, believed it necessary to give him a profile that does not conform to the rules of perspective and is, furthermore, bearded, without taking into account the fact that the face in the mirror is clean-shaven. Between this clumsy portrayal — now almost indistinguishable — and the splendid reflected face there is another area filled in with a neutral colour, while, immediately under the reflected face, a fragment of the original mosaic depicting two small animals embroidered in white on a piece of red-tinted cloth has been arbitrarily inserted. Not knowing how to adapt himself to the enchanting illusionism of the Greek artist, the naive Pompeian decided to turn this piece — which should have been visible in the mirror image — upside down, but it is, in any case, in the wrong place because it belonged to the trouser leg on the upper part of the left thigh of the real figure. The other restoration work in the same figure on the shoulder and right arm is less disastrous because this is an inert area. Lastly, the restorer has substituted the Persian horseman on the far right of the picture with a confused shape of mixed colour.

A special case — which seems to suggest that the original location of the mosaic was in a region conquered by the Romans — is the restoration of Alexander's eye (plate VIII). Ever since the mosaic was discovered it has been observed that the eye is not only anatomically incorrect but also excessively large, in marked contrast with the attention paid to every detail of the king's figure, and the high standard of the other heads. Moreover, it may easily be ascertained that here — unlike the parts restored in antiquity described above — the tesserae are quite different from the original ones, so the damage cannot have occurred while the mosaic was being transported. This fact has not hitherto been related to a similar, clearly demonstrated circumstance that could well provide the answer to the knotty question of the work's provenance. In the mosaic depicting Alexander and Hephaestion fighting a lion,[6] found at Pella in a house next to the one with the stag-hunt (figs. 48, 49), the figures' eyes have been removed. The phenomenon is repeated in other mosaics in the luxurious ed-

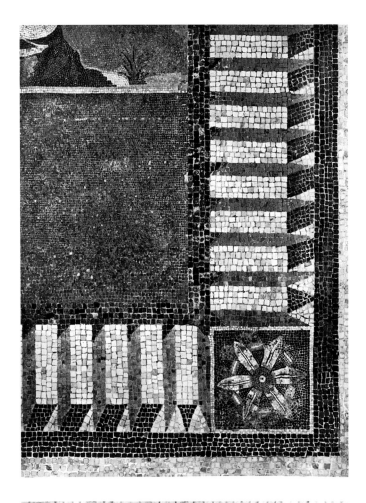

2. Frame formed of dentils and fictive bosses adorned with floral motifs. Detail of the Alexander mosaic, from the House of the Faun, Pompeii. Museo Archeologico Nazionale, Naples

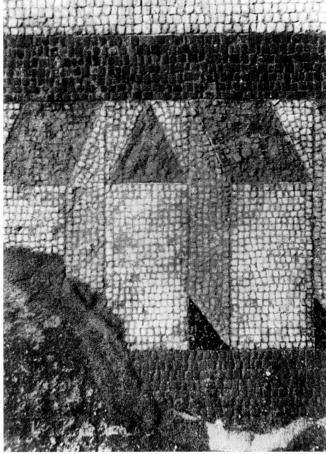

3. Frame formed of dentils. Detail of a mosaic. Building in the sanctuary of the Letoon, Xanthus (Lycia)

ifices of the Macedonian capital after the Roman conquest of 168 B.C. Since, in the scene of the stag-hunt, where the irises are represented by ordinary black stones, these have been left *in situ*, it is evident that in the other works more valuable stones were used, such as lapis lazuli, which were removed from the floors as soon as they were left unattended. A similar situation was at the origin of the anomaly — which now should no longer be surprising — of Alexander's face at Pompeii, providing us with a clue to the mosaic's possible provenance from the eastern Mediterranean, where it may have been deprived of the precious stone that represented the monarch's iris even before it became war booty or was sold on the antique market. Thus the mosaic must have been brought to Italy from an important Hellenistic site at the time when the House of the Faun was being so magnificently constructed (120–100 B.C.).

Together with the historical scene, the ancient craftsmen also detached the corners of the frame (fig. 2) since they were attracted by the elegance of the floral motif (which may still be admired in the Naples museum), leaving the architectural frieze *in situ*, since this was easy to reproduce with its geometrical regularity, as has already been noted with regard to the technique used for the mosaic.

The frame formed by long dentils, with bosses adorned with floral motifs inserted in small squares at the corners, is a typical feature of Hellenistic mosaics. It is interesting to note that in two cases in the Roman period not only the figured panel but also the four corner rosettes were removed, evidently because their refined execution appealed to those who were intending to reuse the mosaics. This explains just what happened in Pompeii, with the reuse of the figured panel and the corner ornamentation, while, after the mosaic's arrival, the dentil frame was reproduced with tesserae that were different from the original ones, but identical to those of the external border, as has already been mentioned.

One of these examples is the large mosaic that was formerly in a building of the Letoon, the Lycians' sanctuary at Xanthus (figs. 3, 4).[7] In this case the dentil ornamentation forms the frame in direct contact with the emblema — which was detached in Roman times — while there was a band adorned with a wave scroll on the outside. The dentil frame is 23 centimetres wide, and the pattern is executed as if seen from a central viewpoint on each side, as it was in the reproduction of the same design made in Pompeii: the colours used are light grey, reddish grey and black. The squares placed at the corners — in which the rosettes removed in Roman times were originally located — are included in the rectangle of the frame, as in the House of the Faun.

The other example is in Rhodes,[8] where the figured panel and the corner squares, originally containing rosettes (fig. 5), were also removed. The resemblance to the floor at the Letoon (figs. 3, 4) lies in the fact that here, too, the dentil frame is surrounded by a wave scroll. It is possible that the Alexander mosaic also originally had this double frame.

That the mosaic was not designed for the Pompeian house may also be inferred from the fact that the exedra where it was located was hardly big enough to contain it. Standing at the doorway — the floor of which was decorated with a Nilotic landscape — leading from the first peristyle, spectators would not have been able to see the whole battle scene and, stepping back to get a better view, they would have found that the columns got in the way. The damage — not filled in with mosaic — to the left half of the scene, to the body of the fallen Oriental (which had already been modified when the floor was reinstalled in Pompeii) and, on the right, to the area where Darius's standard was held aloft, may have been caused by the eruption of Vesuvius in A.D. 79, or perhaps during the nineteenth-century excavations. These areas were filled in with stucco at the Museo Borbonico (now the Museo Archeologico Nazionale) in Naples in 1843.

The Sun of Gaugamela

And then there is a very large flat province where there is the Solitary Tree, which Christians call the Dead Tree; and I shall tell you what it is like. It is tall and imposing [...] And the people of this place say that the battle between Alexander and Darius took place here.
Marco Polo

The landscape is barren, with just the parched earth of the Gaugamela Plain, rocky outcrops and an ancient plane tree (fig. 6, plate II). The trunk and main branch of the tree have been lopped off, the other surviving branches are leafless. This is the 'Dead Tree', the plant relict that was a thousand years old, or, at least, still remembered in Marco Polo's day (*Il Milione* 39. 4–7) as a symbol of the final battle for the conquest of Asia and recognizable in the medieval description as a plane tree:[9] 'And then there is a very large flat province where there is the Solitary Tree, which Christians call the Dead Tree; and I shall tell you what it is like. It is tall and imposing; its leaves are green on one side and white on the other, and it produces prickly burs like chestnuts, but there is nothing inside; it has strong wood, yellow like box. And there is no other tree for a hundred miles,

4. Mosaic with dentil frame: the figured panel and the corner bosses were removed in Roman times. Building in the sanctuary of the Letoon, Xanthus (Lycia)

5. Mosaic with dentil frame: the figured panel and the corner bosses were removed in Roman times. Rhodes

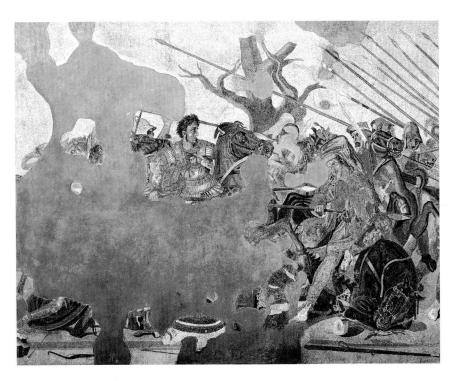

6. Macedonians attacking. Detail
of the Alexander mosaic, from
the House of the Faun, Pompeii.
Museo Archeologico Nazionale,
Naples

except in one direction, ten miles away. And the people of
this place say that the battle between Alexander and Dar-
ius took place here.'

Since we know that on the Gaugamela Plain a track
had been created for the charge of scythed chariots, it is
possible that the huge tree had been left there to signal the
position of the command post to the messengers who had
to take orders and information along the endless front, and
that it had a special meaning: the 'golden plane' was a pre-
cious ornament of the Achaemenid court. An archaic work
by Theodorus of Samos, it was given to Darius I by Pythius,
a rich and devoted subject of Lydia. The relic was then dear
to Xerxes (Herodotus, *History* 7. 27. 2), thus becoming the
symbol of the Greeks' enemies. However, we know from
historical sources that Darius occupied an unlevelled area
at Gaugamela (Arrian, *Anabasis of Alexander* 3. 13. 2). The
terraces sloping down in the picture give emphasis to the
rise where the observation post chosen by the Great King
(Darius III) is located, at the foot of the low hills that, in
reality, surround the plain.

The scene obtains space and concreteness from the lost
and broken weapons on the slope in the foreground, which
are balanced by the twisted branches of the tree, the mass
of pikes and the standard seen against the sky. All the colours
in the distance are toned down by the dust, which is om-
nipresent in the account of the battle of Gaugamela (Diodor-
us Siculus, *Bibliotheke* 17. 60. 4; Quintus Curtius Rufus,
The History of Alexander 4. 15. 32), and obscures the vast
dome of the sky.

All told, this scene comprises over fifty men — in-
cluding the hidden bearers of the long pikes — and around
twenty horses, counting those belonging to the riders of
whom only the heads or the crests on their helmets are vis-
ible. The figures are considerably smaller than life size.

The light comes from above. The sun appears to be to
the left of the spectator, illuminating obliquely the backs
of the attackers. This is an important detail if we assume
— in the absence of precise information — that the opposite
alignments at Gaugamela were initially more or less from
north to south: the Macedonians attacked the Persians, who
occupied a position to the east, from the west. By break-
ing through enemy lines diagonally, Alexander — as we shall
see later — headed for Darius in a north-easterly direction:
the painter appears to have rendered the light bathing the
Macedonians' charge crosswise.

The sun's height may be deduced from the shadow of
the broken pike at bottom right, or from the chiaroscuro
and the shadow of the horse seen from behind. In partic-
ular, the shadow of the wheel is cast on the side of the char-
iot and it is possible to distinguish the point where the ver-

tical spoke of the wheel meets the rim, in both the real thing and its projected shadow (plate XI). By combining these two points and prolonging upwards the segment thus formed, we obtain the position of one of the sun's rays, and hence of all the rays of light bathing the scene. The resultant is parallel to the nearest pike in the forest of fourteen forming the background to the centre of the picture; these appear to give concrete form to the rays of the sun, which is at about 45° above the horizon. The battle took place on 1 October, just a few days after the autumnal equinox (23 September), and this allows us to make a simplified calculation of the time of day represented in the painting. On the day of the equinox, at midday the sun is overhead (90°) at the equator. At Gaugamela, which is located at about 37° latitude north, at the same moment the sun is 53° above the horizon (90° – 37°). Since at the equinox the sun sets at 6 p.m., in the six hours of the afternoon it sinks a little less than 9° every hour here (53 ÷ 6 = 8.83). If, in the picture, the sun is 45° above the horizon, this means that it has sunk 8° (53° – 45°) — that is, almost an hour after midday. Thus Alexander, who only entered the battle after midday, is leading his personal attack in the early afternoon: this explains how he was able, after defeating Darius, to drive inwards to the centre of the Persian line, fight the enemy cavalry positioned there, beat them and still find time for a long pursuit before nightfall overtook him on the road to Arbela, which he reached the following day.

The astronomical coordinates place the event with a lucidity that is, in all respects, astonishing: in later centuries it is difficult to find such a perceptive and intense illustration of warfare until Paolo Uccello's paintings of the *Battle of San Romano*, Velázquez's *Surrender of Breda* — also known as *Las lanzas* — or the military evolutions of feudal Japan in Akira Kurosawa's film *Kagemusha*. Together with a historical account there is spectacularity, a global vision of an event that, as it takes place, contains both its premises and its conclusion.

The day of the battle at Gaugamela opened with the crisis of the Macedonian left wing under the pressure of the Bactrians, while the camp was devastated by the satrap Mazaeus's cavalry:[10] so 'wishing to make up for the defeat of his forces, Alexander personally led the charge against Darius with the royal squadron and other handpicked horsemen' (Diodorus Siculus 17. 60. 1). This is the event depicted, focusing on the moment in which the two monarchs confronted each other at close quarters (fig. 1). Although he is an impartial and attentive witness of the enemy's heroism, the painter highlights the contrast between Alexander who is leading the attack on the Persian front line at the head of his Companions and, on the other side, Darius

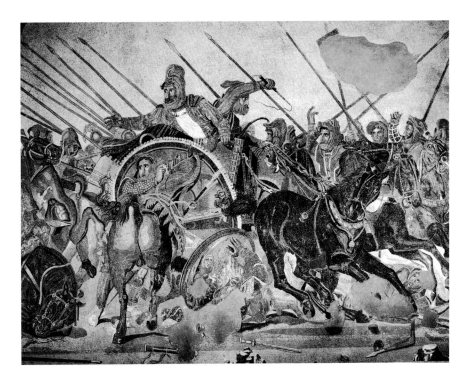

7. Darius and the Persians. Detail of the Alexander mosaic, from the House of the Faun, Pompeii. Museo Archeologico Nazionale, Naples.

whose life will be saved, thanks to the initiative of the charioteer, by running over his own troops. From the left, the Macedonians are advancing relentlessly. In the middle, under the anguished gaze of the Great King, one of the Orientals is voluntarily sacrificing himself, while, on the right, the flight of the vanquished is imminent.

The Royal Squadron of Companions

Wishing to make up for the defeat of his forces, Alexander personally led the charge against Darius with the royal squadron and the other handpicked horsemen.
Diodorus Siculus

In the right wing were located the horsemen, whom they called agema. *They were commanded by Cleitus the Black, to whom Alexander added Philotas's squadrons, and he put them next to the other cavalry commanders.*
Quintus Curtius Rufus

It is possible to distinguish the bent right arm of the first of the *hetairoi*, whose elbow is raised and held outwards as he reins in his horse (fig. 6, plate III). The nose of the animal emerges three-quarters on with its excited eye and harness jolted out of place. The rider was turning his head round — part of the neck and the left cheek-piece of the helmet, fastened under the chin, have survived — in one of those pictorial devices that convey the sense of what cannot be seen. In this case — offering further proof that the mosaic reproduces the picture right up to its original edges — this gesture meant that, in the real battle, the troops extended way beyond the limits of the picture-space. This observation is useful in order to support the basic assumption — for which further evidence will be provided later — that the painter did not intend to allude visually to different events that in reality took place far away and/or at a different time (as the majority of writers maintain), but rather depicted the place and the actors at the culminating moment, and this was selected and reassembled according to the conventions of painting with such a combination of effects as to allow it to represent the whole event.

The second figure is a Persian who has a head wound and is leaning to his right, his eye wide-open and his hair bloody. An almost vertical section of his lance is visible in front of the silver helmet of Aristander (to whom reference will be made later). All that remains of the bay horse ridden by the dying man is the end of a back leg, near the lower left corner of the scene, while its neck and head are hidden by Alexander. Above the cloak adhering to the curve of the king's right arm are just visible the top of its mane, an ear and the forelock tied on its forehead. Thus, although the animal's head follows the norm, the victim's head has slipped to a level below the isocephaly that is respected by the majority of the combatants (fig. 14). This anomaly confirms the extent of the drama: we may imagine that his lowered right hand still has a weak grip on the lance (perhaps because its handle is fitted with a loop like the one visible on the portion of a broken javelin on the ground near the centre of the picture). Slumped down, the body is slipping off the horse's back in a manner that was later copied by the sculptor of the Abdalonymus sarcophagus, now in Istanbul, which depicts an Oriental dying in one of Alexander's battles (fig. 26) and may be used as a guide for the reconstruction of the lacuna.

Just behind the dying man is the Macedonian who has struck the mortal blow; although almost all of this figure has been lost, the edge of his cloak and part of his raised right arm, covered by a sleeve, remain. The spirited head of his black horse with a red bridle is higher than that of the wounded Persian's steed: the assailant has had to rein in his charger, making it rear, in order to deal his deadly stroke. Since there were no other Greek warriors wearing a sleeved chiton, this garment assimilates its owner with Alexander: he must be a commander. His gesture, further prolonged by his sword, made this image emerge clearly from the line linking the heads of the combatants — known as the isocephaly — in the picture (fig. 14), recalling the action with which Alexander was immortalized at the Granicus in a group by Lysippus reproduced in a bronze equestrian statuette from Herculaneum (now in the Museo Archeologico in Naples).[11] The downward stroke with the sword is also a feature of the horseman in the centre of the battle represented on the Abdalonymus sarcophagus (fig. 25): this parallel continues to assist us in the imaginary restoration of the mosaic.

The graphic reconstructions made soon after the discovery of the mosaic in Pompeii place particular emphasis on the elusive warrior. When examining a reconstruction executed in pencil and ink on eight sheets of lightweight paper,[12] another on twelve sheets,[13] and a detail in tempera signed by Michele Mastracchio,[14] we note that the commander was completed as a horseman who rose above the other troops by the height of his bust, which is hardly logical when galloping on level ground. A copy of the mosaic, painted on ceramic tiles shortly after it was discovered, was a better depiction of the posture of the Macedonian with his arm raised ready to strike. This representation seems to confirm that at this point there was an element rising

above the isocephaly of the attackers, forming a pendant to the Achaemenid banner, which, being in the opposite half of the picture, helped to give symmetry to the work (figs. 7, 8).

At Gaugamela the royal squadron of Companions was under the command of Cleitus the Black (Quintus Curtius Rufus 4. 13. 26). The distinction of the sleeved chiton and the intrepid act of war are suited to the commander of this élite unit. In the very brief time-span of the attack, the episode marks the point at which the commander came into contact with the enemy at the same time as Alexander, after the sudden decision to break through the Persian lines in the direction of Darius.

In the lower left corner are depicted — next to the leg of the bay horse belonging to the Persian with a bloodied head — the arm of a fallen Oriental with the rear of shield and, on the ground, an arrow, a bow and a quiver (fig. 6, plate IV).

The Soothsayer

Wearing a white cloak and a gold crown,
Aristander rode between the ranks.
Plutarch

Behind Alexander, Aristander may be seen in profile, with his silver helmet in Boeotian style surrounded by a golden laurel wreath. He is the soothsayer, remembered by the historians for his white apparel and gold crown (Plutarch, *Alexander* 33. 2), who was particularly prominent in the battle of Gaugamela because he spent part of the previous night in Alexander's tent, 'carrying out mysterious rites with him and making a sacrifice to Phoebus' (Plutarch, *Alexander* 31. 9). Just before the direct attack on Darius he had given a favourable interpretation to the portent of an eagle flying over Alexander's head towards the enemy (Plutarch, *Alexander* 33. 2). In the mosaic, his is the arm raised with a lance that is about to strike those threatening Alexander at close quarters. Above the king's right shoulder — in addition to the forelock, mentioned previously, of the bay horse belonging to the wounded Persian — there is a small yellow area, which may represent the fair hair of a nearby horseman. Beyond the breast of Alexander's horse, Bucephalas, protrudes the tip of the pike held by the shield-bearer following the king on foot; near the horse's muzzle is visible the plume and little more than the outline of the helmet of a Macedonian who is turning towards his sovereign holding a short sword. He is probably the owner of the black horse of which an ear and the knot at the top of its mane may be noted. Behind this, another two superimposed horses' muzzles reveal the limited depth of the apex of the advancing squadron, in the form of the 'wedge' described by Arrian (*Anabasis* 3. 12. 2–3): 'Since the horsemen who came in support of the encircled Companions on the right wing had broken through the front line of the barbarians at one point, Alexander, turning in the direction of the gap formed a sort of wedge [*embolon*] with the cavalry of the Companions and the phalanx that was drawn up there, and, at the head of this, uttering a war cry, led it against Darius in person.'

The charge overtook Alexander and continued into the enemy lines, in the manoeuvre outlined by Quintus Curtius Rufus (4. 13. 26), after the information that Cleitus commanded the *hetairoi*: 'Alexander added the squadrons of Philotas, and placed the other commanders of the cavalry at his flank.'

In addition to the use of linear perspective, the representation of the distance of these combatants is entrusted to the progressive diminution of the intensity of the colour, produced, as has already been stated, by the dust that, according to the historians, enveloped the battle of Gaugamela. Beyond the Persian nobleman with his sword raised and rearing horse (to whom reference will be made later), there is the head of a Macedonian, of whom we can see an eye with the eyebrow raised by the tension of the battle and a tuft of black hair emerging from his leather cap, which may be the lining of his lost helmet. Then there is the figure wearing a helmet (mention has already been made of the inaccurate restoration carried out when the mosaic was brought to Pompeii): the whole of his head and a small part of his lance are visible. The helmets and plumes of at least two other cavalrymen appear under Darius's outstretched arm; the crest of a helmet beyond the charioteer's chin indicates the furthest point of Macedonian penetration.

Mercenaries and Horsemen

The Greek mercenaries flanking Darius and the
Persians who were with him, were set against the
phalanx of the Macedonians, because they were
the only ones capable of opposing them.
Arrian

Darius, who commanded the left wing, had at his
flank the cavalry of the 'kinsmen', a thousand soldiers
chosen for their valour and loyalty grouped in a single
squadron. Having the king as the spectator of their
prowess, they fearlessly exposed themselves to danger.
Diodorus Siculus

Passing to the opposing side, in the picture we see arrayed in defence of the monarch the remarkable variety of troops described by the historians as being present on the field of battle at Gaugamela. Arrian (*Anabasis* 3. 11. 5–7) refers to the presence of the *mysthophoroi* (mercenaries): 'The Greek mercenaries flanking Darius and the Persians who were with him, were set against the phalanx of the Macedonians, because they were the only ones capable of opposing them.'

Two of them may be picked out in the picture due to their hoplite equipment; the presence of others may be deduced; the majority are identified by the long pikes they are carrying.

One is almost in front of Alexander (plate X): his head, bleeding from his wounds, is partially visible, as is the round shield on which may be recognized the incomplete reflection of the Oriental who has been run through by the king's lance; the tip of a pike pokes through a split in the shield (plate VII). An important work deriving from the painting, an Italo-Megarian bowl with relief decoration by Caius Popilius, now in Boston (it will be described later), appears to move this dismounted mercenary into the foreground, between the Oriental transfixed by Alexander and the chariot (figs. 36, 37).

The second mercenary has fallen, and he was the owner of the other resplendent circular shield — the subject of a similar, ampler optical artifice, which will be mentioned later — next to the chariot's wheel. Probably the shield remains upright because it is still held by the dying man, of whom we can see part of the head and legs; the latter are bare, unlike those of the Medes and their foreign auxiliaries, which are covered by *anaxyrides* (trousers) (plate XII). A third Greek combatant in the service of the Persians has probably fallen in the lower left corner of the picture, where mention has already been made of a left arm holding a round shield (plate IV).

A fourth fighter may have been crushed under Bucephalas, where part of the edge of a round shield and the representation of a stream of blood remain. In this position, all the Etruscan urns (in Perugia) — we shall be examining these later among the works deriving from the original painting — show a kneeling naked warrior, holding a shield, his body bent forward and his head touching the ground (figs. 30–35); the Dacian knocked down by Trajan's horse in the Great Trajanic Frieze on the Arch of Constantine has a similar pose.

The bearded Persian horseman — found in both the mosaic and the relief on the bowl in Boston (figs. 36, 37), and also present on one of the urns in Perugia (fig. 35) — who is raising his sword and looking towards Alexander,

reins in his horse (which rears three-quarters on towards the observer's right) with the aim of turning towards the bare-headed attacker and dealing him a blow from above. Together with the horsemen that we shall see in the right part of the picture (plates I, XVIII, XX), the intrepid cavalryman forms part of the special bodyguard mentioned by the sources as being present at Gaugamela: 'Darius, who commanded the left wing, had at his flank the cavalry of the "kinsmen", a thousand soldiers chosen for their valour and loyalty grouped in a single squadron. Having the king as the spectator of their prowess, they fearlessly exposed themselves to danger' (Diodorus Siculus 17. 59. 2–3).

'Las lanzas'

This is a picture that has always fascinated me. Since I was a child I have wondered why we cannot see those who are carrying the pikes, the people who had done the dirty work of the war. In the game of chess I admire the pawn more than the king, queen, bishops and castles.
Arturo Pérez-Reverte[15]

Between the Persian wielding a sword and Darius's chariot, we shall ignore the incongruous restoration carried out when the two sections of the damaged mosaic were adapted to the floor in Pompeii, because this is irrelevant as far as the reconstruction of the picture's origin is concerned. This damage has made the solution of the most controversial problem more complicated: to whom do the long pikes standing out against the sky belong (plate I)?

From the beginning of the Asian campaign up to and including the battle of Issus, the awesome *sarissa* (pike) was only used by the Macedonians. We know, however, that at Gaugamela, the Persian army was equipped for the first time with long pikes in order to oppose the invaders' phalanx (Diodorus Siculus 17. 53. 1). The oft-repeated explanation that the mosaic represented the battle of Issus meant that these extremely prominent pikes were attributed to the Macedonians. In the end, however, the supporters of this interpretation accepted the hypothesis that these weapons belonged to the horsemen whose plumes are visible;[16] moreover, they believed that the majority of the pikes, slanting upwards to the observer's left, were being carried on the warriors' shoulders for use elsewhere. But this is impossible in this promiscuity with the enemy, contradicting what we have observed with regard to the other almost horizontal lances of the Macedonian horsemen, although they were further back; nor is there a relation between the number of heads and that of the weapons. According to this theo-

ry, the last ones towards the observer's right, pointing in the same direction but tilted at a slightly different angle, were those used to put the Persian horsemen to rout: this is another unacceptable suggestion because it implies that the Macedonian victory was already so complete that the encounter of the two monarchs was now deprived of any suspense.

There are details that make this conjecture unlikely, favouring the hypothesis that this is the battle of Gaugamela. Observe the pike of which the greatest length is represented, passing in front of the tree, close to the area where the most important action is taking place: the lower part, which ought to begin immediately behind the left side of Darius's chariot, was reconstructed in the restoration at Pompeii in a direction that was not aligned with the part still existing today, and cannot, therefore, be used in this interpretation. But the original — and very significant — position of the weapon may be deduced from the wholly-preserved fourth pike (counting from the left), which is also closer to the picture plane than the attacking horsemen. Given the height from which it starts, it is evident that it can only be held by an infantryman. Since he is hidden in the midst of the Persian lines next to the chariot, it may be excluded that this is a Macedonian still marching to the front with his pike on his shoulder. This weapon is pointed in a hostile manner against the Macedonians, and its bearer cannot but be one of the mercenaries that Darius has armed with long pikes in imitation of the phalanx. Thus we have proof that, in the battle scene depicted on the mosaic, at least one foot-soldier of the Achaemenid army is pointing against the Macedonians a long pike similar to those carried by Alexander's troops: and this corresponds with Darius's decision to adopt this weapon at Gaugamela.

The position of the pike — the bearer of which is, as I have demonstrated above, certainly a soldier in the Persian army — is congruent not only with that of the longest pike, the lower part of which was altered by the restoration in Pompeii, but also with the positions of those in the background, which must also be attributed to the Persian infantry. Thus — in contrast with other interpretations — it may be confirmed that, in the picture, Darius had an overwhelming numerical advantage, which was noted by Goethe and other early commentators. This is only to be expected with regard to the battle of Gaugamela, as it accords with the historical accounts emphasizing the inequality of the forces and the risk that Alexander deliberately ran when he penetrated (*eis ta mesa*) the enemy lines (Plutarch, *Alexander* 33. 5).

The first lines (towards the Greeks) of the Oriental infantrymen involved in the fray in the background could not be depicted by the painter since the men on foot were hidden by the horses and their riders, and their pikes were lowered in order to strike the assailants. What may be seen behind the heads of the attacking cavalry is a group of fourteen pikes all tilted at the Macedonians, indicating the main body of a detachment of Oriental infantry in a phalanxed position: they are those who are immediately behind the first — for us, invisible — rows.

In this series of pikes pointing at the Macedonians, the last three on the observer's right are slightly more vertical, as was stated previously. They cross two of another set of three (separate from the group of fourteen pikes described) facing in the opposite direction from the majority, and significantly positioned behind the group of Persian horsemen in rout. These final pikes are thus much fewer than the first dense group, suggesting that, unlike the soldiers still engaged in fighting, discipline was weaker among those in the rear: some must have already abandoned their arms (hence the gaps); others, although continuing to hold their weapons, have turned their backs on the enemy.

The fanlike array of lines that is expanding behind Darius's back becomes, in our eyes, an analysis — one could almost say filmic — of the postures of each of the bearers, who pass from the regular procedure for attack, with their weapons pointing at the Macedonians and ready to be lowered against them, to the confusion of flight. As will be explained in greater detail later, this is a moment of high drama, remarkable for its historical concreteness and expressed in a masterly manner without recourse to the human image.

The Standard-Bearer

And they said they had seen the royal banner,
a sort of golden eagle raised on a javelin.
Xenophon

In front of the forest of pikes stood out the standard — now almost wholly lost, but in a better condition at the time when the mosaic was discovered — borne by a horseman of Darius's retinue. Thanks to the drawings and copies on ceramic tiles of the nineteenth century (fig. 8), which have also served to confirm the presence of Cleitus in the left-hand side of the picture, it has been possible to recognize the banner of the Achaemenids bearing a fabulous bird.[17] Xenophon wrote — from hearsay — of this device in two controversial passages, from which a translation has been obtained that is confirmed by the very faint vestige of it in the mosaic and archaeological evidence from the Persian world: 'Cyrus had a banner with a golden eagle raised on

8. Darius's standard. Detail of a copy of the Alexander mosaic painted on ceramic tiles, Chatsworth

a long spear, and this is still the banner of the king of the Persians' (*Cyropaedia* 7. 1. 1); 'And they said they had seen the royal banner, a sort of golden eagle raised on a javelin' (*Anabasis* 1. 10. 8).[18]

Apart from the pikes, the banner is the last of four elements emerging clearly from the line linking the highest heads of the combatants, rhythmically dividing the picture into five horizontal sections (fig. 1). After the first part (containing a pair of horsemen), there was the raised arm wielding a sword belonging to the warrior who may well be Cleitus; after the second section (comprising Alexander) the plane tree soars up; this is followed by the central portion, which is wider than the others (and was even wider before the loss of an intermediate section when the mosaic was installed in Pompeii), with the Oriental sacrificing himself; then there is the group of Darius and his charioteer poised precariously; lastly, between the fourth and fifth parts — occupied jointly by the quadriga and the Persian horsemen in rout — the standard is held aloft. Thus, on the opposite sides of the imaginary central axis, Cleitus's sword-stroke is counterbalanced by the banner of the vanquished, and the bare trunk by the defeated monarch, with an inauspicious reference to the Achaemenids''golden plane tree'. I have already referred to the notable symbolic value of the tree at the time of the Persian invasion, while, at the court of Artaxerxes II, the Greek ambassadors ironically noted that 'the much-praised golden plane was not sufficient to provide enough shade for a cicada' (Xenophon, *Hellenica* 7. 1. 38).

The face of the standard-bearer is not visible because he is looking towards the Macedonians' charge. The pole supporting the banner, shorter than the pikes, is held almost vertical, indicating its extraneousness to the detachment of infantry wielding the numerous pikes, and, at the same time, the steadfastness of the standard-bearer, undaunted before the assault of the enemy cavalry.

Bucephalas

> *As soon as Alexander mounted Bucephalas,*
> *the attack began.*
> Plutarch

The mass of soldiers engaged in the manoeuvre and fray at Gaugamela highlights the failure of the conflict to come to a head in a duel, of which everything else is a consequence: 'The two kings, with their two armies almost in contact, had started the battle' (Quintus Curtius Rufus 4. 15. 23). Alexander bursts into the picture space, but is not intercepted by anyone: the shield-bearer running alongside him, perhaps Peucestas, was on his left. His profile is still visible immediately behind the king's arm, with the edge of his yellow cloak and a trace of his crimson hat, the traditional *kausia* of the Macedonian nobility (plate VII). He has already been mentioned as the bearer of the pike projecting beyond the breast of Alexander's horse.

At Gaugamela, Alexander mounted Bucephalas, as Plutarch recounts (*Alexander* 32. 12) when giving details of the attack represented in the picture: 'While he was engaged in drawing up units of the phalanx or exhorting, admonishing and inspecting his men, he used another horse in order to spare Bucephalas, which was now too old; but when he went into action they brought him his own horse and, as soon as Alexander mounted Bucephalas, the attack began.'

The horse has been abruptly reined in by Alexander pulling with his left hand — which is hidden behind the steed's arched neck — so that its front legs are raised and bent. The horse's body and rear legs have not been preserved in the mosaic, but their position may be reconstructed from the series of works deriving from the painting (some of which have already been mentioned), which show the animal's hindquarters still extended by its momentum: a frieze in Isernia (fig. 29), six Etruscan urns (figs. 30–35), a bowl by Caius Popilius (figs. 36, 37) and a relief from the period of the Roman Empire now in Zurich (fig. 39). The latest of these works, a Byzantine miniature (fig. 41), adds the ox-head brand-mark — from which the name of the famous steed derived according to one of the explanations proposed by Pliny (8, 154) — to Bucephalas's right haunch. The picture we are concerned with here, with its fresh authenticity, may have helped to diffuse the horse's name: the custom of reproducing the brand-mark in pictures of horses was already attested around 400 B.C. in Early South Italian pottery (Early Lucanian period), with a pelike by a painter of the Karneia Group, in the Museo Nazionale della Siritide (fig. 42).[19] The vase shows Hermes in arms on his steed, which has a large brand-mark in the form of a caduceus on its haunch, corresponding with the ox-head on Bucephalas as depicted in a codex in Venice (fig. 41). Such is the pregnancy of the mythological symbol that it is sufficient to allow the observer to identify the messenger of the gods in an unusual guise, with Poseidon and Athena, there being no other evidence to this effect. The brand-mark consisting of a figure of Nike on a bronze horse in Pergamene style from Artemisium, now in the National Museum in Athens, is in the same position.[20]

Compared to the schema, which is more common in Greek art, of the horse rearing with its hind legs bent[21] — which is found, for example, on the Abdalonymus sarcophagus (fig. 25) — and also regards Alexander's head-

long gallop in the group of Sagalassus in Pisidia (333 B.C.), known from local coins of the Imperial period,[22] the iconography of Gaugamela introduces a third model, that of the intermediate stage. The gallop, still expressed by the extension of the hind legs in accordance with classical convention, is frozen at the moment when the reins are used, but before the horse has been able to rear up on its hind legs in order to regain equilibrium: thus Trajan dominates the fray in the relief depicting the victory over the Dacians, inserted in the Arch of Constantine.[23]

Alexander

Alexander, turning in the direction of the gap formed a sort of wedge with the cavalry of the Companions and the phalanx that was drawn up there, and, at the head of this, uttering a war cry, led it against Darius in person.
Arrian

Darius rode in a chariot, while Alexander was on horseback.
Quintus Curtius Rufus

The wavy mane of Bucephalas echoes the animation of Alexander's leonine hairstyle: in what seems to be a technical illustration of horse-riding, the animal is brusquely reined in after the king has taken an impetuous decision to solve a tactical problem (plate VII). Alexander 'personally took command of the right wing and, having adopted an oblique formation, he resolved to personally decide the outcome of the battle' (Diodorus Siculus 17. 57. 6): the steadiness of his bust depicted frontally and his hand holding the lance reveal the strength and determination needed to follow up the daring manoeuvre. In his head seen in profile, his gaze — despite the unhappy restoration of his eye in antiquity, which has already been explained — is directed towards the objective, Darius in person, who is so close to Alexander that he could almost reach him with his lance: 'Alexander pursued the enemy troops that had yielded into their lines [*eis ta mesa*], where Darius was to be found. He had seen him from afar, directing his gaze through the rows of the regiment of the guard arrayed before him' (Plutarch, *Alexander* 33. 5).

The sleeved chiton that Alexander is wearing under his armour recalls another detail in Plutarch's account of the king's day at Gaugamela from his late and difficult awakening to his triumph: 'He had been wearing the rest of his armour since he emerged from the tent. It consisted of a close-fitting Sicilian doublet, which he wore underneath, while over this was a double cuirass of linen, part of the booty he had taken at Issus' (Plutarch, *Alexander* 32. 8).

What Alexander is wearing externally to protect his body is a rigid cuirass (*thorax stadios*), with the plates cushioned internally by two layers of linen. The Gorgon's head appliquéd on the breast — magically animated in the picture, she glowers at the enemy — and Zeus's thunderbolt on the shoulder-piece on Alexander's left suggest that it may have belonged to a commander of the Greek mercenaries routed at Issus (plates VII, VIII). In the mosaic the shoulders of the cuirass are covered by the cloak worn at Gaugamela: 'He wore a cloak that because of its workmanship was more precious than his other equipment; made by old Helicon, it had been presented to him as a sign of honour by the city of Rhodes, and he used it for the battles' (Plutarch, *Alexander* 32. 11).

The crimson cloth is fastened on Alexander's right, below his neck, with a round-headed fibula.

In order to strike Darius, towering above him in his chariot, Alexander ought to have pointed his lance upwards, as is shown on one of the Apulian vases depicting this subject — where Darius's saviour does not interpose himself between the two monarchs (fig. 17) — or on the decadrachms struck by Alexander in 324 B.C., which show the pursuit of King Porus seated on an elephant (fig. 16). In the mosaic, however, the lance is horizontal: its thrust has been diverted thanks to the prompt reaction of the Oriental horseman, who does not hesitate to sacrifice his own life.

The Unknown Soldier

The best, the noblest of these horsemen allowed themselves to be killed before their king, and, after they had fallen on top of each other, they delayed the pursuit.
Plutarch

Next to them fought the guards of the royal palace and the most valiant Indians.
Diodorus Siculus

The black horse belonging to the courageous warrior flanks the central axis of the picture with prominent signs of its terrible wounds: leaving aside the severed hoof — as I have already stated, this is an error in the mosaicist's interpretation of the original painting — blood is pouring from the animal's breast, where the tip of a javelin has been driven in, and from its mouth, following a lung haemorrhage. The javelin has broken and part of it lies on the ground (as I have already mentioned) with the loop (*ancyle*) that allowed

a rotary movement to be given to it when it was thrown (plate X). Darius's resolute defender has taken advantage of this incident in order to stop the assailant by throwing himself forward into the path of Alexander's lance. At Gaugamela, 'many splendid horsemen, disposed in large numbers, especially around Darius's chariot, formed a barrier to protect him and were ready to bear the brunt of the enemy attack [...] the best, the noblest of these horsemen allowed themselves to be killed before their king, and, after they had fallen on top of each other, they delayed the pursuit by clinging to each other and writhing at the feet of the men and the horses' (Plutarch, *Alexander* 32. 5–7).

In view of the speed of the attacker, the young man must have rapidly grasped the tip of Alexander's lance with his right hand, lowering it. Although slowed down by his grip, the lance continued its progress in the new direction with deadly momentum. As the horse slid to the ground, bending its legs, the warrior drew back to avoid injury, but the weapon reached him nevertheless. Entering his right hip, the tip emerged from the opposite side. In terrible pain and still holding onto the lance, the victim raises his other arm and emits a cry from his half-open mouth.

Since the use of stirrups was unknown in antiquity, Alexander would not have been able to inflict such a strong blow with his lance on a body situated so close without being unhorsed himself by the rebound. In fact the Oriental attached to the lance — as I have already deduced — has not only deviated it, but he has also involuntarily slowed down the horse, reducing the consequences of the impact on his killer. Thus Alexander has remained in the saddle, but, due to the jolt, has lost his helmet of the Chalcidian type, which is rolling on the ground with its brightly coloured plume: '[The king] was recognizable [...] by the crest on his helmet, since all around splendid plumes reared up, tall and intensely white' (Plutarch, *Alexander* 16. 7).

The fact that Alexander had lost his helmet increased the emotional charge because of the greater danger to which the king was exposed and also due to the pregnancy of the gesture with which he had previously put it on, which Plutarch describes as taking place in a critical situation. The messengers of Parmenion, the commander of the Macedonian left, reached the king with the inauspicious news of the retreat of the left wing and the incursion of Mazaeus into their camp at the moment he was about to give the signal for the attack to his troops. With great audacity, Alexander replied that, if he won, he would save his own baggage and conquer that of the enemy, and, if they lost, they would not have to concern themselves with it any more: 'having sent this reply to Parmenion, he put his helmet on his head' (Plutarch, *Alexander* 32. 8).

Having missed his only chance to strike Darius with his lance, Alexander had to abandon the weapon he had thrust into the anonymous hero's body and unsheathed his sword of Cypriot manufacture — note the ivory hilt — which also has its importance in Plutarch's account of Gaugamela: 'The sword that he wore at his side had remarkable temper and was very light. The king of Citium had given it to him, and Alexander was ready to use the sword for almost the whole duration of the battle.'

Also this predicament — requiring the switch from lance to sword — reveals the culminating nature of the moment chosen by the painter. Alexander's most urgent requirement is to defend himself from the mercenary confronting him on foot and the bearded horseman who is approaching him brandishing a sword — that is, if he is not preceded by one of the *hetairoi*, to whom reference has already been made, and, in particular, Aristander's lance. And it may be presumed that, with his left hand — hidden behind Bucephalas's neck — Alexander is tugging on the reins to guide his reluctant horse round the obstacle of the dying man.

Although they did not have the hoplite equipment — which has already been mentioned — of the Greek mercenaries, Darius's other defenders are not dressed and armed in a homogeneous manner. With the king's 'kinsmen', mentioned previously, 'there were the *melophoroi* [palace guards] [...] the Mardi and the Cossaeans, who were admired for their physical superiority and magnanimity. Next to them fought the guards of the royal palace and the most valiant Indians' (Diodorus Siculus 17. 59. 3–4).

The exploits represented in the picture tally with various writers' vivid accounts of these troops coming from the far-flung provinces of the Persian Empire: 'When the armies were close together, it was possible to see that Darius and those surrounding him, the Persian *melophoroi*, the Indians, the Albani, the deported Carians and the Mardi archers, were making a stand against Alexander and the royal squadron' (Arrian, *Anabasis* 3. 13. 1).

While the warrior who has thrown himself into the path of Alexander's lance may be an Indian — he is dark-skinned, clean-shaven and wearing heavy earrings, in accordance with the anthropological features described by Quintus Curtius Rufus (8. 9. 20–22) — the other horseman capable of extreme self-sacrifice is also beardless and is dressed differently from the Medes. He has leapt to the ground in order to offer Darius the chance to escape on his steed (plate XI). The spontaneity of his generous gesture is stressed by the bridle still hanging in mid-air on the horse's right. A tall palace guard on foot (*melophoros*) has shifted his lance to his left hand; with his right hand he has curbed the horse

by seizing its bit, and he brusquely pulls it towards the chariot to facilitate Darius's possible escape. Meanwhile, he turns to watch the grisly end of his comrade run through by Alexander's lance. The arc of the wheel circumscribes and crowns the memorable group: the terrified animal, foreshortened from behind, is close to the central axis, in evident symmetry with the Indian's dying horse: 'Men who did not think of themselves, since, if they lost their king, they would have neither wished nor been able to save themselves, and each of them considered it to be the greatest of all honours to meet their deaths before the eyes of their king' (Quintus Curtius Rufus 4. 15. 24).

Darius

Darius was a handsome man, large in stature, standing in the high chariot.
Plutarch

High on his chariot, gazing around and gesticulating to the left and the right towards the surrounding troops.
Quintus Curtius Rufus

Concluding his observations on the superhuman efforts of the combatants, Quintus Curtius Rufus (4. 15. 25) noted, however, that 'the greatest danger was faced by the two men they most sought to protect, given that all of them craved for the glory of killing the enemy king'. It was Darius who, because of the requirements of dynastic pomp, was most at risk: '[he] was a handsome man, large in stature, standing in the high chariot' (Plutarch, *Alexander* 33. 5). In the Persian camp at Gaugamela, the chariot had assumed a symbolic role from the outset. Darius was in the left wing (Quintus Curtius Rufus 4. 14. 8–9), where he was in command, 'surrounded by a large number of his own men, the flower of the cavalry and infantry […] High on his chariot, gazing around and gesticulating to the left and the right towards the surrounding troops' he began a long speech urging them to fight bravely for the Persian cause, an exhortatory performance that was, however, the prelude to tragedy.

The day at Gaugamela is efficaciously summed up in the picture by the unfinished combat between the warrior in his chariot and the horseman — in other words, between an archaism that, for the Greeks, evoked the Homeric world, and the revolutionary tactical use of the cavalry (Quintus Curtius Rufus 4. 15. 23): 'Darius rode in a chariot, while Alexander was on horseback' (in Latin: '*curro Dareus, Alexander equo vehebatur*').

The disconcertment of the Great King, who escapes

from the onslaught at the price of a human life offered spontaneously, is in marked contrast to Alexander's conviction and concentration. However, rather than by the direct threat of danger, Darius seems to be upset by the sacrifice of his horseman, to whom the anguished, albeit impotent, gesture of the right hand is addressed (plates I, XI, and XV).

Meanwhile, the panic-stricken charioteer has turned the vehicle and is slackening the reins in order to start the horses off at a full gallop. It seems evident that Darius is contrary to this. As the chariot lurches forward, he is thrown towards the advancing enemy, and in order to keep himself on his feet he has to hold onto the side with his left hand in which he is also gripping a bow. The reason why he is not attempting to shoot an arrow at Alexander is that his large quiver — attached to the side of the chariot — is now empty. His cloak spreads out behind his back following the direction of his extended arm, revealing the speed with which his body has been jolted to one side by the chariot's sudden turn: 'Darius now had, before his eyes, all the horrors that the fray presents. The troops that were arrayed before him for his protection, threw themselves onto him, nor was it easy to turn the chariot and flee because the wheels got stuck as they wallowed in the dense sludge, the horses floundered, held back and submerged by the mass of bodies, or they reared up, disorienting the charioteer' (Plutarch, *Alexander* 33. 8).

The quadriga occupies the lower right corner of the picture as it rotates away from the front: the graphic reconstruction compensates for the mistake in the interpretation of the original by the mosaicist, who had omitted most of the white horse, as I pointed out at the beginning of this chapter (fig. 9). The first horse is placed obliquely with regard to the picture-plane, the others turn progressively towards the direction of the flight; they all look towards the spectator. The difficult manoeuvre, carried out under the pressure of the enemy attack, has turned out to be disastrous for Darius's defenders. The first victim is the mercenary who has been crushed by the right wheel: I have already described his legs, head and shining shield still standing upright on the ground.

The young man with an embroidered tunic who, at the moment of danger, had abandoned his steed in favour of the king, could also be a victim of the chariot's course: he has fallen supine, losing in the violent impact his sword's empty scabbard with the baldric that has slipped off his shoulders (they lie on the ground on his left) and, at the same time, dropping the sword he held in his right hand; this is visible in the foreground. Now he is leaning with his left hand on the ground and pushing away the dead mercenary's shield with his right hand. In the convexity of the

9. Drawing of Darius's quadriga.
Detail of the Alexander mosaic,
from the House of the Faun, Pompeii.
Museo Archeologico Nazionale,
Naples

metal he sees the distorted reflection of his own face, perhaps a split second before his death if the giant wheel should run over him: a fine reward for his heroic gesture! Nevertheless his face is impassive — this will be explained later — while the face of the archer, possibly one of the Mardi, who has ended up between the legs of the central horses of the quadriga, expresses terror.

A senseless consequence of the wars throughout history — today we talk euphemistically about the victims of friendly fire — this progress of the king's chariot over the bodies of his own subjects was referred to with bitterness by a late writer (*Alexander-Romance* 2. 16). Providing further confirmation that this battle is that of Gaugamela, the rotation of Darius's chariot, with tragic consequences for the Persian troops, appears only in the description of the final battle — not Issus, but Gaugamela, therefore — albeit distorted by the confusion between the royal vehicle and the numerous war-chariots used at other times during the battle: 'It was nothing but a tangle of those who were striking and those had been struck by the missiles; many died and others lay dying on the ground. The air was dark and seemed to be sodden with blood. Many of the Persians were dead and Darius was terror-stricken, so he tugged the reins of the scythed chariots and made them turn round in order to flee; with the wheels he reaped many Persian lives, like a peasant harvesting grain in a ploughed field.'

The Finale

> *I ride in a chariot not only because of an old-*
> *established custom, but also in order to be seen,*
> *and I do not oppose those who imitate me, whether*
> *I be taken as a model of valour or of vileness.*
> Quintus Curtius Rufus

> *Darius now had, before his eyes, all the horrors that*
> *the fray presents [...] nor was it easy to turn the*
> *chariot and flee because the wheels got stuck as they*
> *wallowed in the dense sludge, the horses floundered,*
> *held back and submerged by the mass of bodies,*
> *or they reared up, disorienting the charioteer.*
> Plutarch

> *No longer a battle, it was a massacre.*
> Quintus Curtius Rufus

Plutarch (*Alexander* 33. 6) attributes the beginning of the catastrophe entirely to Alexander's sudden impulse, confirming the object of his hero to make history with his own

initiatives: 'But as soon as they saw Alexander — who was terrible at that moment — at close quarters, while he drove the fugitives on top of those who resisted resolutely, a shudder went through their limbs and most of them took to flight.'

The first impression is that the painter sought to represent this state of affairs (plate I). The passage from Plutarch quoted previously (p. 24) corresponds to the picture: Darius's escort seems to split up under the pressure of Alexander's attack, so that there are those who make a stand and sacrifice themselves, while the majority retreat. However, if we observe the different behaviour on the battlefield according to the respective positions of the combatants, the situation in the picture is different. None of the Orientals located between the two kings — and so exposed to Alexander's terrifying assault — show any signs of yielding; on the contrary they actively resist the enemy, succour their sovereign, or even sacrifice their lives for him. This is also the case with the most advanced infantry whose pikes are resolutely pointed at the Macedonians.

The reverse is only evident behind Darius, unbeknown to him, both among the 'kinsmen' on horseback and among the more distant infantry, whose pikes were turned away from the enemy, as I have already observed (plate XX). It was those behind the chariot, who were compelled to see something much more alarming than a cavalry charge — their king turning to flee — who were disheartened. This was the fatality attending the place that inauspiciously repeated an obscure precedent in the history of the Achaemenids: the etymology of Gaugamela ('house of the camel') was ascribed to the fact that Darius I, 'having escaped from his enemies on a dromedary, had it quartered here, earmarking the revenues of a number of villages for its maintenance' (Plutarch, *Alexander* 31. 7). This is, therefore, yet another contribution to the identification of Gaugamela as the battle centring on the flight of a king.

The speech that Darius made before the battle, haranguing his troops from his chariot, turned out to be chillingly prophetic: 'I ride in a chariot not only because of an old-established custom, but also in order to be seen, and I do not oppose those who imitate me, whether I be taken as a model of valour or of vileness' (Quintus Curtius Rufus 4. 14. 26).

This rhetorical conclusion *post factum* regarding the paradigmatic value of the ancient custom of using chariots in battle seems, once again, to have been reached by the historians of antiquity in accordance with this picture, if not as a result of its influence.

This phase of the battle is illustrated — together with an interpretation of the disaster — by Arrian (*Anabasis* 3,

14, 2–3), who differs from Plutarch because his account tallies with the way the situation is represented in the picture. He only refers explicitly to a rout after Darius had, first of all, yielded: 'For a short time the battle was hand to hand; but as soon as the horsemen surrounding Alexander — and Alexander himself — pressed home their attack, striking the Persians with their lances, and as soon as the Macedonian phalanx with its close-packed formation and bristling with pikes threw itself upon them and the situation appeared to be desperate to Darius, who was already terrified, he, before anyone else, turned round and fled.'

Later on, describing the battle on the Hydaspes in India, Arrian returns to the theme with great clarity, stating that, by contrast, Porus 'did not leave the field like the great king Darius, who by so doing, had started off the flight of those who surrounded him' (Arrian, *Anabasis* 5. 18. 4).

Through the limited sample of the combatants near the command post — distinguishing between those who only see Alexander's advance and the others who are aware of Darius's hasty retreat — the painter seems to be in the thick of the battle with Alexander (*eis ta mesa*). Thus he portrays the moment at which the fortunes of war change, with the disconcerting phenomenon of a powerful army that is in sight of victory and does not give way in its front lines, but crumbles in its rear, which is panic-stricken because the sovereign has abandoned the fight.

The course of the battle of Gaugamela may, therefore, be summed up by the relationship between the key objects: the whip, the pikes and the banner constituting the pivot of the reverse. The horsemen's frantic gesticulation echoes the infantry's wavering pikes, both of them standing out against the sky to symbolize the drama of a proud army. The charioteer's figure resembles and counterbalances that of the king since, in the absence of decisions, it is his subordinate who sets the seal on the outcome of the day. After turning the chariot, he does not whip the horses, which are all too excited by the confusion. As Goethe intuited in his unrivalled interpretation of the mosaic work, which he saw reproduced in Wilhelm Zahn's drawing, the charioteer raised his whip in order to get his comrades out of the way; although its crack has an effect on the horses, the peremptory request is directed at the men, becoming, thanks to the striking way it emerges from the composition, the sinister climax of the event: 'the forest of pikes pointing at the Greeks rose as if it were paralysed by this single gesture'.[24]

[1] A. Niccolini, in *Real Museo* 1832, pp. 1–50, plates 36–42; F.M. Avellino, in *Real Museo* 1832, pp. 51–54; B. Quaranta, in *Real Museo* 1832, pp. 55–68; Körte 1907; Winter 1909; Pfuhl 1923, II, pp. 757–765, fig.

648; Rizzo 1925–26, fig. 4, plate on p. 530; plate on p. 538 (graphic reconstruction of the gallop of the Bucephalas in the mosaic); Curtius 1929, pp. 323–336, figs. 182–185; Rizzo 1929, pp. 28–31; Fuhrmann 1931, plates II, VI (1), VII; Byvanck 1955 (arguments in favour of dating the original to *c.* 331 B.C.); Andreae 1959; Robertson 1959, pp. 13, 15, 168–170, 172, 175; Rumpf 1962; Hölscher 1973, pp. 122–162, plate 12–13; Andreae 1977, figs. 1–8 and 25; Bruno 1977, pp. 64, 74–77, 83, 86, 87, 99; Schefold 1979, plates II (2), III (2); Simon 1984 pp. 656–657, fig. 8; Daszewski 1985, pp. 51, 85, 150, plate 45; Hölscher 1987; Moreno 1987, pp. 125–128; Fehr 1988; Salviat 1988; Gall 1989, p. 322, note 20, plate 45 (1–2); Hölscher 1989; Philipp 1991; Zevi, Jodice 1992, pp. 63–67, figures on pp. 206–207; Geyer 1993, p. 444; Goldman 1993; Stewart 1993, pp. 130–150; Zanker 1993, pp. 49–50, fig. 11; M. de Vos, in *Pompei*, V, 1994, pp. 124–125, nos. 56–57; Scheibler 1994, pp. 63, 70, 102, 119, 124–125, 216, plate 5: Boardman 1995, pp. 174–175; Calcani 1995, pp. 147–149; Catapano 1996, fig. 1 (reconstruction of the Alexander mosaic, painted on ceramic tiles, 1833–34, Naples, private collection); Hoesch 1996; Cohen 1997; Trinkl 1997; Zevi 1997; Zevi 1998; Zevi, Pedicini 1998, pp. 59–85; Badian 1999. See notes 5, 9, 12–14, 16, 17, 24, 29, 33, 36–39, 43–51, 53, 55.

² A. Hoffmann, in *Pompei*, V, 1994, p. 125, fig. 58.

³ Marzani 1961; M. de Vos, in *Pompei*, V, 1994, p. 125, fig. 59; V. Sampaolo, in *Pompei, La documentazione* 1995, p. 196, fig. 79.

⁴ Donderer 1990, p. 27, plates 10–11; Zevi, Jodice 1992, p. 66, figures on pp. 200–201; M. de Vos, in *Pompei*, V, 1994, pp. 123–124, figs. 52–55; Cohen 1997, p. 195, fig. 81; Zevi, Pedicini 1998, pp. 53–55.

⁵ Donderer 1990: this is an analysis of the repairs of the mosaic carried out in antiquity that is favourable to the Oriental provenance of the work, with reference to similar frames of floors removed in ancient times from the Letoon of Xanthus and Rhodes. See notes 7 and 8.

⁶ Robertson 1959, figures on pp. 166 and 169; Hölscher 1973, pp. 226–228; Pétzas 1978, pp. 95–97, figs. 8, 9; Willers 1979, fig. 1; Salzmann 1982, pp. 105–106, no. 98, plates 30, 31, plate 99, iv and vi; Makaronas, Giouri 1989, pp. 137–139, plate 25b; Rouveret 1989, pp. 237, 246–247, plate XXI, 2; A.-M. Guimier-Sorbets, in Ginouvès 1993, pp. 133–136, fig. 112; Moreno 1993, pp. 103–104, figs. 6, 7, 9, 11; Moreno 'Efestione' 1994, fig. 467; P. Moreno, in *Lisippo* 1995, p. 63, no. 4.7.1.

⁷ Siebert 1992, pp. 66–73, plates 32–35; Binghöl 1997, p. 99, figs. 65–66.

⁸ Phatourou 1964, p. 465, plate 547 c; Donderer 1990, p. 30, plate 12,2. For the dentil frame see: Fuhrmann 1931, p. 127; Daszewski 1985, p. 51.

⁹ Bianchi Bandinelli 1977, p. 474: this writer identifies the plane tree in the background of the Alexander mosaic with the Dead Tree mentioned by Marco Polo.

¹⁰ Devine 1986; Hammond 1997, pp. 103–110, fig. 13. For the figures in the mosaic whose identification is proposed, see Berve 1926, II, pp. 62–63, no. 117, Aristander; pp. 206–209, no. 427, Cleitus; pp. 116–119, no. 244, Darius III; pp. 340–345, no. 683, Peucestas.

¹¹ L.A. Scatozza Höricht, in *Le Collezioni*, I, 2, 1989, p. 140, no. 216; G. Calcani, in *Lisippo* 1995, pp. 153–154, no. 4.18.2. See note 28.

¹² M. de Vos, in *Pompei*, V, 1994, p. 24, no. 56 (but printed back to front); V. Sampaolo, in *Pompei, La documentazione* 1995, p. 897, fig. 22.

¹³ V. Sampaolo, in *Pompei, La documentazione* 1995, p. 897, fig. 23.

¹⁴ I. Bragantini, in *Pompei, La documentazione* 1995, p. 460, fig. 41.

¹⁵ Arturo Pérez-Reverte is the author of *El Sol de Breda*, Madrid 1998, inspired by Veláquez's *Surrender at Breda*: the passage quoted — of interest because of the evident analogy with the Alexander mosaic — refers to the painting in the Prado, Madrid, and is part of an interview with Mino Vignolo (*Corriere della Sera* [Milan], 22 November 1998, p. 33).

¹⁶ The pikes in the background of the Alexander mosaic are attributed to the Macedonians by: Pernice 1908, pp. 13–14; Schöne 1912, p. 190; Rumpf 1962, pp. 230–231; Hölscher 1973, p. 144; Robertson 1975, p. 500; Andreae 1977, pp. 8, 15; Schefold 1979, pp. 20–21; Hölscher 1989, p. 304; Stewart 1993, pp. 134–139; Calcani 1995, p. 151. The pikes are attributed to Darius's army by: Pfuhl 1923, pp. 760–761; Fuhrmann 1931, p. 324; von Salis 1947, p. 91; Pfuhl 1955, p. 95; Nylander 1983, pp. 20–22; Cohen 1997, pp. 124–126; Badian 1999, p. 80.

¹⁷ The standard in the Alexander mosaic is attributed to the Macedonians by: Pernice 1908; Rumpf 1962, pp. 230–238; Hölscher 1973, p. 144; Robertson 1975, p. 500; Andreae 1977, p. 15; Stewart 1993, p. 139. It is recognized as being Darius's banner by: Nylander 1983, figs. 1, 2, 9–13; fig. 14 (detail of the reconstruction of the mosaic, painted on a ceramic tile, Chatsworth Castle); Nylander 1993; Catapano 1996, fig. 3, a–c (reconstruction of the banner from various interpretations dating from shortly after the discovery of the mosaic); Cohen 1997, p. 125, fig. 64; Badian 1999, p. 80.

¹⁸ The translations are not univocal. In the first passage from Xenophon, I have given the verbal form from *anateino* — usually translated as 'with spread wings' — its primary meaning of 'raised'. In the second, *pelte* has been interpreted not as a 'semilunar shield', but as a synonym (or possible corruption) of *palton*, which is the short lance of the Persian cavalry; thus the following *epi xylou*, 'on a lance', has been eliminated as a gloss. Apart from the solutions proposed here to the textual and hermeneutic difficulties, the material of the image is ambiguous in Xenophon's text (but without prejudicing my argument) because *chrysos* means both 'golden' or 'gilded', as is the nature of the representation — in other words, whether it is three-dimensional or consists of an embroidered cloth, as it appears to in the banner in the Alexander mosaic.

¹⁹ Trendall 1967, p. 55, no. 282, plate 25, 3; Trendall 1973, fig. 640; S. Bianco, in *I Greci in Occidente*, catalogue of the exhibition in Venice, edited by Giovanni Pugliese Carratelli, Milan, 1996 (Eng. trans. *The Western Greeks*, Milan, 1996), p. 710, no. 220 I; Ciancio 1996, figure on p. 397.

²⁰ Moreno, *Scultura ellenistica*, 1994, I, pp. 297–298, fig. 371: detail with the brand-mark on the bronze horse from Artemisium.

²¹ Ensoli 1987, pp. 297–298, fig. 19, plates 5, 10b, 14–15.

²² Moreno 1993, pp. 119–121, fig. 21; Stewart 1993, pp. 45, 50, 54, 128, 310–312, fig. 112; P. R. Franke, in *Lisippo* 1995, pp. 170–171, no. 4.21.1.

²³ Rizzo 1925–26, fig. 14; Giuliano 1955, p. 12, fig. 7; Hölscher 1973, pp. 123, 136, 138; Andreae 1977, fig 22; Calcani 1989, p. 70, fig. 87; Philipp 1991; Capodiferro 1993, pp. 88–89; Hannestad 1993, p. 65, fig. 4; Melucco Vaccaro 1993–94, pp. 22–24, fig. 20; Cohen 1997, p. 70, fig. 21: the relationship of the Trajan frieze with the Alexander mosaic.

²⁴ Andreae 1977, pp. 29–36; Andreae 1997, pp. 135–139, figure on p. 137: pencil drawing of the Alexander mosaic by Wilhelm Zahn (Goethe-Nationalmuseum, Weimar), on the basis of which Goethe expressed his opinion. The engravings published by the artist himself were derived from the drawing: Zahn 1842, II, plates 91–93.

The Painter

With Alexander

It is superfluous to list the number of times Apelles painted Alexander and Philip.
Pliny

Besides the general reflections relating to the scene depicted in the mosaic, the exact reproduction of the details of the clothes and arms of the vanquished is another element favouring the dating of the original painting to a period close to the battle of Gaugamela (1 October 331 B.C.). Everything seems to be drawn from life with ethnographic precision. In the study of the different costumes — Persian, Mardi and Indian — one senses the wonder of exploration and the fascination with the colourful world of the Orient. The artist has had the prisoners in front of him in order to make sketches, and a pile of the booty so he could observe the details of the clothing, arms and horse-gear: this is the prelude to the repertoire of the Pergamene friezes of arms and the annalistic precision of the Roman triumphal reliefs.

Without resorting to anecdotes or theatrical costumes, the artist has investigated more profound values than mere folklore. In the painting he has captured not only outlandish emotions to which the irrational panic of the fugitives may be attributed, but also universal sentiments and values: loyalty to the leader and indifference to death. These are the most extreme aspects and characteristics of men dominated by the artist with a sure hand under the damask clothes and the colourful mitres.

The 'Orientalist' painter interprets this world with the adhesion promoted by Alexander, when Hellenic culture began to take root, in order to communicate with the new subjects in the unknown country. This is the ideology that developed after the victory at Gaugamela, in which direct hostility towards the Persians was reduced as a result of the recognition by Alexander of the audacity of the vanquished and the assignment of offices and satrapies to the nobles of this people. This political trend included the fascination with battle scenes typical of the Mesopotamian tradition, for instance in the dense figuration of the Assyrian reliefs. Having crossed the Tigris, the new invaders descended the east bank of the river near to what had been the most important cities of Assyria. Khorsabad, Nineveh and the capital, Nimrud, were not far from Arbela and Gaugamela: in particular, in Arbela, at the sanctuary of Ishtar, King Ashurbanipal had carried out the ceremonies for the final triumph over the Elamites, the main threat to his rule.

The celebratory friezes of the Assyrian civilization that had nurtured the Orientalizing taste of the 'primitive' Greeks until the fall of Nineveh in 612 B.C. now offered the models for distinctive aspects of the battle. Once again, this takes us to the new experience of those following the Macedonians in their intrepid reconnaissance of Mesopotamia. With reference to the works of art adorning the citadel of Nineveh, at Kuyunjik, there is, in a relief in the British Museum from the south-west palace, an impressive scene from the battle on the River Ulai, where Ashurbanipal (known to the Greeks as Sardanapalus) defeated the Elamite army (figs. 10, 11).[25] There are evident similarities to the mosaic: the trees behind the mass of combatants as an indication of the landscape; the arms clearly visible, lying on the ground; galloping horsemen pursuing the enemy with their lances; horses that have collapsed under their riders; and enemies that have fallen in various ways, including one seen from behind who is holding himself up from the ground with his left arm. Above all, enemy chariots in flight run over foot-

10–11. Details of the victory of the Assyrians over the Elamites at the River Ulai. Limestone relief, from the south-west palace at Kuyunjik, Nineveh. British Museum, London

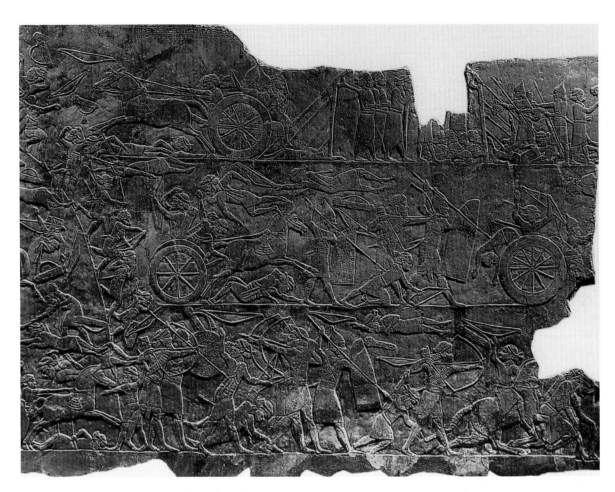

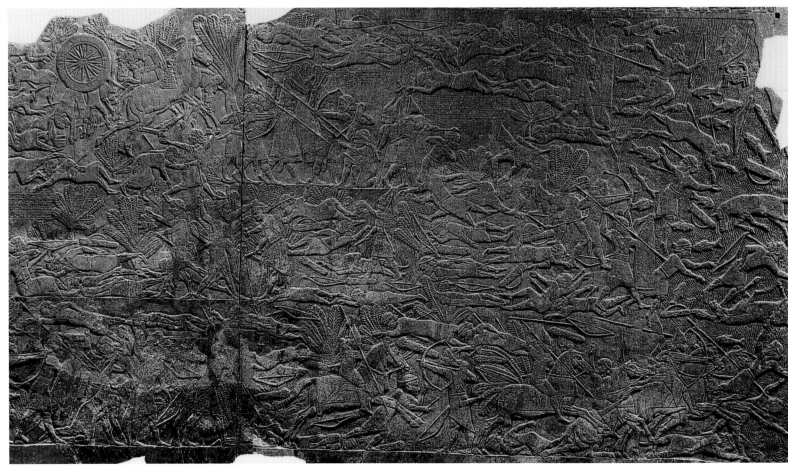

soldiers on their own side, while, on one of the chariots there is the same dramatic contrast between the warrior turning towards the attackers with a gesture of desperation and the charioteer using the whip in order to speed up the retreat.

In this regard, one notes a remarkable degree of precision when comparing another Assyrian relief with the representation of Darius's imposing chariot, which had eight-spoked wheels with metal studs on the rim in order to allow it to travel over rough terrain; these are the 'Persian wheels' described by Diodorus Siculus (18. 27. 3) on Alexander's funeral carriage, which was decorated by Apelles. Not only was Darius's chariot — together with the king's bow, which we have also noted in the same picture — captured on the day after the battle of Gaugamela, when Alexander reached Arbela after a forced march in the hope of finding his rival (Arrian, *Anabasis* 3. 15. 5), but the composition of the monarch and the charioteer derives from a local archetype. Another relief in the British Museum depicting Ashurbanipal, from the northern palace of Nineveh, at Kuyunjik (fig. 12),[26] shows the king turning, like Darius, in the opposite direction to that of the charioteer, with his arm outstretched from the side, except that on this occasion the gesture was a command (urging his assistants to hand him the weapons for the hunt) and it was as a 'heroic glory' that it was interpreted by Greek sculptors working for the Oriental dynasties in the coastal satrapies. In the friezes of the cemetery wall from Gjölbaschi-Trysa, in Lycia, now in the Kunsthistorisches Museum in Vienna, the one on the west wall depicts a battle: turning away from the charioteer, who bends forward to start his horses off at full gallop, the commander of the attackers leans out from the back of the chariot,[27] holding its side with his left hand and, with his right hand, raising his lance in order to strike the enemy (fig. 13). This formal analogy makes the variance with the dismay of the defeated king on the field of Gaugamela even more striking. In the semantic inversion, the theme of the mosaic becomes a dialectic archaeological revival, if we accept the immediacy of the inspiration and the involvement of the artist in the event. The fact that Alexander is not idealized is of fundamental importance for the chronology of the original painting: his poorly proportioned features and the spasmodic tension give him a somewhat disagreeable aspect. This realism reminds us of the observations of the ancient writers on Lysippus's bronze group of the Granicus and the documentary meaning that the portrait had in the dedications arising from the battlefield.[28]

The climate of war is confirmed in the commemoration of Alexander's campaigns, expressed with the emphasis that the king had required of Lysippus for the twenty-five dead at the Granicus, the first battle in Asia. The im-

12. Ashurbanipal and his charioteer on a chariot. Detail of the departure for the hunt. Limestone relief, from the northern palace at Kuyunjik, Nineveh. British Museum, London

13. A commander and his charioteer on a chariot. Detail of a battle scene. Limestone relief from the west wall of the Heroon at Gjölbaschi-Trysa, in Lycia. Kunsthistorisches Museum, Vienna

portance given in the painting to the *hetairoi* (fig. 6, plate I) is a reminder that sixty of them fell at Gaugamela. If indeed Cleitus was the figure with his right arm raised ready to deal a blow, the conspicuousness given to him suggests that he may have been one of those commissioning the painting. If this hypothesis is correct, the painting cannot have been executed after the summer of 328 B.C., when Alexander killed Cleitus during a brawl.

Again, if it were true, it would favour the attribution to Apelles of the original from which the mosaic was copied, since we find the *hetairos* in Pliny's catalogue of the painter's oeuvre: 'Cleitus with his horse while he hastened to battle, and an armour-bearer handed him the helmet that he requested' (Pliny 35. 93). The fact that the subject related to the Macedonian venture is confirmed by the statement immediately afterwards in the paragraph: 'It is superfluous to list the number of times Apelles painted Alexander and Philip.' Plutarch (*de Alexandri fortuna aut virtute* II. 2) states that during the Asian campaign the painter, together with Lysippus, accompanied Alexander (*kat'Alexandron*). In particular, Apelles had accepted the invitation that Aristotle had uselessly sent to another artist 'to paint the exploits of Alexander the Great because they are destined to be eternal' (Pliny 35. 106). Again Pliny recorded (35. 79) that the climax of Apelles' career was in the 112th Olympiad — that is, in the period 332–329 B.C., during which the battle of Gaugamela took place (331) and the picture appears to have been executed.[29]

Tradition and Innovation

> *In effect, Apelles alone has given more to painting than anyone else.*
> Pliny

The artist responsible for the painting on which the Alexander mosaic is based was nurtured on classical culture. In order to meet the new exigencies of narrative, he experimented with the innovations that developed in Hellenistic art, but he involved them in a courageous synthesis of the preceding rules of composition and perspective and the tried and tested conventions of draughtsmanship and colour. Each element of the work becomes a motive for a doctrinal manifesto worthy of the master who comments on praxis with a treatise: 'in effect, Apelles alone has given more to painting than anyone else, even publishing volumes containing the theory of his art' (Pliny 35. 79). The elongated composition derives from the historical and mythical struggles that adorned the porticoes surrounding the agora in Athens. In contrast with the masterpieces displayed in the Stoa Poe-

cile, the global vision of the battle goes beyond the representation of pairs of duellers that was, for example, a feature of the Amazonomachy attributed to Micon. The collective drama consisting of the contrast of movement has developed from the intertwining fates: the unity of action comprises all the figures and the illusionistic effects intended to impress the spectator.

The main movements — the victors attacking from the left and the Persians fleeing towards the spectator — are similar to the painting of the battle of Marathon, which was started in the orbit of Polygnotus during Cimon's regime and completed after 461 B.C. by Panaenus, the brother (or nephew) of Phidias. The representation of a number of Persians dying in the foreground of the mosaic (fig. 1, plate I) is derived from this model of early classicism, although, with regard to the latter, the contemporaries were critical of the fact that the enemies — albeit due to the rules of perspective — were larger than the victors. Thus, in the Gigantomachy on the shield of Athena Parthenos, which we know from vases, the Giants threatened by the gods fall towards the spectator.

The innovation here is that the two types of movement already present in the depiction of the battle of Marathon — from left to right and the background — are coordinated by the spectacular effect of the quadriga's diagonal course. The Macedonians proceed parallel to the picture plane, while the Persians, who occupy three quarters of the painting, are involved in the vortex produced by the sudden turn of Darius's chariot or are even physically trampled underfoot by the horses drawing it. The clarity of the victorious charge dominates the vacillation of the barbaric tide.

In 367 B.C. Apelles' teacher, the Macedonian Pamphilus, had painted a picture to celebrate the joint victory of the exiles from Sicyon and the Athenians at Phlius over the tyrant Euphron (Pliny 35. 76). Euphranor, the versatile artist who had been in contact with the Macedonian dynasties as a bronze-sculptor (Pliny 34. 78), depicted the disproportion between the forces on the battlefield, the composite nature of the army destined to be defeated, the temerity of the assault that brought victory, the visionary frenzy of the battle in which swords replaced spears, and the recognizability of the protagonists. In the Stoa of Zeus Eleutherios, in fact, the artist had celebrated the victory of the Athenians over the Thebans and Thessalians at Mantinea on the eve of the great and uncertain battle which took place there in 362 B.C. According to Plutarch (*Of the Glory of the Athenians* 2), the *hippeis* (horsemen), 'although they were few compared to the host of the enemy [...] immediately drew up in battle order to confront the overwhelming force of the enemy. And the horsemen were the first [...] to hurl

themselves into the battle [...] This was what Euphranor painted, and in the picture one sees the full impact of the battle, the combat full of violence, audacity and animation'.

Xenophon (*Hellenica* 7. 50. 15–16) confirms that 'neither of them had arms too short for them to reach each other'.

In Euphranor's case, the desire to depict certain personages in spectacular confrontation led him to distort historical truth: Pausanias (1. 3. 4) states that 'it was easy to recognize Gryllus, Xenophon's son, among the Athenians, and the Theban Epaminondas at the head of the Boeotian cavalry', although both fell the following day in the final conflict. The painting itself contributed to the diffusion of the idea that Gryllus killed the enemy general (Pausanias 8. 11. 6; 9. 15. 5). This may explain the emphasis that was apparently given in the missing area in the left part of the mosaic to the commander of the cavalry, who may be Cleitus.

Bare trees may be seen in the hunt frescoed by Nicias on Philip's tomb (336 B.C.),[30] but in Alexander's battle the twisted shape of the tree looming up in the background recalls the Achaemenids' 'golden plane'; echoing the group of Darius and the charioteer, it was, until the Middle Ages, a symbol of the fatal encounter.

Space and Sign

There is truth in the hands of the Ephesian, in every line of Apelles.
Herodas

Specific features of the Alexander mosaic suggest that the original painting was strongly influenced by the school of Sicyon: according to Pamphilus, everything was based on drawing and geometry (Pliny 35. 76).

Despite the use of mosaic, the narrow outlines — praised as one of Apelles' greatest achievements (Herodas, *Mimiambi* 4. 73; Pliny 35. 81–84) — are visible at the edge of the areas of colour or in the form of a serried row of dark tesserae: in the black shapes of the horses, parts of the legs are outlined by lighter tesserae. As I have already observed, the sun's rays bathe the battlefield at the same angle as the fourteen pikes in the central area. Alluding to the distribution of the shadows, these lines, the source of dramatic tension, dominate the work, interfering with other oblique ones: the weapons on the ground, the lance of the palace guard curbing the riderless horse and, above all, the last pikes on the right pointing in the other direction, which hint — as I have previously pointed out — at the outcome of the conflict.

Giving concrete form to theory in his representation,

the painter has not only stressed the strip of the picture containing the pikes, but has also multiplied the circle with the top of Alexander's helmet, the shields and the chariot's wheels. There are six circles, evenly distributed in the two halves of the picture and they are all foreshortened to form ellipses. Other spatial indicators of the perspective establishing depth in a logical manner are the objects on the ground, especially the broken pike pointing towards us. Otherwise it is the bodies that give order to the volumes: the fallen warriors and, above all, the horses. Alexander's steed gallops along the plane parallel to the spectator, signalling the positive outcome of the victorious attack. The frightened riderless horse seen from behind directs the spectator's gaze towards the chariot, where the animal's head diverges from that of the Persian who is seeking to control it: immediately above them is Darius's desperate face. In the centre, a fallen charger seen obliquely at forty-five degrees highlights the heroic end of the speared Oriental, and has the same orientation as the first horse of the quadriga that announces the rout of the vanquished king.

Although the horizon lines lose their significance in the painting's adaptation as a floor mosaic, they confirm the independence and rigour of the original work, which deserves to be regarded as equal to the *chrestographia* ('supreme painting') of the Sicyonians and, in particular, to the output of the *aristos* ('the best'), as Apelles was described (*Greek Anthology* 9. 595).

The principal line indicates the visitor's eye-level on the wall where the *megalographia* ('great painting') was displayed. This is a lowered viewpoint, a third of the way up the figured strip (from the rocks to the top of the tree); thus the line passes through the raised foot of Alexander's victim, under the hand of the fallen warrior who is pushing away the shield in the foreground and almost touches the bellies of the horses drawing Darius's chariot. A second horizon line is established harmoniously two-thirds of the way up the picture, and comprises the tree and the horsemen in the background. In this way the artist makes both the weapons lying on the ground and the heads of the more distant combatants clearly visible; they would have been hidden behind the figures located in the nearer planes if only one type of projection had been used. Instead the spectator is able to follow the battle at its most crucial moment and, at the same time, to behold the natural environment and the more distant consequences. I have already observed that, in this way, the artist manages to give concrete form to the paradox underlying the battle — namely, the sudden retreat of an army that, up to then, had been winning. So broad is the narration in the part closest to the spectator that the painter has placed three vanishing points along

the lower horizon line: one in the centre and two at the extremities. This is why spectators feel they are immersed in the scene as they are able to take it all in at a glance, while, at the same time, they may observe the realistic detail of both halves of the painting from close quarters. The central cone of vision comprises the greatest number of figures and all the objects strewn on the ground. The point of convergence on the left regarded the majority of figures in the mosaic that have been lost. On the right the cone comprises the quadriga and the Persian horsemen. The chariot is depicted in accordance with the two lateral vanishing points: the monumental width of its side seems to augment the threat it poses to the soldiers.

Colour and Light

The reader should bear in mind that all those works were painted by Apelles with just four colours.
Pliny

The way in which colour and chiaroscuro are used to create three-dimensionality in the picture gives further credibility to its attribution to Apelles. The black with which the front of the chariot below the charioteer is painted derives from a carefully controlled palette, clearly indicating the artist's independence from the school of Athens. In the hunting scene painted at Aegae in 336 B.C., Nicias went beyond the limit of four colours, while to celebrate the battle of Gaugamela in 331 only white, yellow, red and black were used, together with mixtures and shades of these, without blue or its secondary colours, green and violet. This is even more surprising given that the subject takes us into the height of the Asian campaign, and from the time of the invasion of Anatolia the court artists became familiar with materials that, from the Greek point of view, appeared to be exotic. A painted tomb from Nea Mihaniona (the ancient Aenea), now in the Archaeological Museum in Salonica, proves that in Macedonia, during Alexander's reign, a workshop serving private clients used lapis lazuli and malachite-green.[31]

The use of four colours, a practice adhered to also in the mosaic, allows us to consider Apelles with astonishment just as Pliny did (35. 92), and we also feel this with regard to the painting of Alexander portrayed as Zeus with a thunderbolt, datable to 334 B.C. (fig. 51): 'The reader should bear in mind that all those works were painted by Apelles with just four colours.' Apelles was the most long-lived of the painters who continued to be faithful to the classical principle; they were listed in inverse order by Pliny (35. 50): 'Apelles, Aetion, Melanthius and Nicomachus painted their immortal works with only four colours: the whites were obtained from *Melinum*, ochres from Attic, reds from Pontic sinopia and blacks from atrament.'

In particular, the spectacularly foreshortened charger in the foreground and the black horses in the quadriga reveal Apelles' challenge to his fellow painter and sometime assistant, Pausias. According to Pliny, Pausias, 'even when he wanted to show the length of an ox, painted it from the front, not in profile, and its length is quite evident. Then while everyone paints what they wish to appear as prominent in a light colour, and in black what they want to hide, Pausias painted the whole of the ox a dark colour and gave substance to the shadow from the shadow itself with truly great art, which showed the protrusions in the even areas and the whole mass in irregular ones. (Pliny 35, 126–127).'

The painter of the battle scene even dared to depict a horse from behind, rather than from the front, while in the three black horses in the quadriga he displays his virtuosity by using black on black, in accordance with the strict rules of the school of Sicyon.

Pure white only appears in a few places: the silver scales of Alexander's armour, Darius's silken garment, the backs of the swords and the tips of the lances. Otherwise the shadows are grey or tinged with yellow, the predominant colour in the tones of ochre. Red is used in the clothes of the Orientals, and in the harnesses and caparisons of the steeds; tragically in the blood of the wounded; and disgustingly in the foam issuing from the mouth of the kneeling horse.

Intermediate values, from yellowish grey to rose and dark brown all contain white and yellow or red, with the addition of greater or lesser amounts of white or black. The realism of the modelling is the result of these gradations of halftones, which may also be admired in the deer hunt executed a decade earlier and attributable to Apelles' fellow painter Melanthius or even to Apelles himself (figs. 48, 49).

Vitality emanates from the light bathing the *sfumato* of the bodies, lengthens the shadows and animates the projections with highlights, a feature that was already evident in the painting of Alexander as Zeus executed at Ephesus in 334 (fig. 51). This reflection of the sun's glare has various forms — as if this were an experimental stage, not long after its discovery — not only on metal, but also on the perspiring faces and even on the haunches of the horse in the foreground. On Alexander's face the highlights are brightest on the projections reflecting the sunlight incident upon them towards the spectator, and become softer as the surface slopes away. The light — which, as we have seen, reaches the king three-quarters on from behind — falls on his ear, cheekbone, temple and eyebrow. It strikes his chin, lips and the ala of his nose: the discontinuity on the dorsum of

his nose reveals the irregularity of his form with incredible precision, contributing to the realism of his face. The shade materializes under the chin, in the fold of the cheek, in the middle of the forehead and at the bridge of the nose, where its also stresses the concavity of the juncture.

Transparency

*The painters who want to represent something
that appears through the air.*
Aristotle

The harmonious tone, which softens both chiaroscuros and colour contrasts, corresponds to what we know about Apelles, and, in the specific context of this battle-piece, the reduced resonance of the colours is a reminder of the cloud of dust enveloping the field of Gaugamela. These environmental conditions are those referred to by Aristotle (*De sensu* 439 b. 9–10) in his observations on the *diaphanon*, the virtual visibility that requires light to become concrete reality:[32] this is the case with painters who 'want to represent something that appears through the air'.

In the case of the painting on which the Alexander mosaic is based, Apelles made use of all his most precious artistic skills, and these were echoed by the mosaicist with his heterogeneous technique. In particular, Apelles applied the paint by means of glazes, as Aristotle so perspicaciously observed (*De sensu* 440 a. 7–9): 'the colours show through each other, which is what those painters who put one colour on top of another brighter one are sometimes able to do'. The transparent paint toned down the contrasts. And this is what Pliny had to say (35. 97), after he had seen Apelles' masterpieces — which were influenced by Aristotle's theory of the transparent medium — in Rome: 'In art, his inventions were also of benefit to others, but there was just one thing that nobody could imitate: when he finished the work, he covered it with a varnish that was so thin that, when illuminated, this heightened the white of the highlights and protected the painting from dust and impurities, and could only be detected by touching it. But this was always done with great skill, because the colours did not seem to be garish, but appeared as if seen through mica, and from a distance this substance gave, without being visible, a certain austerity to the excessively bright colours.'

Self-Portrait

*The outstanding artist Apelles painted himself
in a picture.*
Anonymous epigram

Although I do not wish to give too much credit to the frequently repeated anecdotes of the edict that made Apelles Alexander's only official painter, the artist was closely linked to the king by the latter's gift of his concubine Pancaste (Pliny 35. 86–87; Aelian, *Varia Historia* 12. 34). In fact, he portrayed Alexander on many occasions, as may be seen in the recorded works (Alexander with a thunderbolt, Alexander on horseback, Alexander with the Dioscuri and Nike, Alexander on a chariot with Polemos and Furor bound), and, as is evident in Pliny's preterition (35. 93), quoted at the beginning of this chapter: 'It is superfluous to list the number of times Apelles painted Alexander and Philip'.

While the absence of explicit descriptions of battles painted by Apelles may be fortuitous, in the mosaic the excellence of the style is combined with another series of specific devices used in the literary and archaeological tradition, which help to identify him, including the use of a motif as a signature. The lines that, as we have seen, govern the perspective also contribute to guiding the composition. The lower horizon line marks, at the same time, the upper limit of the narrow strip containing the heads of the fallen in the right half of the picture (fig. 14): only the shields of the other two fallen warriors in the left half have been preserved.

The alignment of the heads manifests itself with the sensibility that we may recognize in one of the most certain copies of an original work by Apelles: the fresco in the Museo Archeologico Nazionale in Naples, depicting Heracles and Telephus in Arcadia (figs. 15, 45). In his evocation of the myth, as in the historical account, the painter reconciles the hierarchy of the figures with the zones of recession divided into three fundamental levels. In this painting from Herculaneum — which reproduces the picture of *Hercules aversus* (Heracles turning round), brought to the Aventine in Rome (Pliny 35. 94) — the lower level is represented by the animals in the foreground (the deer, eagle and lion); the second by the head of the standing figure of Heracles, and the magnificent one of Demeter, who is seated; the third by the more distant heads of Pan and the girl personifying Mount Parthenion.

In the battle scene (fig. 14), which is apparently very complex, the heads of the fallen are at the same height in the first level; the second comprises the standing figures — that is, Alexander's shield-bearer and the two Oriental warriors in the central area, one actually on his feet, the other sliding off his wounded horse with one foot on the ground; the third regards Alexander and the large group of horsemen. As I have mentioned on various occasions, four notable elements stand out at regular intervals above

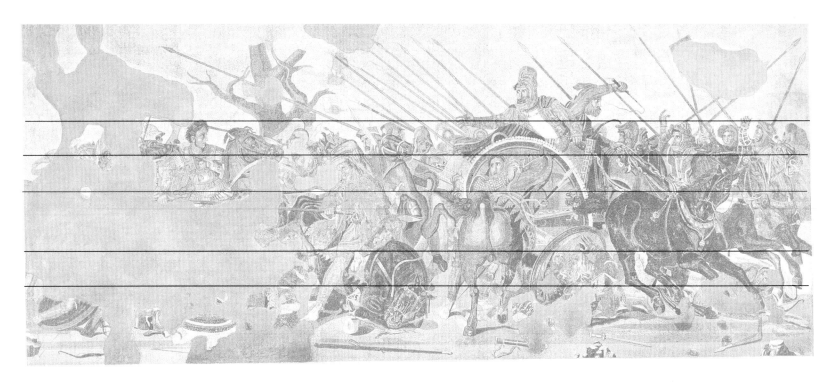

14. Diagram showing the alignment
of the heads in the Alexander mosaic,
from the House of the Faun, Pompeii.
Museo Archeologico Nazionale,
Naples

the fray: what is likely to be Cleitus's raised sword; the bare tree; the group of Darius and the charioteer; and the banner of the Achaemenids. The 'dying' described by Pliny (35. 90) are not identified better in the artist's oeuvre than in the fallen of this mosaic, which shows the depths of human drama.

The episode of a warhorse's foam created accidentally by Apelles, after numerous unsatisfactory attempts, by throwing a sponge at the painting is recounted in another context, to which I shall refer later (Dio Chrysostom, *Orationes* 63. 4–5), but may be associated with the central detail in the lower part of the battle scene. I have already observed that the horse of the Oriental transfixed by Alexander's lance had, in its turn, been struck with a javelin. With its right lung pierced, the animal emits, together with saliva, a stream of blood: this is the crude effect that is presented to the spectator in the foreground. And this is the striking position that Apelles had chosen in 334 for the motif — humble in its substance, but important for the overall result — of Alexander's toes illuminated by the thunderbolt in the apotheosis of Ephesus, which seemed, in Pliny's words, 'as if they were emerging from the picture' (fig. 51). The particular nature of the situation and the difficulty of mixing red with the iridescence of the saliva may have contributed to the story narrated by the ancient writers.

Like the above-mentioned observation with regard to the 'dying', and another source dealing with the humble or unpleasant subjects ennobled by Apelles to which we shall refer later (Marcus Cornelius Fronto, *Letters to Marcus Aurelius* 1. 7), this is also a case of the formal sublimation of distressing or repulsive subjects. In Italian painting, the same central position on the lower edge was chosen by Caravaggio for the blood gushing from St John the Baptist's severed neck in the altarpiece painted for the cathedral of La Valetta, Malta: in this case the painter even used the red of this blood, rather as if it were a stray thread, to write his name. Apelles' unparalleled introspection of the depths of the psyche, as revealed by the face (Pliny 35. 88), is evident in a wide variety of forms, from the fury of the attackers to the consternation of the vanquished. The group of Persian horsemen on the right presents us with a change of sentiment that is underway, and the painting hints at what is not stated expressly, heralding the event that is about to happen (plate XX).

A special case that is virtuosic and, at the same time, offers an unexpected development in the interpretation, is the way in which, in the mosaic, the phenomenon of the reflection of the two Orientals in the mercenaries' shields is realized: once again, Apelle has developed an idea of Pau-

15. Diagram showing the alignment of the heads in the discovery of Telephus. Fresco from the basilica, Herculaneum. Museo Archeologico Nazionale, Naples

sias, taking it an even greater level of perfection. The production of images on a flat, shiny surface was attested in painting both by literary sources and its use by vase-painters from the end of the fifth century. Now there is also the artist's capacity to reduce and alter the mirror image as a consequence of the convexity of the reflective surface. This appears to have been derived from a picture by Pausias, who painted a face seen through the bottom of a cup, deformed by the curve of the glass (Pausanias 2. 27. 3). The careful attention paid to the shadow of the Grace on the shaft of a column is typical of Apelles; this is reproduced in a mosaic from Byblos depicting the allegorical group of Kairos, Akme and Charis, and dedicated to the personification of the aesthetic ideals (fig. 68). Charis's shadow on the column has a much smaller head than the representation of her figure, just as the faces of the fallen are reduced in size in the reflections in the shields.

In the case of the first of the two Orientals, only part of the reflection is visible. Regarding the second, I have already noted the remarkable way in which the whole face is emphasized by the shield, to such an extent that one cannot help thinking that the artist who painted the picture wished this to be, in a manner of speaking, his signature.[33] Otherwise it is not easy to explain why this face is impassive, while the warrior who has fallen in front of the quadriga has a terrified expression, and the faces of all the other combatants are contorted and tense.

The hypothesis that the picture should be attributed to Apelles is further supported by the first report of a self-portrait in antiquity, which regards the same artist, thanks to a fragment of an anonymous epigram: 'The outstanding artist Apelles painted himself in a picture' (*Greek Anthology* 9. 595). The prominence given to the hand reflected in the fallen warrior's shield, because of its size and its contrast with its shadowy mirror image, suggests that it may be the result of the painter's indulging in the contemplation of the hand that has created the work of art. Its representation could be a way of communicating to us that the artist has effectively depicted himself as he painted his own portrait, as may be seen in an analogous work by Parmigianino, his *Self-Portrait in a Convex Mirror* in the Kunsthistorisches Museum in Vienna.[34]

Also in this case the figure of the warrior and his mirror-image do not have a harmonious relationship, but are seen at an oblique angle. Particular significance may, therefore, be attributed to the hand and head: the former is emphasized by its vicinity to the reflective surface, while the latter is reduced to optical distortion. Thus the self-portrait becomes the periphrasis of a reality that is no longer the frontal, univocal one of classical art.

The historical subject is exposed to the ambiguous power of a mirror: the picture is a duplicative event consisting of illusiveness, distortion and a personal point of view. In Alexander's Asian campaign, the oecumene itself becomes an infinite and treacherous opportunity. Consequently, the artist's statement is not made in a discursive manner. The painter's identity passes through the simulated and simulating screen of the shield, which, when it reflects the warrior's image, transforms it and sends it back to the spectator as the artist's revelation of his identity. In this first compromise of the classical unity that is otherwise present in the picture, the painter feels the need to limit the shield to his own figure, to concentrate his self-portrait in the foreground, the only reality explored subjectively: this is the threshold of an antagonistic world that spreads throughout the battle, where only an illusory reflectivity can take the artist back to his lost participation. In the urgency of a process that the individual is no longer able to control, the convex mirror proclaims the reduction of the ego and the compression of the space in which the inhabitant of the *polis* recognized his own role. Oppressed by the chariot's blind thrust, humankind seeks refuge within itself from the overwhelming forces surrounding it.

[25] Matthiae 1998, pp. 157–158, figures on pp. 114–115.

[26] Curtius, Reade 1995, pp. 54–55, no. 6; Matthiae 1998, figure on p. 134.

[27] Oberleitner 1994, p. 34, fig. 71.

[28] Calcani 1989, pp. 36, 40, 54, 78; Calcani 1993, figs. 1–3; G. Calcani, in *Lisippo* 1995, pp. 148–156: Calcani 1995. See note 11.

[29] The painting from which the mosaic was derived has been attributed to Apelles by: B. Quaranta, in *Real Museo* 1832, p. 68; A. Reinach 1921, p. 347, note 2; Rumpf 1962, p. 241.

[30] Andronikos 1984, pp. 106–119, figs. 56–71; Andronikos 1987, pp. 368–371, figs. 1–2; Moreno 1987, pp. 115–125, figs. 121, 150–153, 201, 203, 207–210; Baumer, Weber 1991; Briant 1991; Prestianni Giallombardo 1991; Tripodi 1991; Carney 1992; M. Andronikos, in Ginouvès 1993, pp. 162–164, figs. 128, 138; Boardman 1993, p. 149, no. 145; Moreno 1993, p. 108, fig. 17; Reilly 1993; Saatsoglou-Paliadeli 1993; Stewart 1993, p. 46, note 9, pp. 47, 131, 274–277, 305–306, 339, fig. 11 in the text; Scheibler 1994, pp. 120, 159, 221, plates 2a, 3a, 4; Cohen 1997, p. 54, fig. 31; Drougou, Saatsoglou-Paliadeli 1999, p. 45, figs. 60–62.

[31] Vokotopoulou 1990, pp. 35–49, plates 1–6; Moreno 1998, pp. 22–23, figs. 12–15.

[32] Scognamillo 1994: the relationship between Aristotle's treatise and Apelles' technique.

[33] Trinkl 1997: the writer suggests that the face reflected in the shield is, in fact, the self-portrait of the artist of the original painting of the battle.

[34] Baltrusaitis 1981, pp. 252–255; Bonito Olivo 1998, pp. 159–163, fig. 14 (the significance of the reflected portrait); Balensiefen 1990 (optical reflection in antiquity).

The Alexander Mosaic

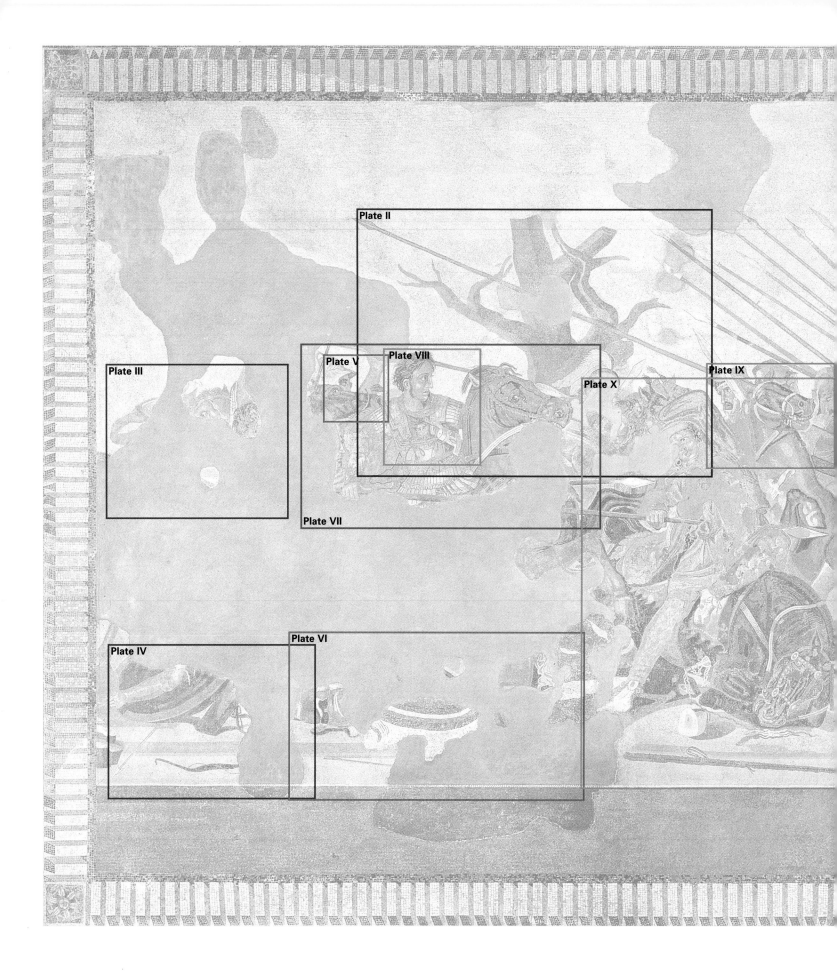

Plate II

Plate III

Plate V

Plate VIII

Plate VII

Plate X

Plate IX

Plate VI

Plate IV

Plate XX

Plate XVI

Plate XVII

Plate XVIII

Plate XXI

XIII

Plate XIV

Plate XIX

Plate XII

Plate XXII

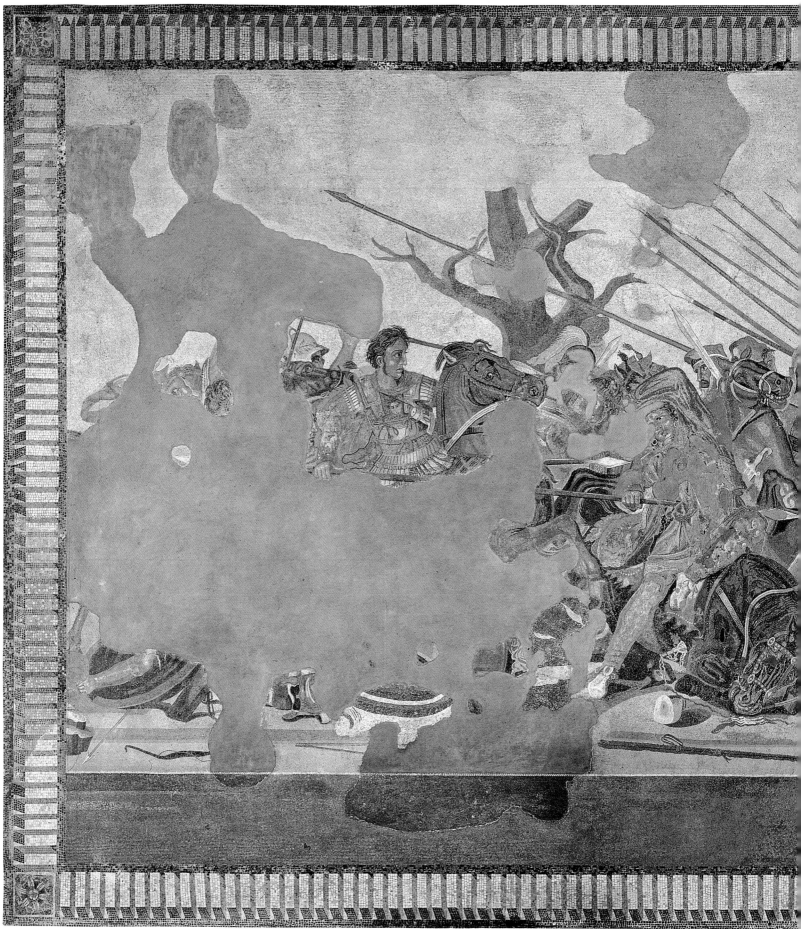

Plate I

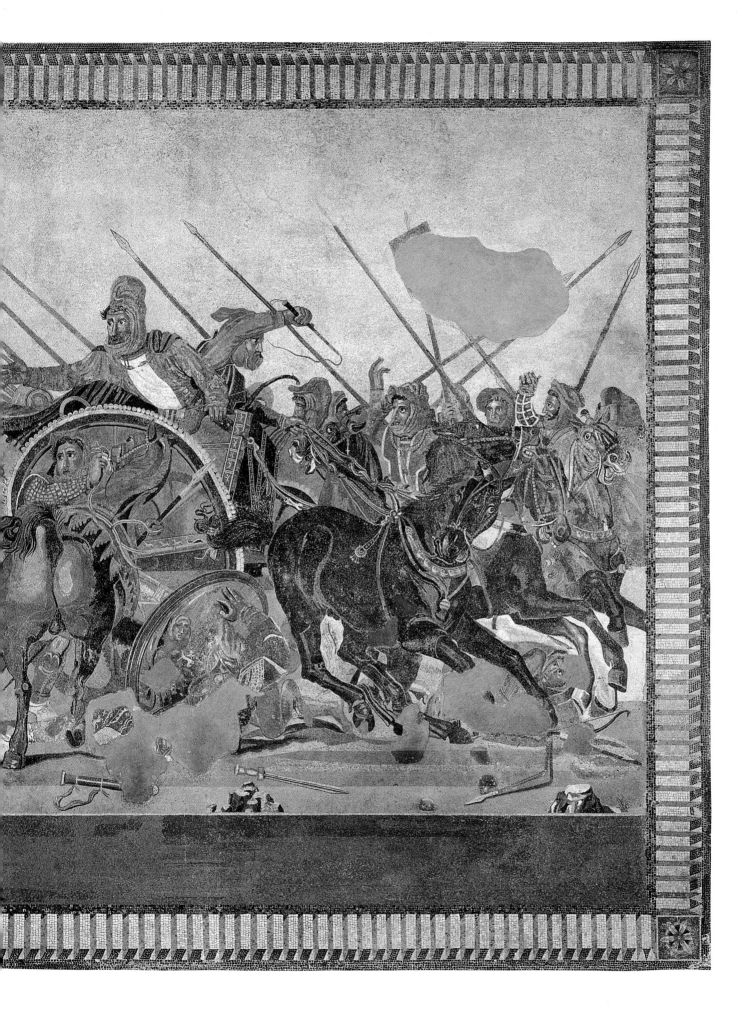

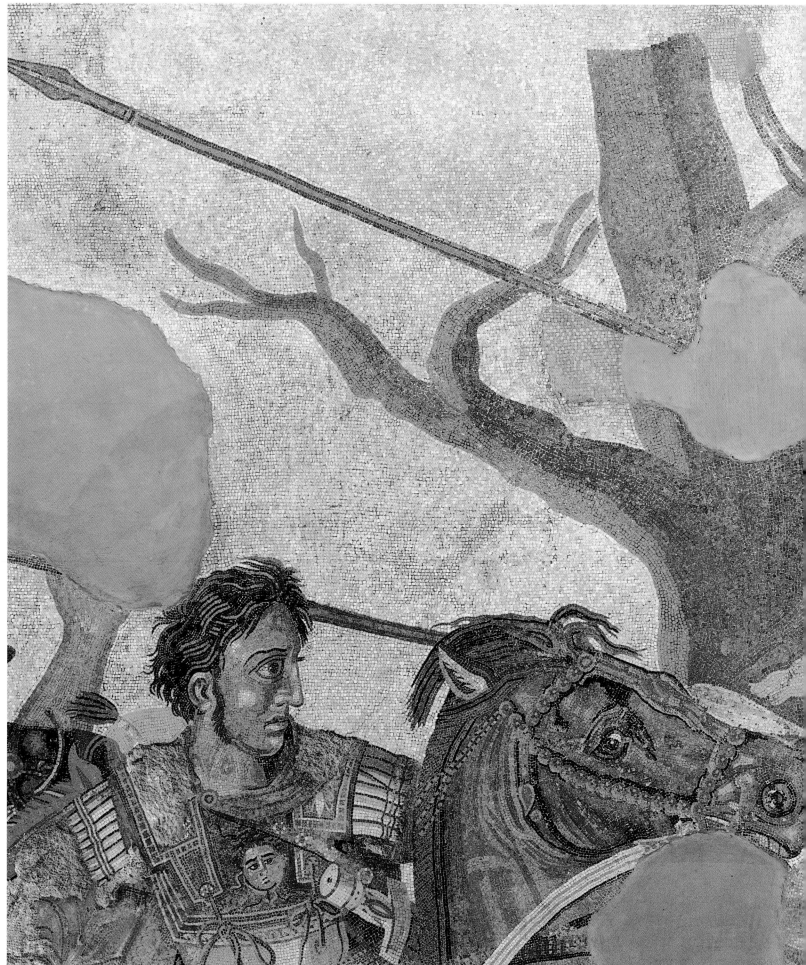

Plate II

Plate III

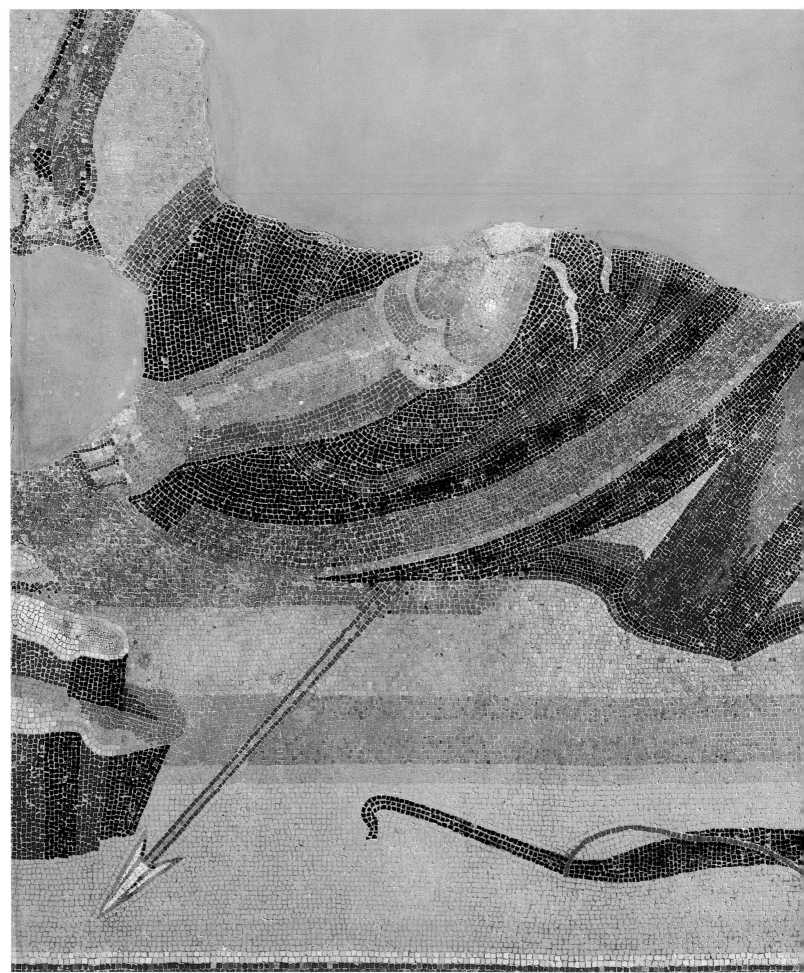

Plate IV

Plate V

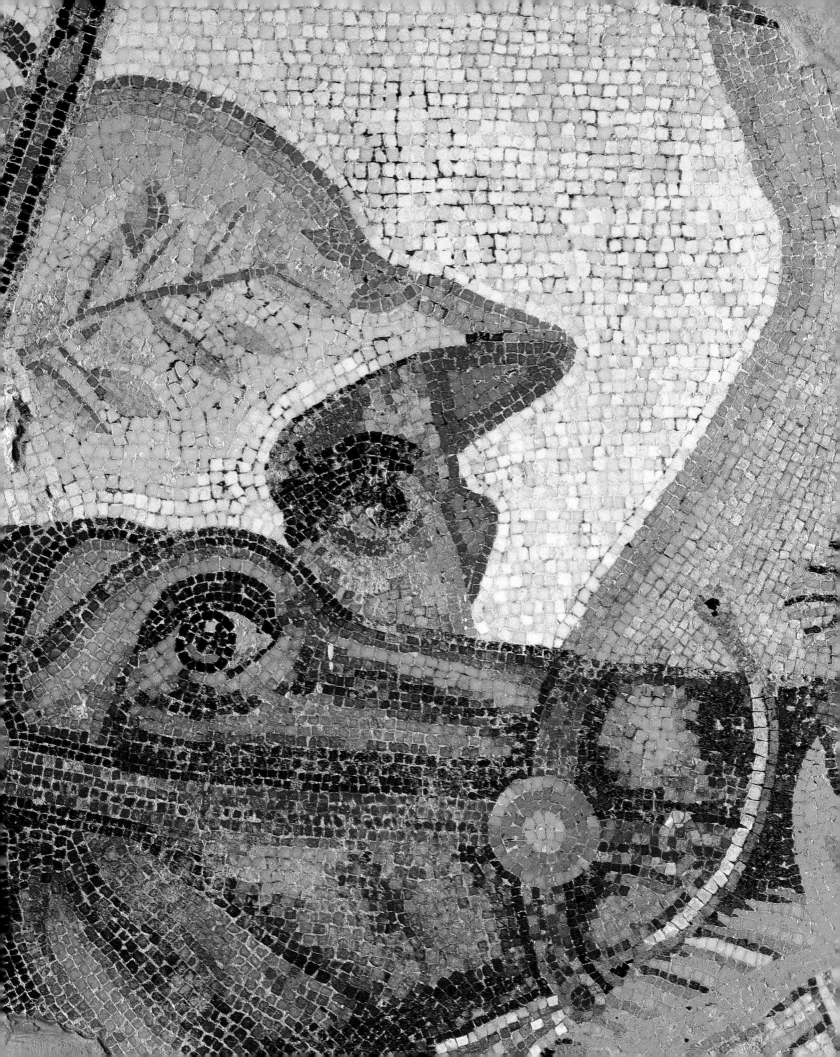

Plate VI

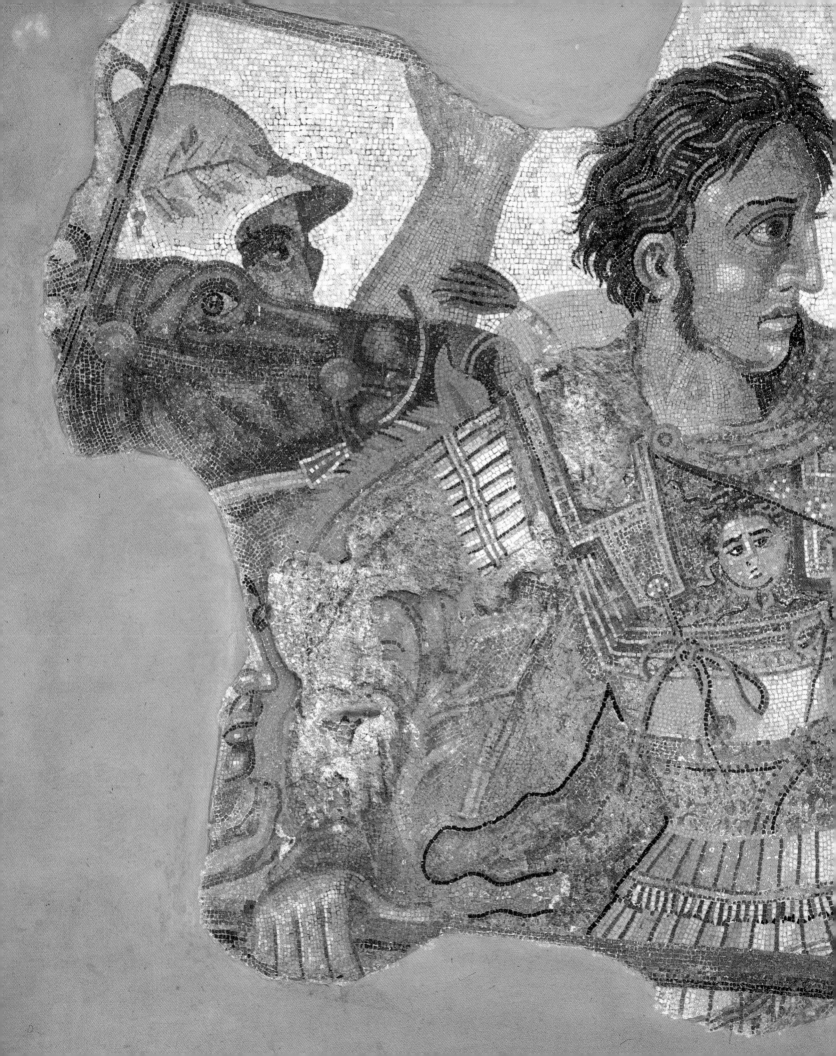

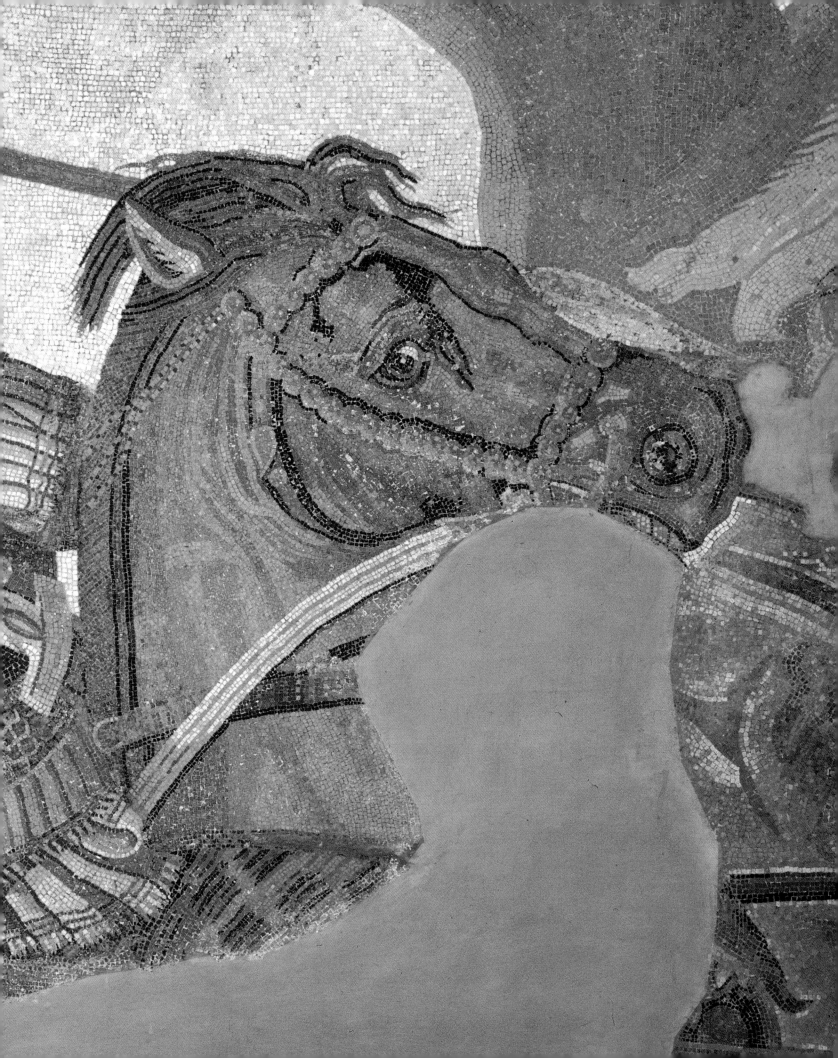

Plate VII

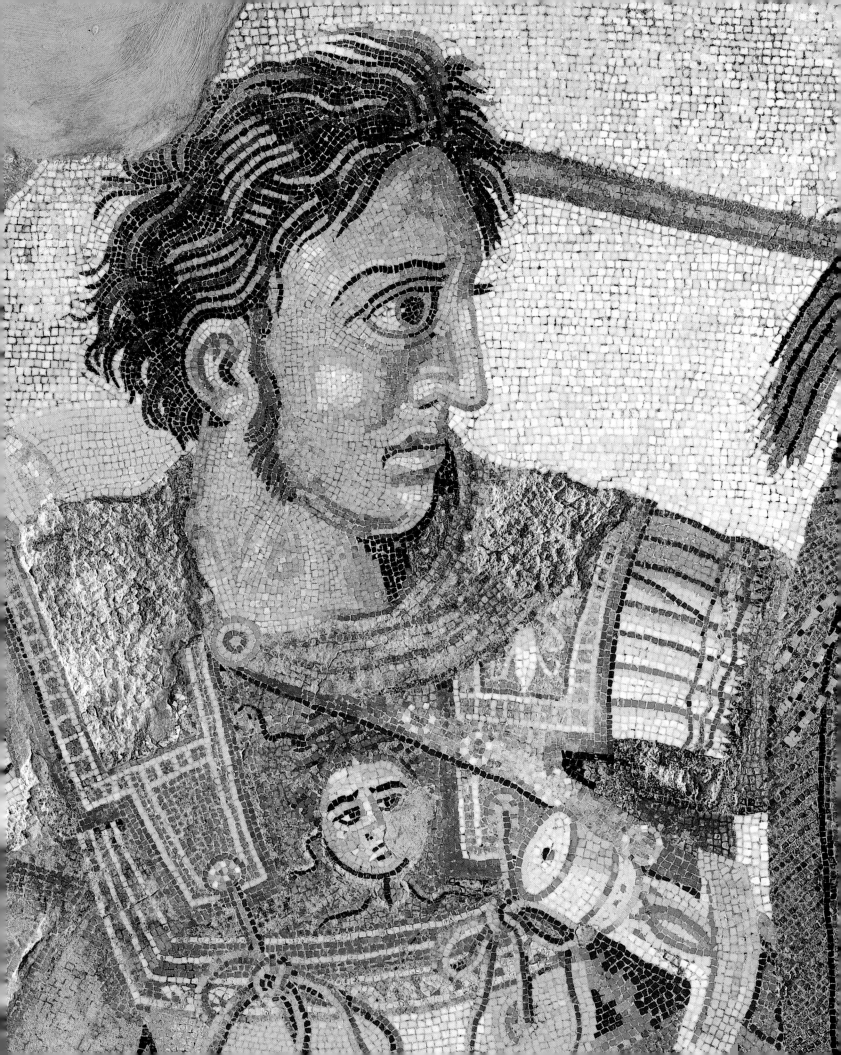

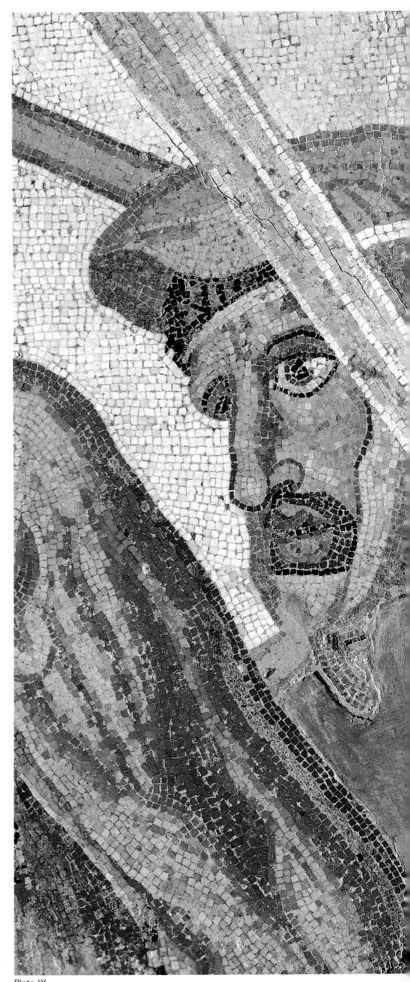

Plate IX

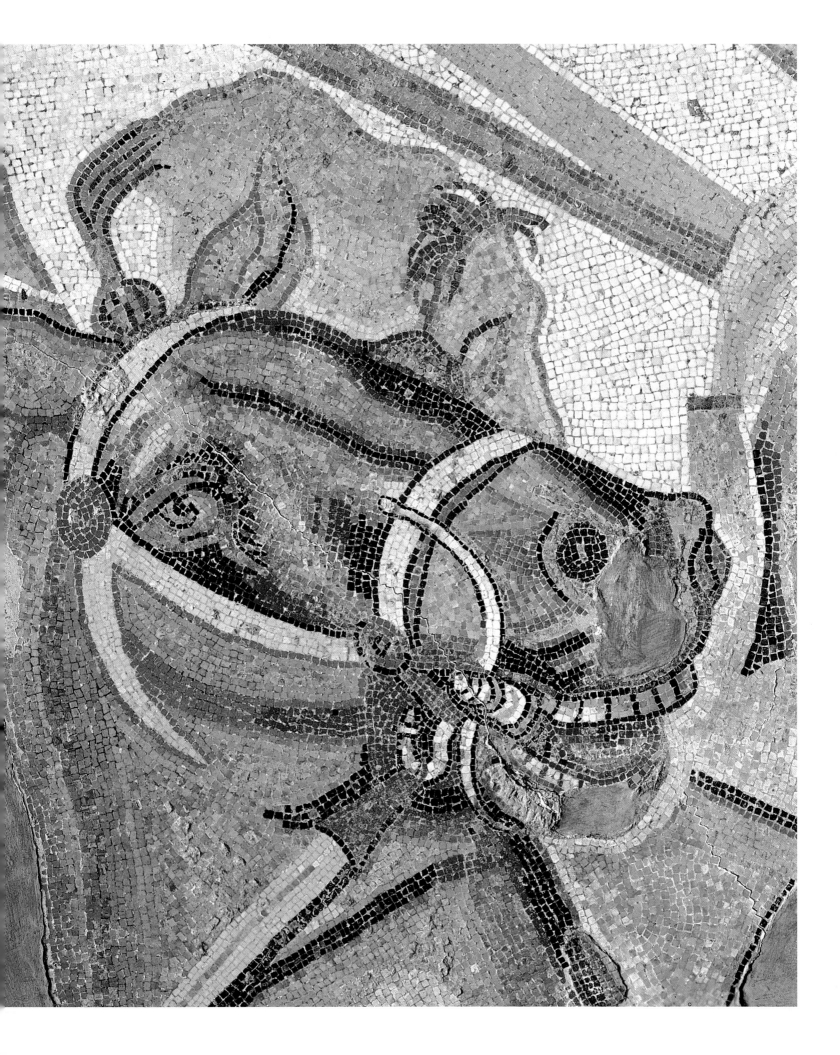

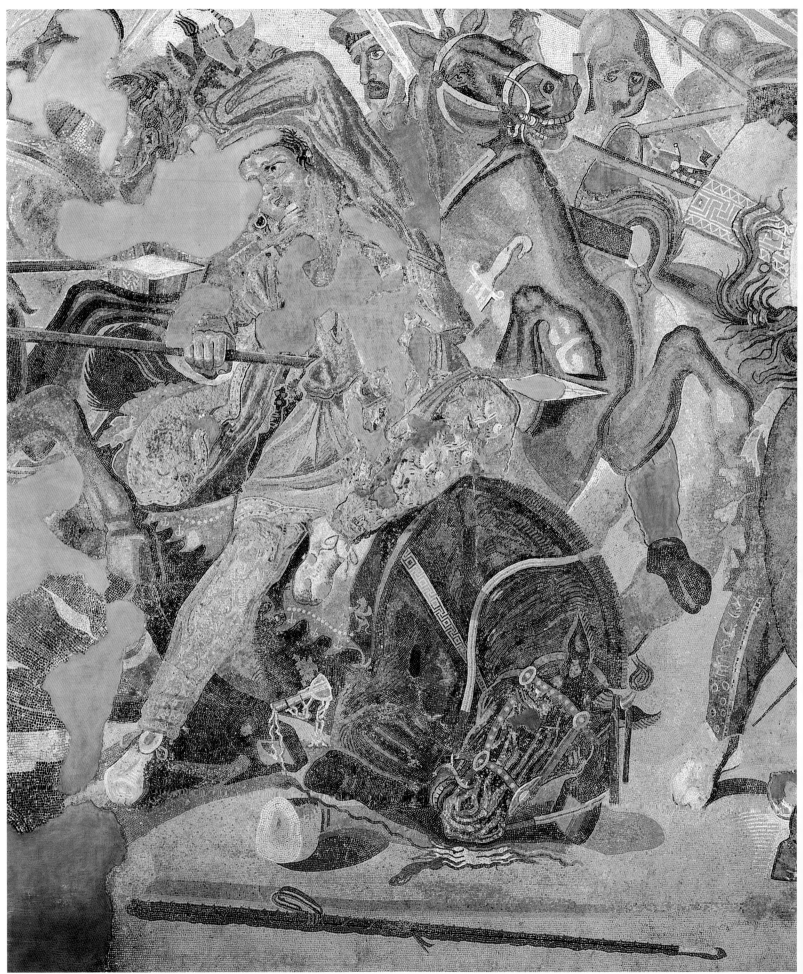

Plate X

Plate XI

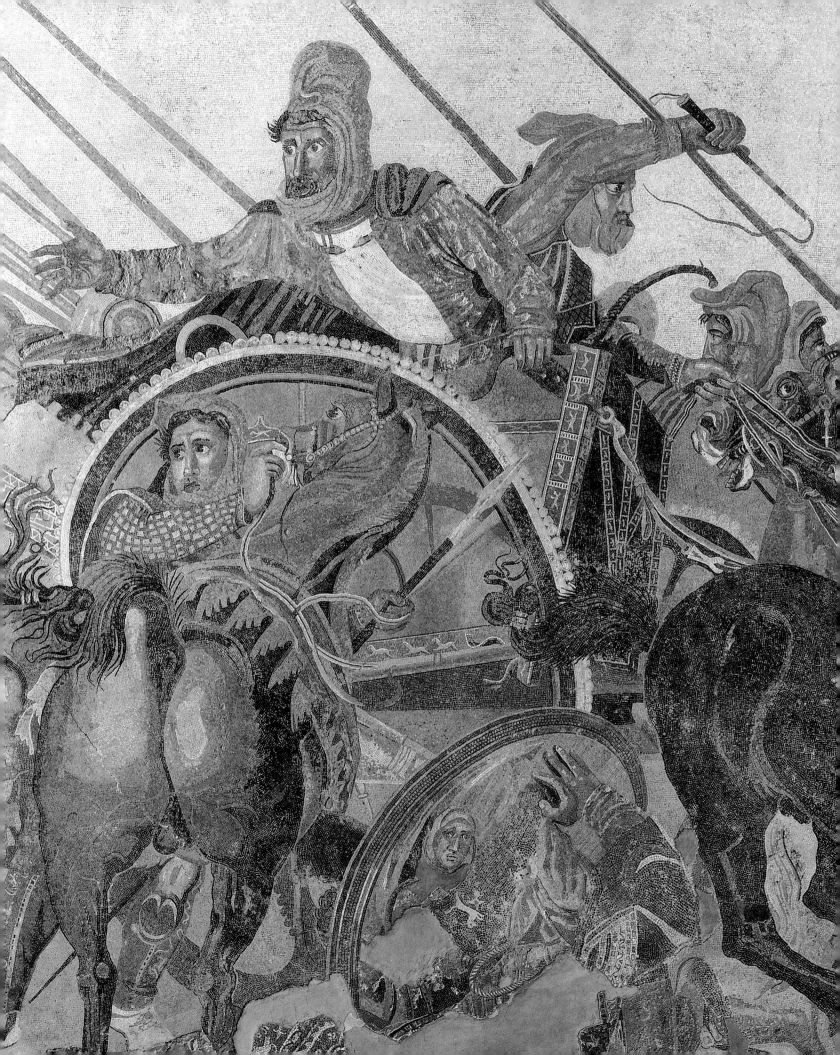

Plate XII

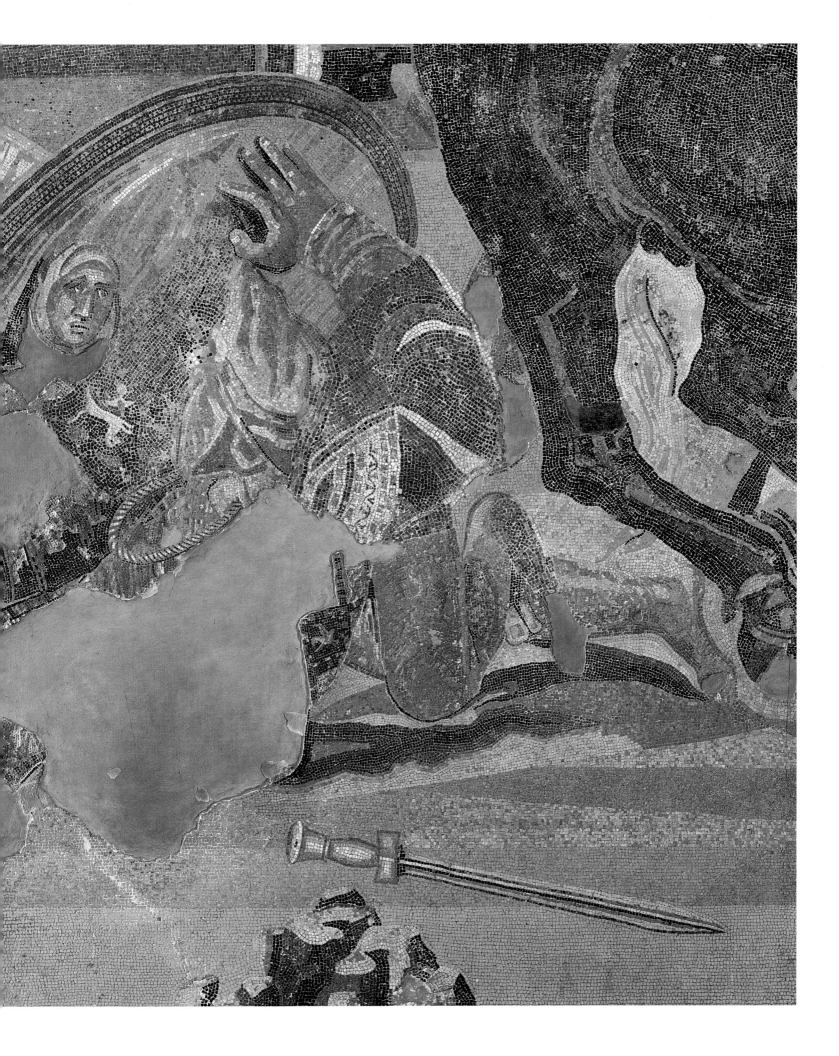

Plate XIII

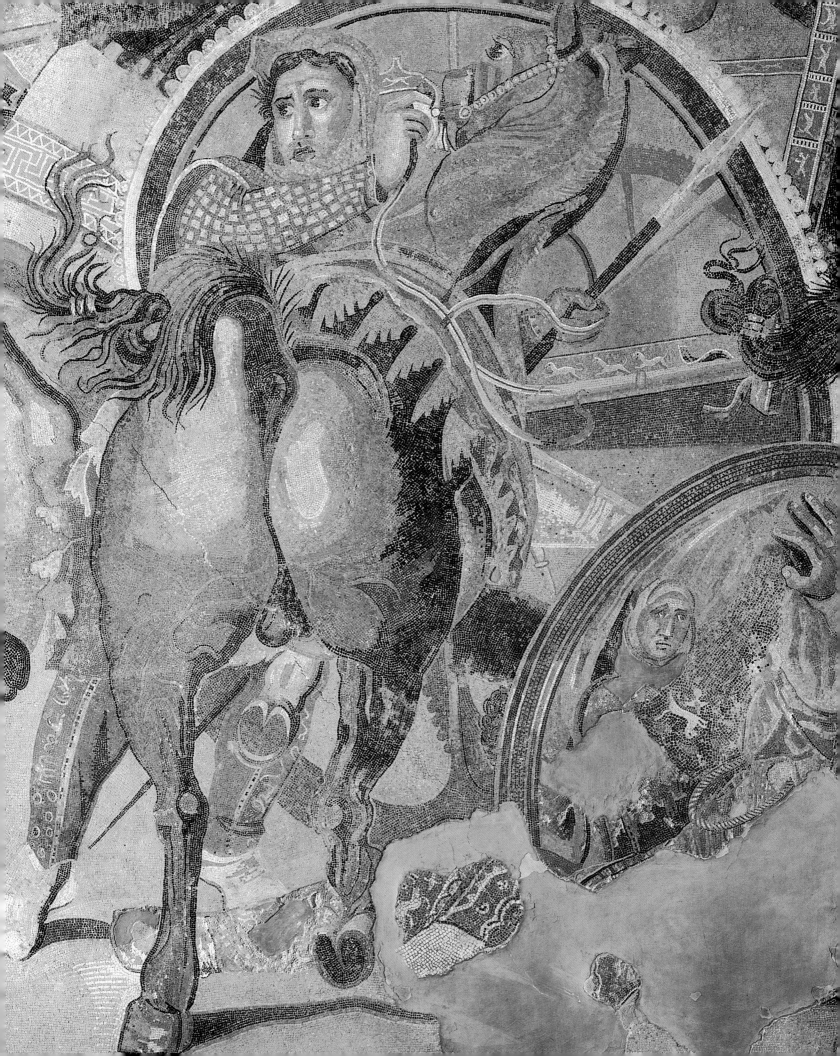

Plate XIV

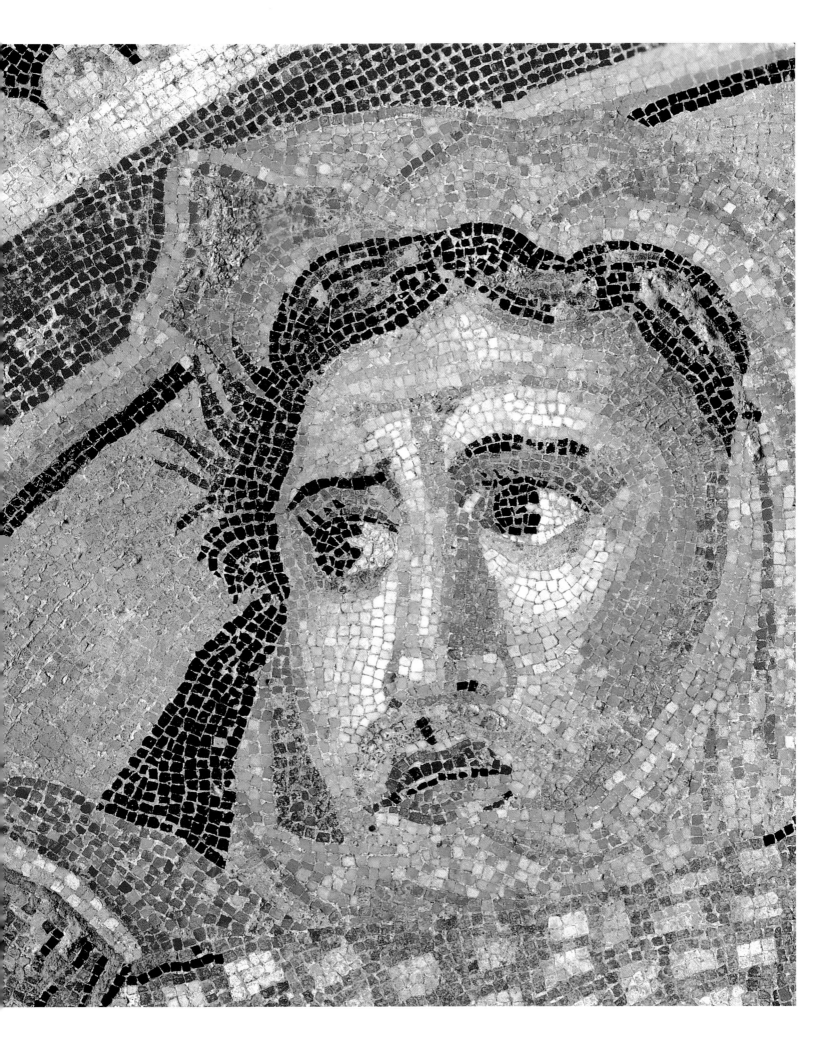

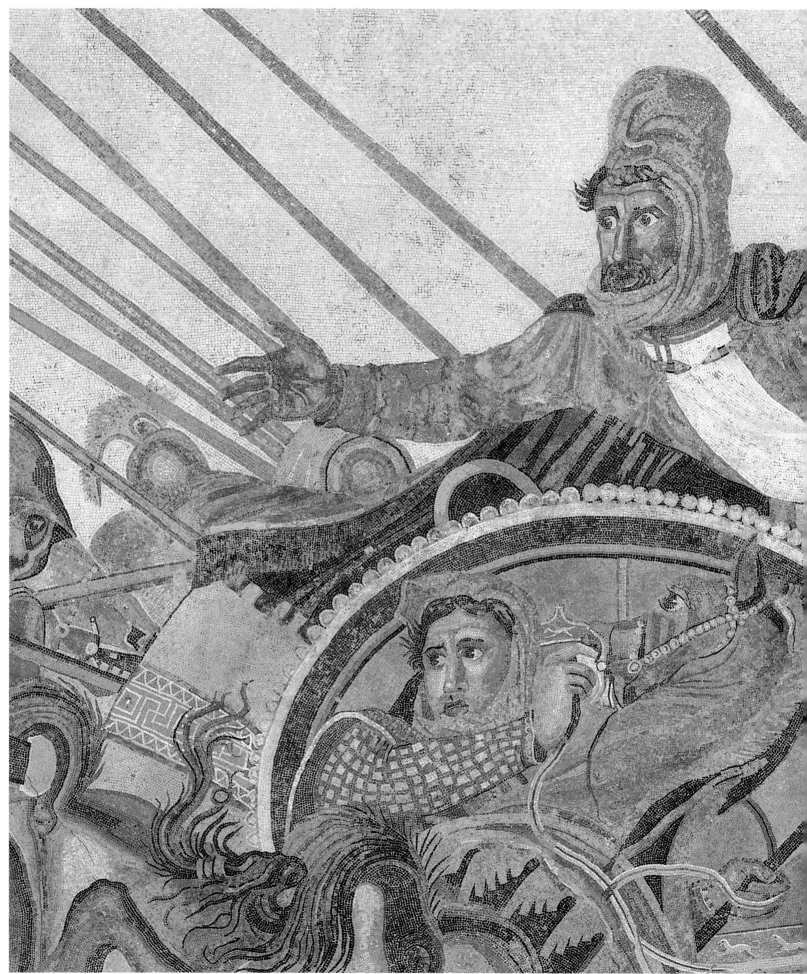

Plate XV

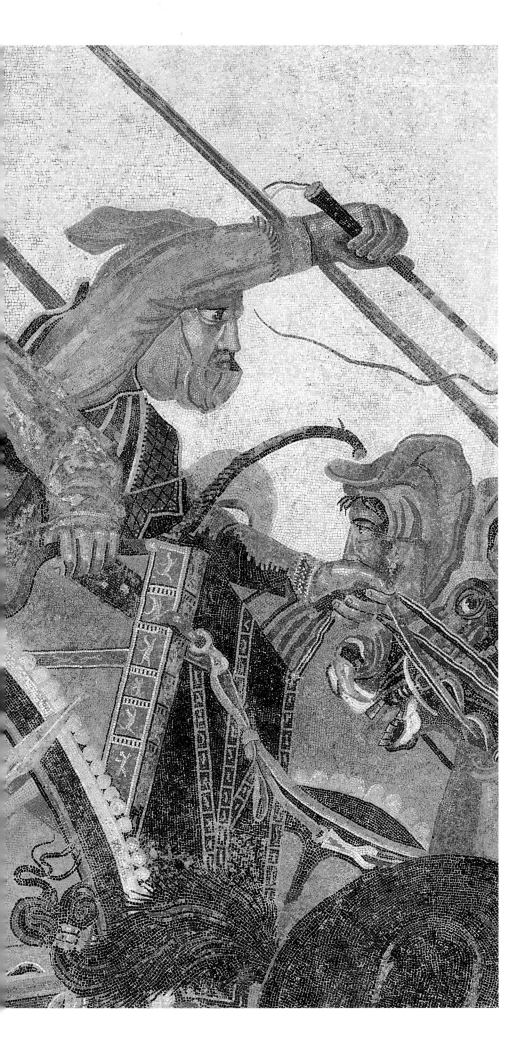

70

Plate XVI

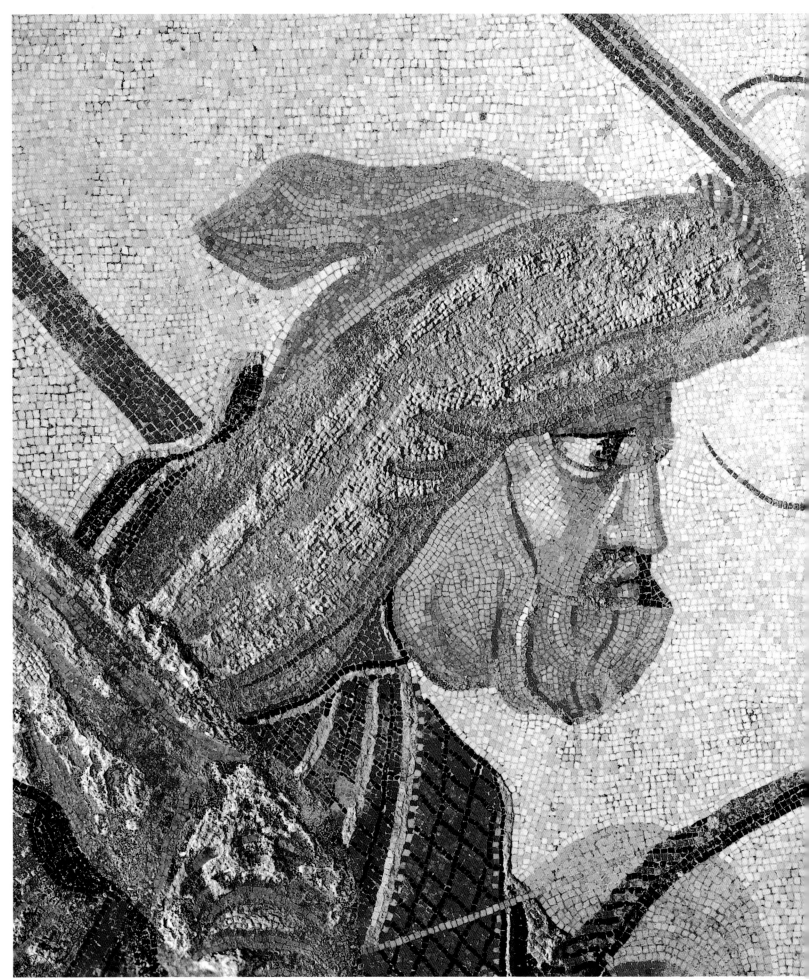

Plate XVII

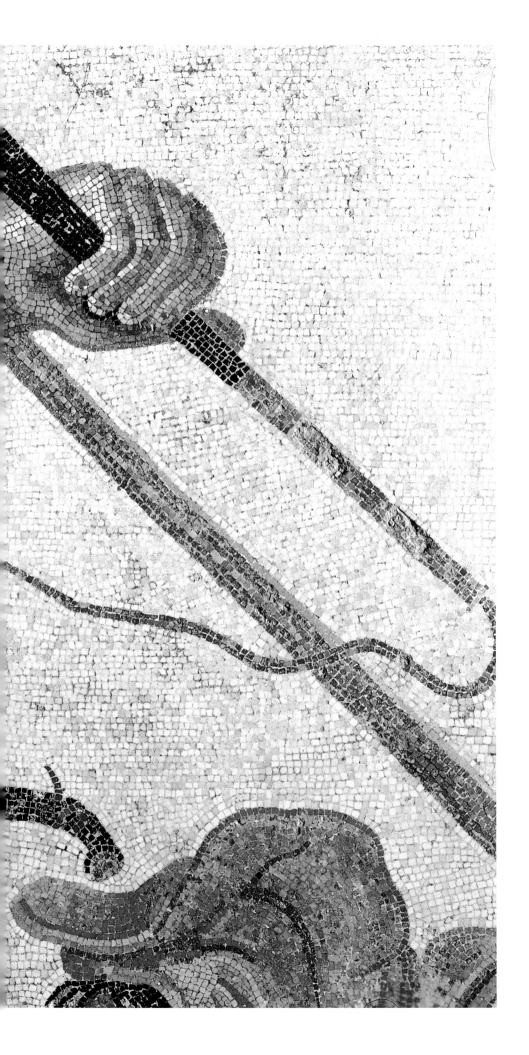

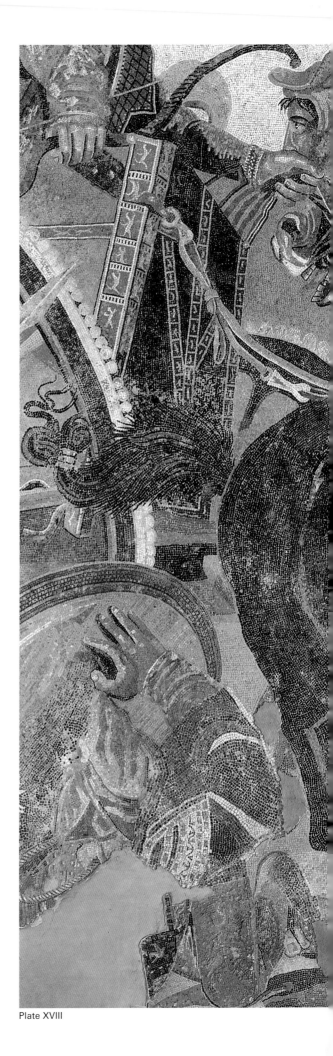

Plate XVIII

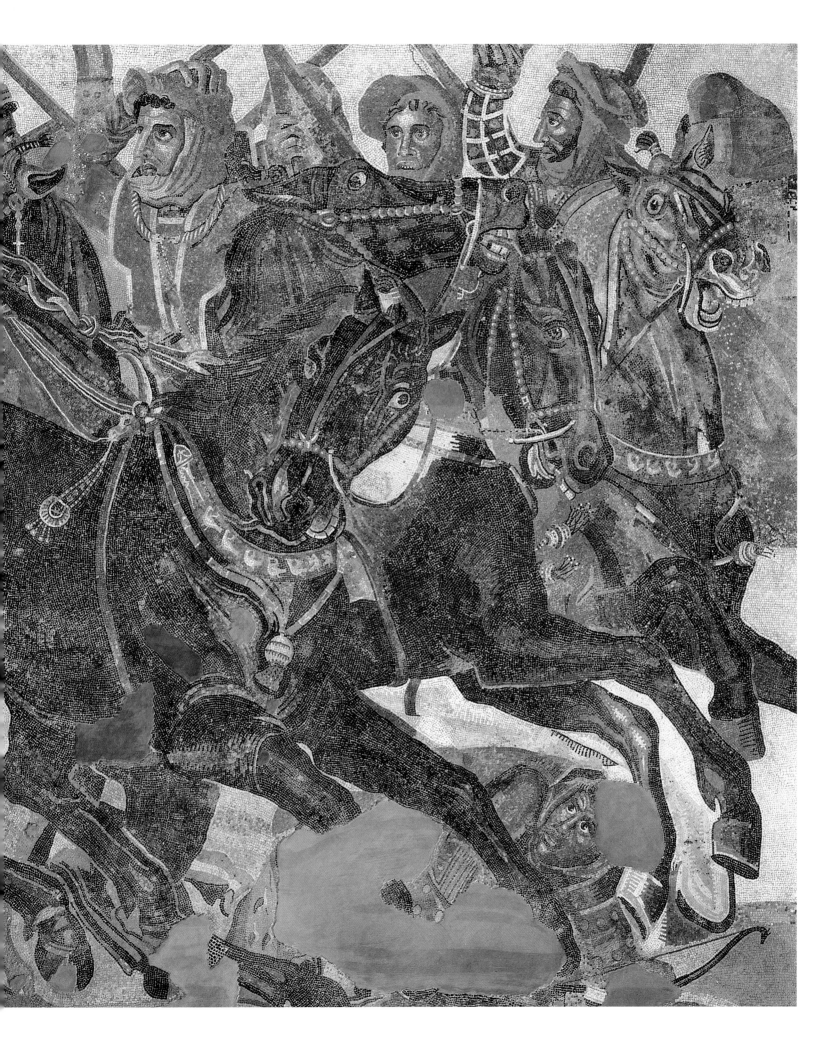

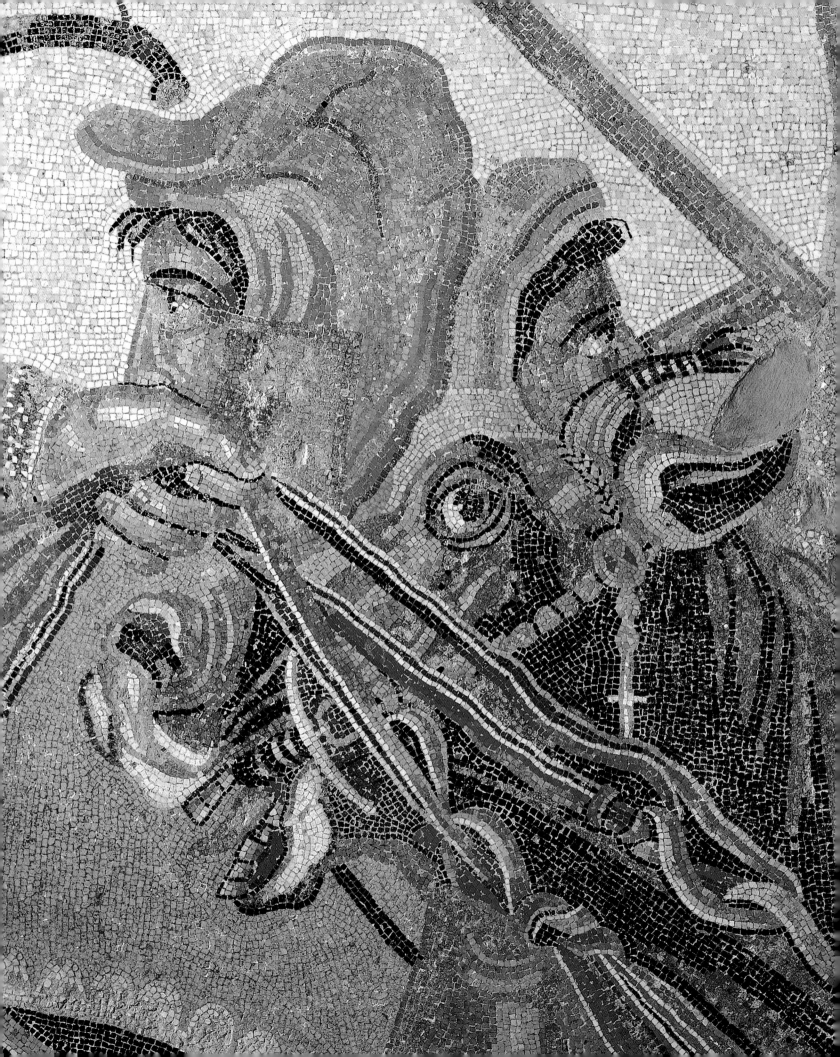

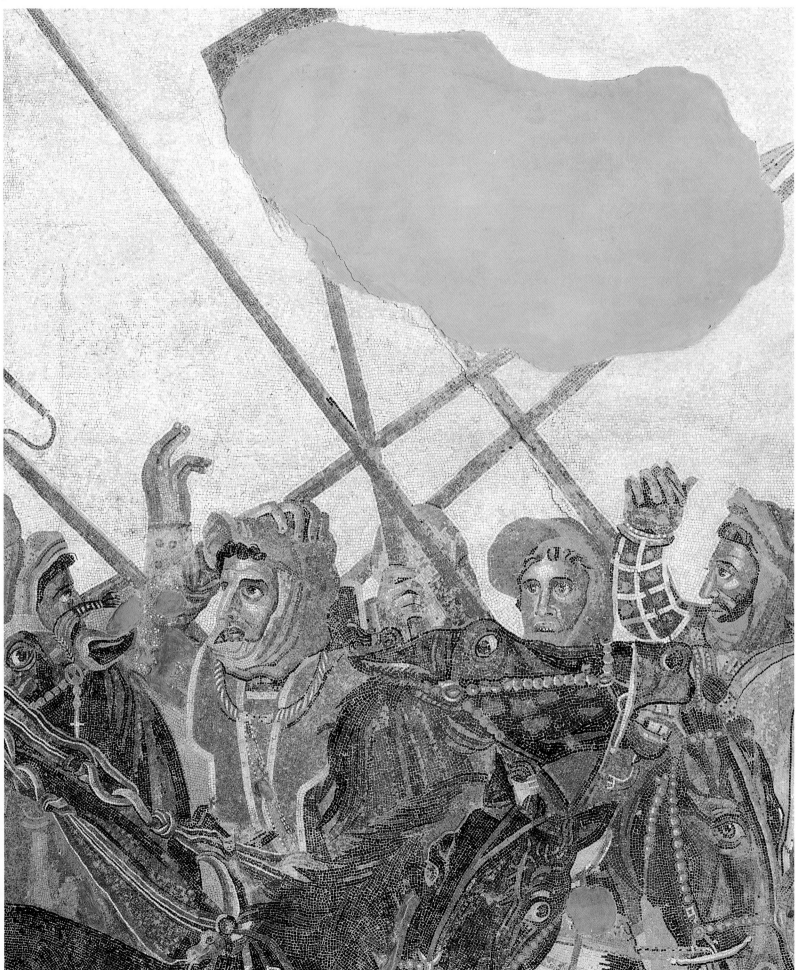

Plate XIX Plate XX

Plate XXI

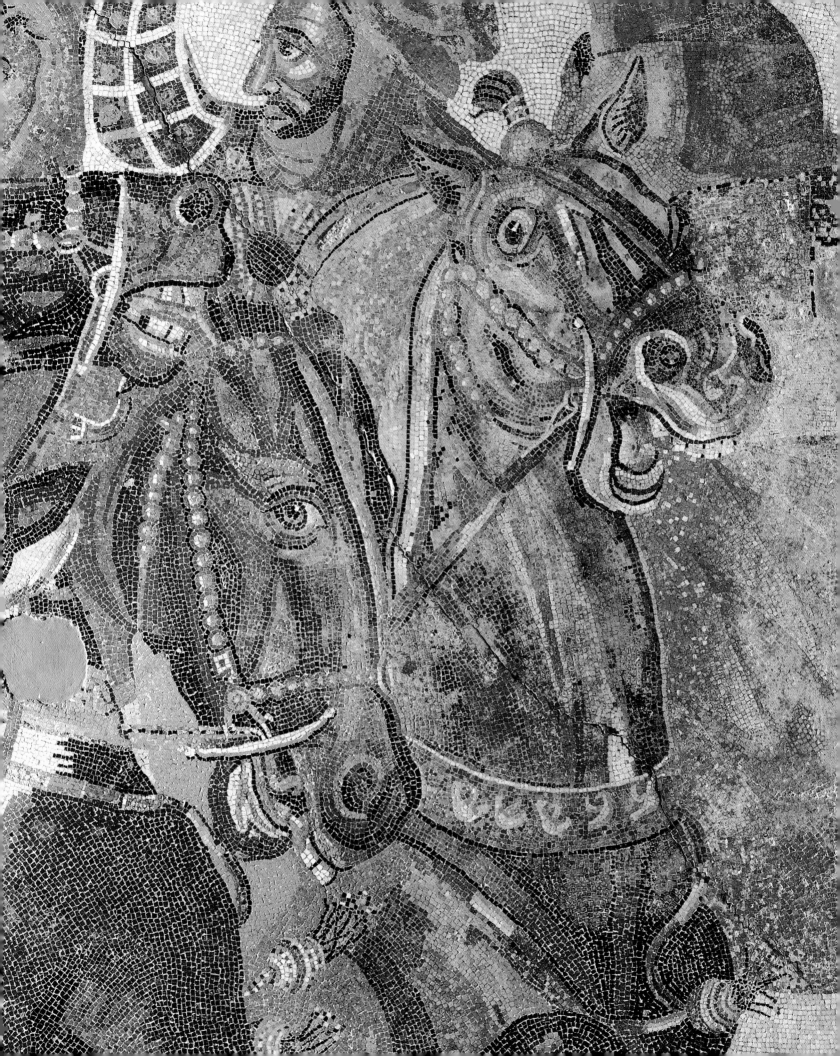

80

Plate XXII

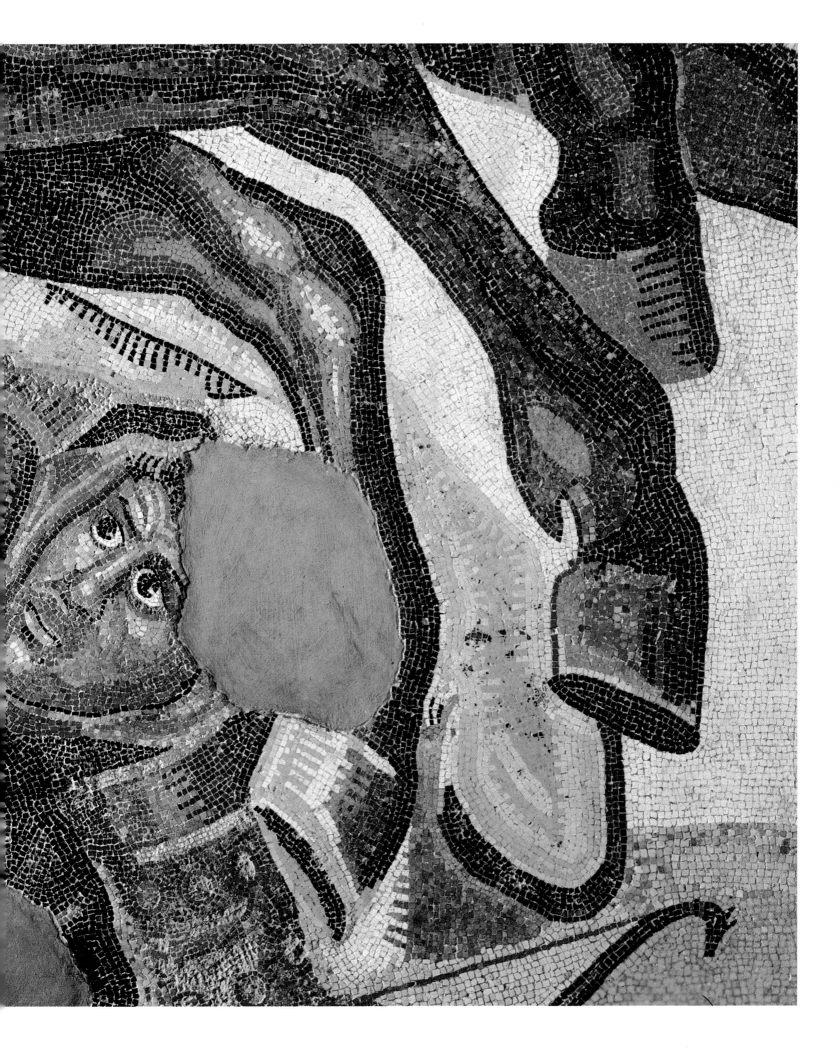

The Legacy of the 'Battle of Gaugamela'

Alexander and Porus

Comparisons with other partial copies of the painting representing the battle of Gaugamela have already shown that the reproduction in mosaic found at Pompeii is the most outstanding example of numerous works based on what is now believed to be Apelles' painting. During Alexander's reign, the schema of the victor on horseback pursuing the enemy king was revived in the commemoration of the battle on the Hydaspes in India against Porus in the spring of 326 B.C. The combat with the Indian monarch is not mentioned by the historical accounts, but there is a curious comment by Lucian relating to this (*Quomodo historia conscribenda sit* 12), which quotes an author who was contemporary with the event: 'When Aristobulus of Cassandreia described the duel between Alexander and Porus, and he chose to read this very passage to Alexander — he wanted to ingratiate himself with the king as much as possible by inventing false deeds and exaggerating his exploits — the king seized the book and, since they were sailing on the River Hydaspes, threw it into the water, saying "You too, Aristobulus, should meet the same end, you who take part in duels instead of me and put elephants to rout with a single arrow", and was about to fly into a rage'.

Shortly after Lucian — who knew and appreciated Arrian for other reasons — had written this essay, Arrian published his *Anabasis of Alexander* (A.D. 145–150), in which he explained that Aristobulus's account only saw the light of day after the king's death, and for this reason it appeared to be objective and not tainted with flattery (Arrian, *Anabasis* Introduction 2). The contradiction with Lucian's assertion that Alexander already had one of Aristobulus's writings is less significant than it may seem at first because Arrian himself confirms both that Aristobulus took part in the Asian campaign and that the author made use of his personal memories to write the final version of his history. In particular, Arrian admitted that Alexander had actually seen Porus in action (Arrian, *Anabasis* 5. 18. 6). Nor is it possible to ignore the literal meaning of the final observation when Porus, persuaded by one of Alexander's Indian emissaries, gave himself up to the victor 'after having fought well (*egonismenos*) for his kingdom against another king' (5. 19. 1).

With regard to the battle on Hydaspes, the type of obverse on the decadrachms struck in Mesopotamia from 324 to 323 (fig. 16)[35] confirms that the encomiastic version read out by Aristobulus before Alexander — and the object of Lucian's sarcasm — had begun to circulate at an early date. For this special occasion, the engraver has adapted the motif of Alexander on his rearing horse used by Apelles for the battle of Gaugamela (plate I) and perhaps renewed by the artist himself in a picture commemorating the event. Bearing his long lance, Alexander is attacking from the left; the vanquished king — placed on a higher level than the victor — is retreating with the means of transport that in his military tradition ought to have ensured his victory: in other words, the elephant rather than Darius's chariot. A warrior intervening between Alexander and the enemy king is run through by the Macedon's deadly lance. In this case, the speared soldier is on the elephant's back behind Porus, and seems to be making the same attempt to extract the lance from his wound that the young man (also an Indian) was making when he sacrificed himself for Darius at Gaugamela. Porus's posture resembles that of the Persian king, with his left arm lowered — here he is gripping a spare javelin instead of the bow held by Darius — and his head turned towards his assailant. Lastly, the raised right arm also corresponds, except that it is being used differently: this

83

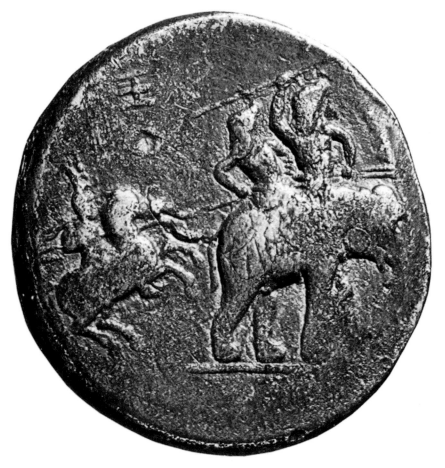

16. The battle between Alexander
and Porus. A decadrachm
of Alexander minted in Susa, obverse,
silver. British Museum, London

is not vain desperation, but rather a desire to fight, and Porus is wielding a javelin that he intends to hurl at Alexander. The mahout and, above all, Porus are very large compared to the elephant: this not only reflects the classical convention of showing steeds as being small in proportion to their riders, but also tallies with the description of Porus's remarkable height (Arrian, *Anabasis* 5. 19. 1). Behind the elephant, but set further back in the picture space, Alexander seems to be much smaller, stressing the audacity of his solitary challenge, in accordance with Aristobulus's account.

While, in the picture representing the battle of Gaugamela, I have reconstructed the position of Alexander's horse in the conventional schema of the gallop with the back legs extended — only just interrupted by its being reined in, causing the front legs to rise — here there is the more usual rearing up with the animal nearly halted and bending its back legs. Alexander's left hand, not visible here, is occupied with the reins; his right arm is bent in order to point his lance upwards, its position causing Alexander's attack to differ from standard practice both in battle or when hunting. This depiction of the hero on horseback, which is not extraneous to Apelles' initial output in the orbit of Alexander and could have been developed during the five years separating the battle of Gaugamela from the one on the Hydaspes, interfered in both the East (fig. 25) and in the West (fig. 17) with the direct iconographic tradition of Gaugamela.

The Darius Painter
In addition to the arguments for identifying the battle depicted in the mosaic from Pompeii as that of Gaugamela it must be observed that not only did the characteristic motifs of this scene evolve in the iconography contemporary with Alexander's short reign, but they also reappeared long after and/or at a considerable distance from his orbit. This was, moreover, in contexts where the memory of the battle of Issus was overshadowed by the fame of the decisive victory over Darius at Gaugamela. The further one goes in time and/or space from the period of these events the more it was Gaugamela that was regarded as the symbol of the nemesis that the Persians' hubris deserved and, more generally, as an allegory of the victory of Graecism. The widespread and enduring success of the subject gives greater credit, furthermore, to the painting's attribution to the most famous painter of antiquity.

The first echo of the picture in Italy was on Apulian vases datable to 324–323 B.C. and contemporary with the decadrachms depicting the battle of the Hydaspes (fig. 16). Alexander and his favourite portraitist were still alive when the Darius Painter, the leading vase-painter of his day, re-

peatedly commemorated the victory at Gaugamela by combining the modes that we attribute to Apelles.

The armed encounter between Alexander on horseback and Darius in his chariot — variously supplemented with other combatants, personifications and deities, the possible relevance of which needs to be discussed — appears on at least four large vases dating from the same period. Although the partially recomposed fragments of a krater, formerly in the Hamilton Collection, have been lost, a drawing of them has been preserved (fig. 17);[36] a volute-krater is in the Museo Archeologico Nazionale, Naples;[37] a fragment of a third krater is in the National Museum, Copenhagen;[38] an amphora is in the Museo Archeologico Nazionale, Naples (figs. 19–21).[39] That this is the decisive battle between the two monarchs and not the battle of Issus may be deduced not only from the iconographic analogies with the Alexander mosaic but also from the other decorations of the krater in Naples and an external comparison. As far as the krater is concerned, the side opposite the one bearing the battle scene is adorned on the neck with the fatal chariot-race between Pelops and Oenomaus, which decided the sovereignty over the land of Elis. Here, too, the king, destined to be defeated and killed, is in his chariot, and Myrtilus, his disloyal charioteer, is about to cause his ruin, just as Darius's charioteer is the cause of the downfall of the Achaemenid dynasty. The parallel was no doubt evident to the observer, who would also be acquainted with the fact that Pelops then married Hippodamia, the daughter of the dethroned king, just as, in the spring of 324, Alexander had married Stateira, Darius's daughter, at Susa (fig. 53). With reference to the Byzantine codex mentioned previously and described in detail later (p. 95), the illuminator repeats the same simplified version depicted by the Apulian painter — Alexander on horseback pursuing Darius in his chariot — in order to illustrate the end of the battle of Gaugamela in the *Alexander-Romance* (fig. 41).

On the amphora (figs. 19, 20) and krater in Naples (fig. 18), the victor gallops with his lance horizontal (in the former) or slightly raised (in the latter), similarly to the mosaic. On the Hamilton krater he slants the lance upwards, causing the horse to rear (fig. 17), revealing the influence of the schema that I referred to in the battle of Hydaspes (fig. 16), which must have been as familiar to the vase-painter as the picture of the battle of Gaugamela. The Naples krater (fig. 18) and the fragment in Copenhagen both preserve the heads of the horses of Darius's quadriga. The Hamilton krater (fig. 17) and the amphora (figs. 19, 20) show Darius's gesture and the charioteer leaning in the opposite direction most clearly. Although the other combatants do not correspond explicitly to those in the picture of Gaugamela,

17. Drawing of the krater showing the battle between Alexander and Darius in the presence of the gods, who assist the Greeks. Formerly in the Hamilton Collection, Naples

18. The battle between Alexander and Darius in the presence of the gods, who protect the Greeks. Apulian red-figured volute-krater, by the Darius Painter. From Ruvo. Museo Archeologico Nazionale, Naples

they cannot be dismissed merely as conventional supernumeraries. In the Naples krater (painted on three registers), the Macedonian horseman who terminates the central register on the right is based on the same schema as the rider presumed to be Antigonus Monophthalmos whom we shall see in a similar position in the battle of Alexander on the sarcophagus from Sidon (fig. 26).

The possibility that in an upper register of the battle of Gaugamela painted by Apelles, or even in other compositions by the same artist commemorating the event, there were personifications and divine apparitions cannot be ruled out, especially if we bear in mind that a number of allegories thronged one of the paintings he executed for Alexander's funeral carriage (Diodorus Siculus 18. 26–27). The series of vases decorated with battle scenes by the Darius Painter reflects the divine assistance promised to the Athenians before the battle of Marathon, as represented in the painting in the Stoa Poecile that has already been mentioned with regard to its other similarities to the Alexander mosaic. On the Apulian kraters the scene is accompanied by a 'heavenly prologue' in the third register, which was above the two devoted to the historical episode and was the same size as these. These groups were so closely linked to Alexander's ideology that there must have been an archetype planned at court. In actual fact, the deities found on both the better-preserved kraters depicting the battle comprise those to whom supplications were addressed as the battle of Gaugamela approached. In particular, the simultaneous presence of Artemis and Apollo is a reminder that on 20 September 331 B.C., ten days before the battle of Gaugamela, Alexander had offered sacrifices to the Moon and the Sun, as well as to the Earth, on the occasion of a lunar eclipse, correctly regarded as a normal astronomical event by this royal disciple of Aristotle, but which the soothsayer Aristander — who may be identified in the mosaic — had meanwhile declared to be auspicious for the Macedonians' forthcoming victory over the Persians.

Lastly, Zeus, Athena and Nike are to be found in the vigil under arms before Gaugamela: 'Alexander, who was more concerned than he had ever been before, called on Aristander to make votive offerings and say prayers. In a white robe, holding verbena in his hand, his head veiled, the seer chanted prayers for the king who sought to propitiate Zeus and Athena Nike' (Quintus Curtius Rufus 4. 13. 15).

On the day of the battle, having finished his inspection of the troops he 'shifted his lance to his left hand and, raising his right, invoked the gods, according to Callisthenes, with these words: "If I am truly the son of Zeus, defend and support the Greeks"'; and after the victory 'he offered splendid sacrifices to the gods' (Plutarch, *Alexander* 33. 1; 34. 1).

On the amphora in Naples the story could not have an immediate divine accompaniment in the narrow band of the battle scene (fig. 19), but on the other areas of its surface the mythological references are even more significant because they not only help to identify the event but also reveal the wealth of ideas in what may well have been Apelles' models. On the neck of the vase (above the battle) Boreas is depicted carrying off Oreithyia, the daughter of King Erechtheus of Athens (fig. 20). The god of the north wind was invoked by Achilles, who was adopted by Alexander as his model. Furthermore, Boreas's marriage with Oreithyia made the god a relative of the legendary rulers of Athens. When, in 480 B.C., the Athenians were threatened by Xerxes' fleet, the oracle advised them to appeal to their 'relative by marriage' (*gambros*, which also means 'son-in-law'), and they all understood that it was necessary to pray to Boreas (Herodotus 7. 189). For three days a violent storm battered the enemy fleet, sinking four hundred ships near Artemisium. After the victory of Salamis, a sanctuary was dedicated to the god on the banks of the Ilissus, and the Attic vase-painters resuscitated the myth that was so felicitously linked to the destiny of their city.

In the light of this, the parallel between the Persian Wars and the nemesis inflicted by Alexander is strengthened. Boreas resided on the Haemus range in the land of the Triballi, which was conquered by Alexander when he decided to extend the borders of his kingdom to the Ister (lower Danube) to guarantee the security of Macedonia during the Asian campaign. Boreas the Thracian, a remote ally of the Athenians, now carried out his work as the northern god of the Macedonians.

A second allegory — of fundamental importance for reconstructing the relationship with the painting of Apelles — may be seen of the other side of the amphora, directly opposite to the battle scene. This depicts Dionysus's journey to the East, which concluded with his victory over the Indians (fig. 21). That this was based on a cycle by Apelles is indicated by the fact that the painter has made the return of the Macedonians through Gedrosia and Carmania coincide visually with Dionysus's Indian triumph, as will be seen later with regard to the decoration executed for Alexander's funeral carriage in Egypt (see pp. 112–113).

On the amphora, the god's chariot is drawn by a pair of panthers: above shines the star of the Argeads; under the animals a long vine-branch arches up. Dionysus, heading towards India, had crossed the Euphrates by magically building a bridge of ivy and vine-leaves across the water. The river was the border to be crossed, following a divine

impulse, in order to expand the mission that Isocrates (*Philippus* 182) believed should be limited to Anatolia when he urged the king of Macedonia to begin the campaign against the Persians, but was now being extended to the extremities of the oecumene by Alexander: 'only this war is better than peace, resembling a holy mission (*theoria*) rather than a military expedition'.

The message that the two sides of the amphora (figs. 19–21) seek to convey is a very clear one. Alexander had crossed the Euphrates relatively easily thanks to a mistake on the part of the satrap Mazaeus, who left the banks unguarded; the fording of the Tigris to reach Gaugamela had been much more difficult. The parallel with Dionysus is an auspice post factum. If Alexander's crossing of the great rivers is compared to the exploits of Dionysus, this means that, when he was decorating the amphora, the vase-painter knew that Alexander's expedition, like the mythical one, had now concluded gloriously in India (326–325 B.C.), where the king had found traces of the god's visit (Arrian, *Anabasis* 5. 1–2).

Philoxenus

While Gaugamela's links with the myth of Boreas and Dionysus's journey to the East (on the amphora in Naples, figs. 19–21) and with the chariot-race between Pelops and Oenomaus (on the krater in the same museum) are evident, we do not know if the battle's association with the rape of Persephone (on the krater) was already present in the cycles of painting Apelles' executed for Alexander, or was intended to bring the concept of pursuit — common to both the battle and these myths — to the funerary world for which these vases were destined. What is certain is that this connection helps us to understand the formal resemblance of the schema of Darius and the charioteer to that of Hades and Persephone in the fresco at Vergina (fig. 22),[40] in one of the tombs of the great tumulus that also covered Philip's funeral chamber.

The revival of a motif of the battle marks the beginning, in what might be called the 'mannerist' style, of a phase in the depictions of Alexander subsequent to the early one, which was, in any case, used in the analogy between Hermes, who precedes Hades' quadriga, and the prince as he appeared in the episode of the lion in the mosaic at Pella, which may be related to a group by Lysippus. Thus the allegorical significance of the surprising subjection of the mythical theme to historical reality is reinforced. The Asian campaign was started by Alexander in the form of an epic, which justified a change of policy in the way the new courts celebrated the event: it was the human personages, immortalized by the leading artists of Alexander's reign —

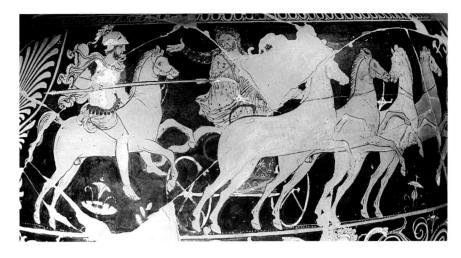

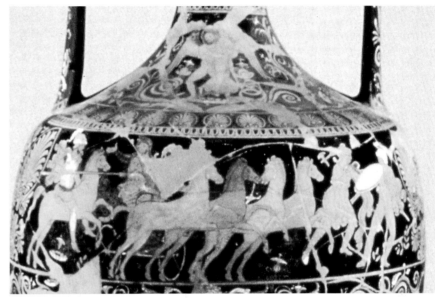

19–20. Boreas abducting Oreithyia, and the battle between Alexander and Darius. Apulian red-figured amphora, by the Darius Painter. From Ruvo. Museo Archeologico Nazionale, Naples

21. Dionysus's journey to India. Reverse of the Apulian red-figured amphora showing the battle between Alexander and Darius on the obverse, by the Darius Painter. From Ruvo. Museo Archeologico Nazionale, Naples

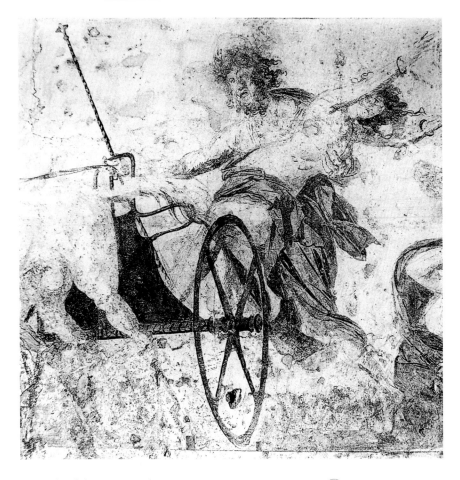

22. Hades abducting Persephone. Fresco, attributed to Philoxenus of Eretria. Great tumulus, tomb of Persephone, Vergina

23. Diagram of the elements in the group of Darius and the charioteer in the Alexander mosaic from Pompeii, corresponding to the composition of Hades and Persephone in the fresco of Vergina

24. Diagram of the elements in the group of Hades and Persephone in the fresco of Vergina, corresponding to the composition of Darius and the charioteer in the Alexander mosaic from Pompeii

Lysippus and Apelles — who determined the forms of the myth in the age of the Diadochi.

Certainly precedent to the plundering of the cemetery of Vergina (formerly Aegae) by the Galatians under Pyrrhus in 274 B.C., the decoration of the Macedonian tombs may be dated more precisely after the discovery of Dionysian paintings on marble beds found in a tomb in the area of Potidaea, now in the Archaeological Museum in Salonica.[41] This decoration was executed immediately after the foundation of Cassandreia, which in 316 B.C. replaced the city destroyed by Philip II of Macedon. Like the *thiasos* from Potidaea, the rape of Persephone is characterized by an airy lightness that finally confirms the celebrated rapidity of Philoxenus of Eretria, the painter then working at Cassander's court, according to Pliny (35. 110). While the decoration from Potidaea contains some weaknesses regarding the composition and the perspective, the rape of Persephone and the paintings that accompany it on the other walls of the tomb at Vergina (the sorrow of Demeter and the Moirai) are of an outstanding standard, suggesting that they are by Philoxenus himself, especially in view of his position in the circle of Cassander and the fact that the monument was intended for a woman of royal rank.

The analogy between Apelles' battle of Gaugamela and the myth depicted in the tomb at Vergina consists in the exact reproduction of the outlines of the group formed by the chariot, Darius and the charioteer (fig. 23) in the group of the chariot, Hades and the upper part of Persephone's body (fig. 24). This similarity even comprises the inclination of the sceptre the god is holding, which corresponds to that of one of the pikes behind Darius's hand.

Since, in the analysis of the mosaic, we have seen that the way the royal chariot was depicted originated in Mesopotamia in contact with the Assyrian iconography (figs. 10–12) and from direct observation on the field of Gaugamela, it is evident that the schema was used for the gods of the underworld after Apelles had created his motif.

Cephisodotus

Contemporary with the decoration of the tomb with the rape of Persephone (figs. 22, 24), a number of motifs of the painting of the battle of Gaugamela attributed to Apelles are to be found on the sarcophagus, referred to previously, of Abdalonymus, the governor of Sidon, who died between 315 and 312 B.C. These subjects regard the relief showing one of Alexander's battles on the front of the sarcophagus now in the Archaeological Museum in Istanbul, which I have also mentioned with regard to the horseman armed with a lance who concludes the composition on the right of the Apulian krater in the Museo Archeologico, Naples. The po-

litical situation in Sidon, after the death of Abdalonymus, makes it likely that the warrior opposite Alexander in the relief is Antigonus, later to be the subject of an equestrian portrait by Apelles.

As far as the mosaic itself is concerned, in the right half of the relief (fig. 26), the wounded Persian horseman, who is slumped forward with his right arm hanging down, derives from the Persian with a head wound whom we have seen behind Alexander in the lacuna on the left (plate III). Similarly, the man who, in the mosaic, must have struck the enemy rider with a downward blow — the supposed Cleitus, part of whose raised arm remains — is echoed on the sarcophagus by the Greek horseman in the centre of the fray, who may be Antigonus's son, Demetrius (figs. 25, 26). The figure of the Oriental, who in the relief, too, appears to have been run through by Alexander's lance as he slips off his kneeling horse (fig. 25),[42] closely resembles the pictorial model in content and form. Nonetheless, this incident is seen out of its original context because of the influence of a different schema involving Alexander on horseback, and other additions and adaptations from models already existing at Philip's court. The episode is deprived of its heroic meaning because Darius, the monarch to whom the warrior sacrificed his life according to the artist who painted the picture, is not represented on the sarcophagus. In Sidon it was necessary to avoid recalling the sovereign to whom members of the local ruler's family had previously sworn allegiance: in effect, Abdalonymus's career at Alexander's service was the result of treason. Thus this and the other echoes of the picture of Gaugamela — in the 'mannerist' style of the relief attributable to Cephisodotus, Praxiteles' son — become purely formal homage to the original, which increasingly appears to be the work of Apelles.

Laocoön

The young man who allows himself to be run through by Alexander's lance in order to save his king — the most striking figure in the mosaic (fig. 28, plate X), so frequently repeated in the copies (figs. 29–36, 39) — was the model for the dying priest in the famous Rhodian Laocoön group (fig. 27).[43] Pliny (36. 37) attributed the work to the sculptors Hagesander, Athanodorus and Polydorus, who are thought to have executed it around 40 B.C., copying a bronze dedicated or inspired by the philosopher Panaetius shortly after 166 B.C. (the beginning of Rhodes' economic and political crisis), when he was priest of Poseidon Hippios at Lindus. For the original, the names of Theon of Antioch and the Rhodian Demetrius, son of another Demetrius of Syriac origin, have been suggested.

There is a close correspondence between the figure of

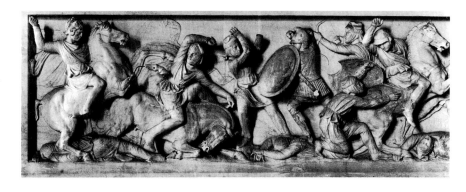
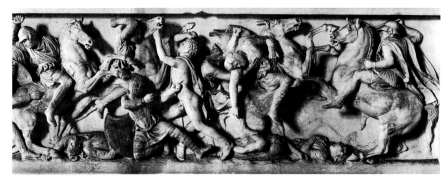

25–26. Details of a battle of Alexander. Relief on the front of the sarcophagus of Abdalonymus. Pentelic marble, attributed to Cephisodotus, Praxiteles' son. From the royal cemetery, Sidon. Archaeological Museum, Istanbul

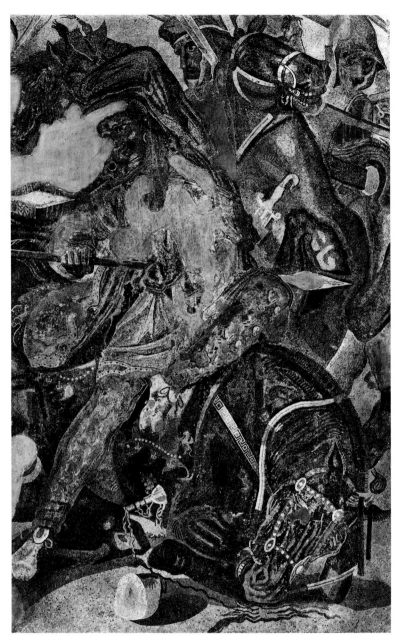

27. Laocoön and his sons being killed
by serpents. Marble, copy executed
by Hagesander, Athanodorus and
Polydorus. From the Baths of Trajan,
Rome. Museo Pio Clementino, Vatican

28. Indian horseman impaled
by Alexander's lance. Detail of the
Alexander mosaic, from the House
of the Faun, Pompeii. Museo
Archeologico Nazionale, Naples

Laocoön and that of the horseman — of which it is the mirror image — regarding both content and form: the instability of the figures, with the rider about to collapse onto his dying horse and the priest falling back onto his altar; the position of the wounds above the hip; the arching of the bodies in the opposite direction to the source of pain; the extension at an angle of one leg and the bending of the other (more noticeable in the picture); the pathetic futility of the effort to ward off what is about to cause death (the enemy's lance grasped by the wounded rider, the serpent seized near its head by the old man); the inclination of the head towards the wounded side; the raising of the other arm to the head, more pronounced in the horseman. In the sculpture the action that determines the immediate reaction of the victim has been elaborated, with the handling of the anatomy revealing the study of the nude that must have been required for the painting.

A Relief in Isernia

Around 100 B.C. the influence of the central area of the battle scene — comprising Alexander and Darius — became particularly evident in the sculptural output of the Etruscan and Italic world. In some cases figures were added that had not been part of the Apulian vase-painter's repertoire. Moreover, some of the works that are described here provide information that I made use of when reconstructing the archetype, especially with regard to the missing or damaged parts of the mosaic. Thus the new popularity of the original painting's iconography was linked neither to the Tarentine vase-painting tradition nor to the transfer of the mosaic to Italy, although the fact that these modest sculptural reproductions were contemporary with the installation of the mosaic floor in Pompeii is certainly of interest. The concentration of so many minor works of art in the area comprising Samnium (fig. 29), Umbria (figs. 36, 37) and Etruscan Perugia (figs. 30–35) in a period when Rome now ruled the whole of Italy, suggests that the new importance of the battle scene's iconography was due to the arrival in Rome from a Hellenistic court of the original painting by Apelles; it may have come from Macedonia in 146 B.C.

In the relief in Isernia,[44] which is the surviving section of a larger frieze, there is a partial adaptation to the different historical context, since one of the vanquished has a helmet of the evolved Attic type and an oval shield with ribs in relief (fig. 29). The attacking horseman, however, has Alexander's cuirass and the Oriental pierced by the victor's lance is wearing *anaxyrides* (trousers) under his tunic; the king himself, on the chariot, is wearing a sleeved chiton. What differ notably are the position of the steed that has fallen under the dead Oriental and that of the first

29. Battle between Alexander and Darius. Limestone relief, section of a frieze. Museo Nazionale Archeologico, Isernia

30. Battle between Alexander and Darius. Relief on an Etruscan urn, limestone. Museo Nazionale Archeologico, Perugia

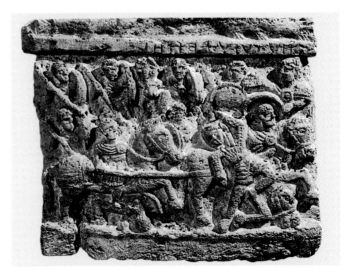

31. Battle between Alexander and Darius. Relief on an Etruscan urn, limestone. From the tomb of the Cutu, Perugia. Museo Nazionale Archeologico, Perugia

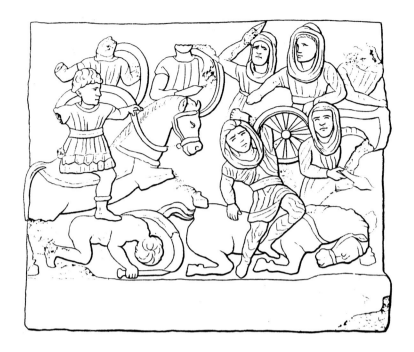

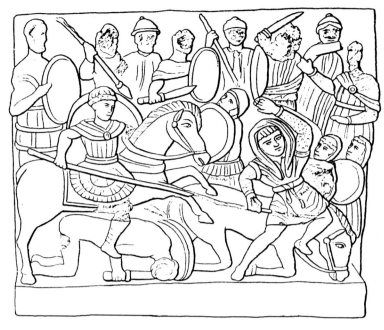

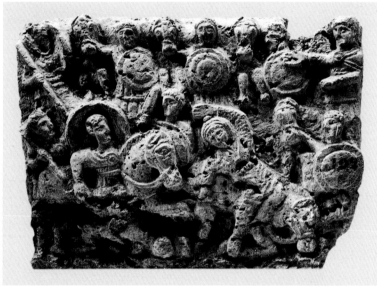

32. Battle between Alexander and
Darius. Relief on an Etruscan urn,
limestone. Museo Nazionale
Archeologico, Perugia

33. Battle between Alexander and
Darius. Relief on an Etruscan urn,
limestone. Museo Nazionale
Archeologico, Perugia

34. Battle between Alexander and
Darius. Relief on an Etruscan urn,
limestone. Museo Nazionale
Archeologico, Perugia

35. Battle between Alexander and
Darius. Relief on an Etruscan urn,
limestone. Museo Nazionale
Archeologico, Perugia

horse of the chariot (simplified as a biga), which is kneeling here: the sculptor has completely ignored the theme of the flight, of fundamental importance in Apelles' picture (fig. 7, plate I).

Etruscan Urns

Six urns in Perugia were carved in limestone to produce effects similar to the frieze in Isernia (fig. 29). Here, too, there are combatants with equipment dating from the period when the urns were made. The nucleus reproducing the original picture varies in size and quality on each vessel, but, in any case, maintains the force of the archetype. What is particularly striking is that in this notable selection of artefacts there is not a direct chain of transmission from one to the other, but rather the sculptors have drawn on a complex repertoire of figures, from which each has selected different elements. All in all, the Perugian urns reproduce no less than eight of the protagonists and supernumeraries of Gaugamela: Alexander; the warrior who has fallen under Bucephalas; the speared Oriental; the mercenary confronting Alexander on foot; the Persian horseman intervening to the same end; Darius; the charioteer; and the Persian curbing the frightened horse. Analysis of the urns reveals that it is the group of Alexander and his victim that constantly appears: it is the only reproduction of the great picture on a vessel with a small front (fig. 30),[45] and on the rustic urn found in the tomb of the Cutu (fig. 31),[46] one of the most recent in the series, close to the interruption of the deposits in the tomb due to the catastrophe of the Perusine War (41–40 B.C.). One example also includes the chariot wheel, Darius and the charioteer (fig. 32).[47] In another (fig. 33),[48] Darius is recognizable as a personage gesticulating in alarm in the upper right corner, without chariot and charioteer, but accompanied at the bottom by the warrior (portrayed with western equipment) holding by its bit the horse ready for the king's flight. Elsewhere the monarch appears isolated (fig. 34),[49] He is totally absent from the urn where the mercenary with a circular shield is visible to the left of the Oriental transfixed by Alexander, and, on the right, the Persian horseman is brandishing his sword ready to strike, although weapon is not easy to distinguish (fig. 35).[50]

A Bowl by Caius Popilius

A Italo-Megarian bowl with moulded relief decoration, now in the Museum of Fine Arts in Boston, displays Hellenistic influence (figs. 36, 37);[51] the inscription assigns it to one of the workshops of Caius Popilius in southern Umbria at Ocriculum (modern Otricoli) or Mevania (Bevagna). On the body of the bowl is depicted a battle in which the ac-

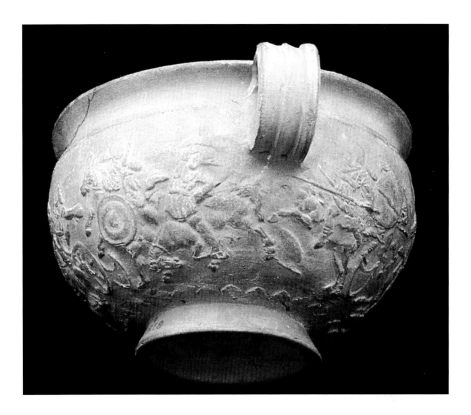

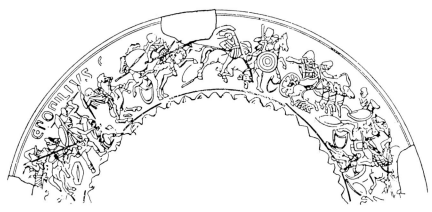

36. Battle between Alexander and Darius. Italo-Megarian bowl with moulded relief decoration. Workshop of Caius Popilius. Museum of Fine Arts, Boston

37. Diagram of the battle between Alexander and Darius. Italo-Megarian bowl with moulded relief decoration. Workshop of Caius Popilius. Museum of Fine Arts, Boston

38. Equestrian statue of Claudius Drusus on the triumphal arch erected in his honour. Gold aureus of Claudius, reverse. British Museum, London. Cast in the Museo della Civiltà Romano, Rome

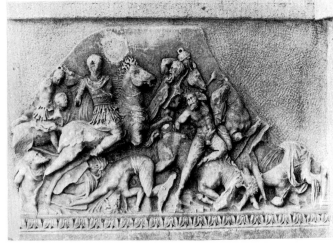

39. Battle between Romans and barbarians. Relief, Italian marble. Formerly Ruesch Collection, Naples, now Schinz Collection, Zurich

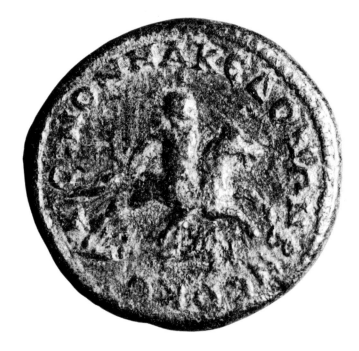

40. Alexander on horseback with his lance horizontal. Macedonian bronze coin, reverse. Reign of Gordian III. Private collection

tions and equipment of numerous figures on foot or on horseback do not correspond to those of the combatants of Gaugamela, but half of the surface is covered with an exact reproduction of the section of the painting showing Alexander and Darius's quadriga. Under Bucephalas's legs appears the shield of which only part of the rim has survived in the mosaic (plate VI), and which I have already associated with the fallen warrior attested by the Etruscan urns (figs. 30–35) when reconstructing the original picture. Between the speared Oriental and his king in flight there is, as stated previously, a Persian horseman wielding his sword vertically before him and facing Alexander. The dismounted mercenary in front of him in the version on the bowl may be the result of the shifting to the observer's right of the warrior who is, as I have already mentioned, confronting Alexander in the mosaic. Completely in accordance with the model (plate I) is the divergence between Darius and his charioteer, despite the direction being taken by the quadriga and the position of the first horse with regard to the wheel; the other three horses are, however, aligned schematically.

In Rome

It is highly probable that Apelles' original painting was present in Rome during the Imperial age. A gold aureus of Claudius, datable to A.D. 41–45, shows that on the summit of the triumphal arch of Claudius Drusus (Claudius's father, who died in 9 B.C.), erected on the Via Appia (Suetonius, *Divus Claudius* 1. 3), the protagonist appeared with his lance held horizontally between two trophies in an equestrian statue closely imitating the posture of Alexander and his horse in the mosaic found in Pompeii (fig. 38).[52] A very similar horseman is to be found in the battle against the barbarians depicted on the Ruesch relief (named after its previous owner), now in the Schinz Collection in Zurich (fig. 39).[53] This is a work that repeats Alexander's charge at Gaugamela even down to the detail of the animal-skin caparison on the horse's back (plate VII). The fallen horse in front of the king is the same, while a bearded man, stripped to the waist, assumes the same posture as the speared Oriental (fig. 28); the *bracae* of the northern costume replace the *anaxyrides* of the young Indian in Darius's service. In this Roman frieze, an enemy warrior has ended up with his shield under Alexander's horse, but in a different direction from the fallen soldier on the Etruscan urns (figs. 30–35).

The reverses of a number of Macedonian bronze coins minted in the reign of Gordian III (A.D. 238–244) are of particular importance;[54] this Alexander on horseback is an intentional copy of him portrayed as the victor of Gaugamela because the young Roman emperor was then

conducting a successful campaign in Mesopotamia (fig. 40). The horse has just been reined in, the lance is held horizontally, and there also is the enemy warrior under Bucephalas. Although it is possible that the major works commemorating Alexander's exploits were still remembered locally, the iconographic programme of the Macedonian mint is likely to have been laid down by the central power, especially if the original painting of the battle by Apelles was now in Rome.

A Byzantine Miniature

That the contrast between Alexander on horseback and Darius in his chariot remained permanently linked to the battle of Gaugamela is demonstrated by a Byzantine miniature of the eleventh century in the Biblioteca Nazionale Marciana in Venice (fig. 41),[55] which has already helped us with our interpretation of the mosaic. The sheet is bound in a codex of the *Cynegetica*, which is attributed to Oppian, but it belonged to an edition of the *Alexander-Romance*, of which it illustrates the passage on the battle of Gaugamela (2. 16); I quoted part of this in the reconstruction of Apelles' picture with regard to the moment when Darius's chariot is turned round (see p. 26). It is worth repeating here that the author of the *Romance* confuses the historical account of the war-chariots employed by the Persians at Gaugamela with the solemn spectacle of the royal chariot. Thus, in the miniature now in Venice, the chariot — reduced to a biga, as in the relief in Isernia (fig. 29) — is equipped at the back with three diverging prongs intended to make it resemble a scythed chariot. Evidently the illuminator also had in mind that Plutarch's description of Darius 'standing in the high chariot'. With regard to Alexander, according to the anonymous account, at Gaugamela, 'he was at the head of his men, sitting on Bucephalas's back', while a visual explanation of the horse's name is provided, as I mentioned previously, by the medieval artist, who depicts the ox-head brand-mark on the animal's haunch both in the scene of pursuit and in the representation of Bucephalas in his stable. This corresponds to what I considered possible in Apelles' picture, by analogy with the depiction of the brand-mark on a horse on a Lucanian vase (fig. 42), and it also tallies with Pliny (8. 154): 'They called him Bucephalas, perhaps because of his fierce appearance or else because of the brand-mark with an ox-head on his haunch'. For the schema of the gallop, the way the lance is held and the cloak streaming out behind, the figure of Alexander in the codex in Venice imitates the remote archetype of the battle scene with remarkable accuracy (plate I), differing only with regard to the inclination of the king's head. Even Darius's charioteer repeats the ges-

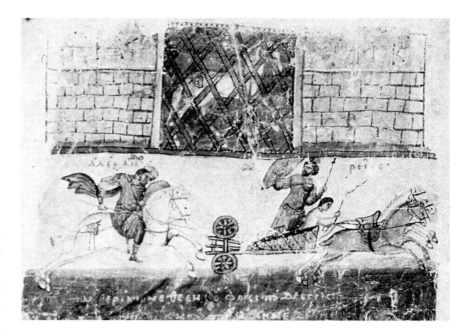

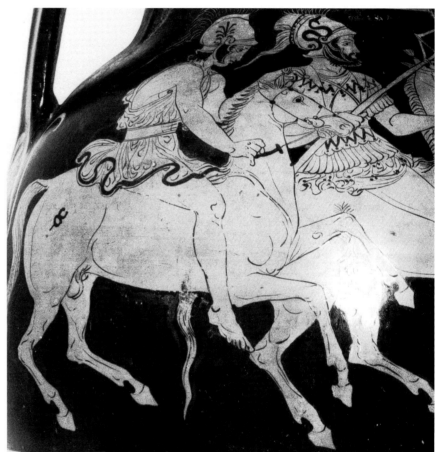

41. Bucephalas in his stable and the battle between Alexander and Darius. Miniature belonging to the *Alexander-Romance* bound in a codex of the *Cynegetica* (attributed to Oppian of Cilicia). Biblioteca Nazionale Marciana, Venice

42. Brand-mark of the caduceus on Hermes' horse. Detail of Hermes and Poseidon on horseback. Lucanian red-figured pelike. Karneia Group. From Heraclea. Museo Nazionale della Siritide, Policoro

ture of the one in the original, and cracks the whip without striking the animals (plates I, XVII).

[35] Hölscher 1973, pp. 172–174, plate 15. 2; Giuliani 1977, pp. 30–31, 35, plate X. 3–4; Price 1982, plates IX. 1 (D), IX. 3 (D), X. 2 (D), the javelin in Porus's raised right hand is visible; C.C. Vermeule, in *The Search* 1982, p. 109, no. 21; C.C. Lorber, in *Wealth* 1983, pp. 209–210, no. 101; Stewart 1993, pp. 201–207, fig. 69; F. Smith, in *Alessandro* 1995, p. 241, no. 33; Bl. B. Brown 1996, p. 89, fig. 1, Porus's javelin is visible; Saatsoglou-Paliadeli 1997, fig. 1. See note 81.

[36] Hölscher 1973, pp. 174–180; Kossatz-Deissmann 1988, p. 688, no. 254, figure on p. 688; Palagia 1988, p. 626, no. 7; Stewart 1993, pp. 150–154, fig. 5 in the text; Aellen 1994, p. 214, no. 95; Cohen 1997, pp. 66–68, fig. 41 b.

[37] Trendall, Cambitoglou 1982, II, p. 495, no. 40; Yalouris 1990, p. 1017, no. 113; Kossatz-Deissmann 1988, p. 700, no. 343; Palagia 1988, p. 626, no. 6, plate 386; Kossatz-Deissmann 1990, p. 751, no. 103; A. Goulaki-Voutira, in Moustaka 1992, p. 873, no. 263; Poulsen 1993, pp. 161–162, fig. 1; Stewart 1993, pp. 150–157, figs. 25–26, and fig. 4 in the text; Aellen 1994, p. 214, no. 96; R. Cassano, in *I Greci in Occidente, Napoli* 1996, pp. 114–115, no. 10.1. For the race between Pelops and Oenomaus see Sarian 1986, p. 838, no. 107, plate 604; Triantis 1992, p. 695, no. 16, plate 412; Aellen 1994, p. 207, no. 40; Triantis 'Oinomaos' 1994, p. 20, no. 19; Triantis 'Pelops' 1994, p. 285, no. 26. For the rape of Persephone see Beschi 1988, p. 871, no. 313; Lindner 1997, p. 740, no. 38, plate 505.

[38] Hölscher 1973, pp. 179; Palagia 1988, p. 626, no. 4, plate 385; A. Goulaki-Voutira, in Moustaka 1992, p. 873, n. 262; Stewart 1993, p. 154, fig. 28; Aellen 1994, p. 214, no. 94.

[39] Rizzo 1925–26, fig. 6; Hölscher 1973, pp. 174–180, plate 14.1; Poulsen 1973, p. 161, fig. 2; Schefold 1979, plate III. 1; Stewart 1993, pp. 150–156, fig. 27; Cohen 1997, pp. 66–68, fig. 41 a; M. Lista, in *Alexandros* 1997, pp. 89–90, no. 3; Badian 1999, p. 79, fig. 6.2.

[40] Andronikos 1984, pp. 86–95, figs. 49–52; Moreno 1987, pp. 103–107, figs. 136, 195; Lindner 1988, p. 383, no. 104; Eberhard 1989; Moreno 1993, p. 108, fig. 12; Andronikos 1994, pp. 59–65, figs. 8, 14, 19, 21, 40, plates V, VII, VIII; Güntner 1997, p. 969, no. 213; Miller-Collet 1997, p. 85, fig. 1; Drougou, Saatsoglou-Paliadeli 1999, p. 53, fig. 71.

[41] Sismanidis 1997, pp. 35–60, plates 1–7, 14–29.

[42] Rizzo 1925–26, fig. 13; Fuhrmann 1931, pp. 271–276, attribution to Praxiteles' sons; von Graeve 1970; Hölscher 1973, pp. 14, 97, 122, 128, 137 (comparison between Alexander's wounded comrade in the mosaic and the dying Persian horseman in the right half of the battle on the sarcophagus), 189–195, plate 16; Schefold 1979, plate II. 1; Giebelmann 1982, p. 495; Messerschmidt 1989, pp. 82–87, plate 25.1; Moreno *Scultura ellenistica* 1994, pp. 98–108, figs. 89, 105–106, 128; Cohen 1997, pp. 35–36, figs. 20, 66; Saatsoglou-Paliadeli, figs. 3–4.

[43] Magi 1961, figs. 548, 550; W. Fuchs, in *Führer*, 1963, I, pp. 162–166, no. 219; Simon 1992, pp. 199–200, no. 7, plate 95; Spinola 1996, pp. 69–71, no. 2, fig. 9; *Bildkatalog*, 1998, II, p. 9, no. 74, plates 62–79; Andreae 1998, pp. 213–229, figure on p. 215. For the similarity between the transfixed Oriental in the Alexander mosaic and the Laocoön see Conze 1877; Conze 1882, p. 902; Moreno *Scultura ellenistica* 1994, II, p. 634, figs. 769, 772.

[44] Rizzo 1925–26, fig. 7; Hölscher 1973, p. 123; Diebner 1979, pp. 12–19, 131–133, no. 23, plate 17; D'Henry 1991, p. 17, fig. 11; Poulsen 1993, p. 165; G. Calcani, in *Alessandro* 1995, p. 238, no. 30; Cohen 1997, pp. 63, 65, fig. 39.

[45] Körte 1916, p. 144, no. 5a.

[46] Mazzanti 1989, figure on p. 21. For the tomb of the Cutu, see Stopponi 1996, pp. 337–338.

[47] Körte 1916, p. 143, plate CXI. 1.

[48] Körte 1916, p. 143, plate CXI. 3.

[49] Körte 1916, plate CXI. 2; Galli 1921, pp. 69–70, fig. 34; Rizzo 1925–26, fig. 9b.

[50] Körte 1916, p. 144, plate CXII. 5; Galli 1921, p. 69, fig. 35; Rizzo 1925–26, fig. 9a.

[51] Hartwig 1898, plate 11; Rizzo 1925–26, fig. 8; Chase 1947; Comfort 1973, p. 807; Andreae 1977, fig. 23; A. Herrmann, in *The Search* 1982, p. 122, no. 45; G. Calcani, in *Alessandro* 1995, p. 240, no. 32; Cohen 1997, pp. 63, 65, fig. 38.

[52] Pallottino 1958, p. 589, fig. 770; Kaenel 1986, pp. 236–239; De Maria 1994, p. 357; Pisani Sartorio 1993, p. 193, fig. 47.

[53] Rizzo 1925–26, fig. 5 and plate on p. 529; Ruesch 1927; Fuhrmann 1931, p. 212, note 29, pp. 226–227; Bloesch 1943, p. 127, no. 45, plates 75–77; von Graeve 1970, p. 66; Hölscher 1973, p. 270, note 690. For doubts regarding its authenticity see Andreae 1956, plate II. 2.

[54] Gaebler 1935, p. 47, no. 3, plate XI, 26.

[55] Weitzmann 1959, pp. 105–107, fig. 113; Cohen 1997, pp. 64–66, fig. 40; Furlan 1997, pp. 15–16.

The Life and Works of Apelles

Ionian Origins

Apelles, the son of Pytheas, was born at Colophon in Ionia around 380 B.C. of a family linked to the local production of jewellery, where various individuals named Pytheas (Pliny, 33. 154) and Apelles (Athenaeus, *The Learned Banquet* 11. 480c) are referred to as goldsmiths.

Apelles trained in Ephesus with the painter Ephorus (*Suda*, s.v. Apelles), but as a historical figure and artist he became a Panhellenist: through the recognition of the leading schools and his activity at the court of Philip II, his son Alexander the Great and the latter's heirs, he experienced both classicism and its crisis, creating the style of painting that was to become universal with Hellenistic art.[56]

Sicyon

When Apelles arrived in Sicyon around 360 B.C. he was already famous and endowed with the gift for observation that characterized the Ionian science and art (Pliny, 35. 76). The choice of this city, which was the 'birthplace of painting' (Pliny, 35. 127) arose from the need for training that made the most of his gifts and, at the same time, gave him the opportunity to become part of an artistic milieu that was recognized in the whole of the Greek world: 'At that time the fame of the Sicyonian Muse was at its height, as was that of the supreme painting (*chrestographia*) that still preserved pure beauty, so that Apelles, already the object of admiration, came to present himself to these men and enrolled in their school for one talent, desiring to share in their fame as well as in their art' (Plutarch, *Aratus* 13. 1). His teacher was Pamphilus, who introduced arithmetic and geometry as the bases of art (Pliny 35. 75–76).

This youthful period was marked by the presence of a woman. The encounter took place in the nearby city of Corinth, where Apelles saw 'Laïs, still a girl, carrying water at the Peirene fountain' (Athenaeus 13. 588c). It is still possible to visit the spring today at the agora of Corinth; this was extended in the Imperial age, but the more ancient basins and the simple architecture forming the backdrop to the appearance of the beautiful water-bearer are still visible between the arches. In this regard, I would like to quote the description of Laïs by Alciphron (fragment 5), who recalls the hostility of the girls of Corinth (where sacred prostitution held sway) to this upstart, initiated into the secrets of love by Apelles: 'Unveiled, she appears to be neither too fat nor too thin […] her naturally curly hair is fair without being dyed and falls gently onto her shoulders, her eyes are round like the moon with the blackest pupils in the whitest of whites that you have ever seen'.

A portrait of a girl called Laïs was kept at Cyrene (Aelian, *Varia Historia* 12. 2; Clement of Alexandria, *Stromateis* 3. 447 C). The theme also inspired Jean Auguste Dominique Ingres to paint *The Source* (in the Louvre), a sensuous nude of a young girl carrying an amphora.[57]

In Sicyon Apelles worked with Pamphilus and his fellow artist Melanthius on a painting in honour of Aristratus (360–356 B.C.) representing the tyrant standing next to a chariot in which Nike is riding.[58] After the change in the city's regime, it was the recollection of such illustrious artists that made the decision to destroy the picture of the former leader all the more distressing: 'The work was worthy of admiration, because Aratus was fascinated by art, but, overcome by hatred for the tyrants, he ordered it to be destroyed.

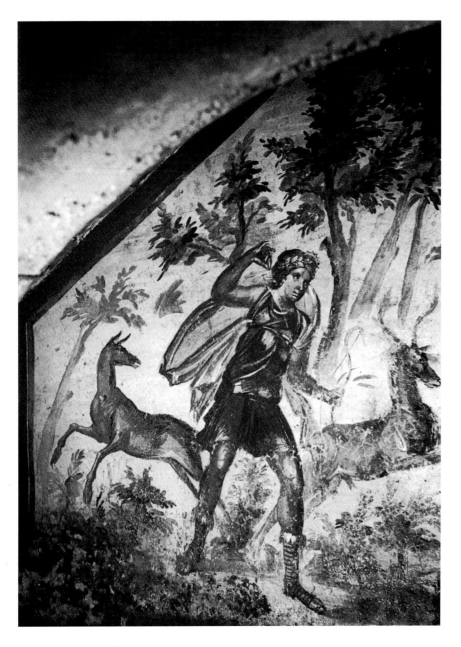

43. Artemis. Detail of Artemis hunting
and a nymph. Fresco deriving from
a painting by Apelles. Nymphaeum
of Via Lavenza, Rome

However, it is recounted that the painter Nealces, who was a friend of Aratus's, began to entreat him and weep. Unable to persuade him, he said that it was necessary to wage war on the tyrants, not their possessions: 'Therefore, let's leave the chariot and Nike, and I promise you I'll remove Aristratus from the picture.' Aratus allowed him to do this. Nealces eliminated Aristratus and painted a palm in his place, not daring to add anything else. But they say that, when he erased the image of Aristratus, he forgot to remove the latter's feet under the chariot' (Plutarch, *Aratus* 13. 2–3).

One of the themes that Pliny (35. 96) considered to be most successful may date from Apelles' period in the Peloponnese: 'Diana together with the choir of sacrificing virgins, with which it seems he has done better than Homer's lines describing the same subject'. This information is not totally correct, because, in the poetic vision to which Pliny refers, the goddess and her acolytes are not making a sacrifice, but are hunting wild animals. The real theme of Homer's account is the arrival of Odysseus, who has been shipwrecked, at the island of the Phaeacians. On the beach, Nausicaa, the young daughter of the king, is playing with her maids: 'Like Artemis shooting arrows she goes into the mountains, on lofty Taygetus or Erymanthus, delighting in wild boar and agile deer, and together with her play the rustic nymphs, the daughters of Zeus *aigiochos* — gladdening Leto's heart — and she rises above all of them with her head and brow; thus the indomitable virgin stands out amidst her maids' (*Odyssey* 6. 101–109).

Pliny has not made a direct parallel between the painting and Homer's poem, but has derived it from a Greek source, which he reveals to us by stating that the preference for that picture was expressed by the 'leading experts on art' (*peritiores artis praeferunt*). It appears that the writer confused the verbal form of *thyo* (with a long upsilon, in the metric quantity), which means 'throw oneself forcefully', with *thyo* (with a short upsilon), meaning 'to sacrifice'.[59] Thus, fully corresponding to the *Odyssey*, Apelles represented an animated hunt by Artemis and the nymphs, which is set in the Peloponnese where the mountains mentioned by Homer are situated. Furthermore, the painting was echoed in Rome by a fresco in the nymphaeum in Via Livenza, near the Via Salaria (figs. 43, 44).[60] With the addition of light blue and green, alien to Apelles' palette, the late Roman artist softens the tones in the distance with great skill. He displays familiarity with landscape and knowledge of the atmosphere in the theory of the *diaphanon* (transparency of the atmosphere), which was mentioned with re-

gard to the dust in the original painting on which the Alexander mosaic is based (plate I). This time it is from out of the mist that the sky gradates into the pink of dawn. Between the vegetation lost in the haze to the nearby foliage, which is given solidity with superimposed brushstrokes, trees and bushes emerge at different distances from the viewer. A pair of deer spring out of the woods in opposite directions; one is dark brown (the female, seen against the light), the other orange-brown (the male, reflecting the light of daybreak). After bounding into the clearing with her short red chiton and cloak billowing in the wind (fig. 43), the goddess comes to a halt, her body at an angle to the picture plane. Looking for all the world as if she were an apparition, she is holding a bow and, with the other hand, draws an arrow from her quiver. Since the light comes from behind, her shadow precedes her. A nymph skimmed by the light participates in this marvel (fig. 44); next to her is a roe-deer, which may provide the first evidence of the *nebros* (fawn) that Apelles painted, according to Aelian (*On the Nature of Animals*, epilogue p. 435).

The neutral form *nebros* in the passage from Aelian could of course also mean that the fawn in question is a female, which recalls another Peloponnesian myth treated by Apelles: the discovery of Telephus. Referring to the central figure of the composition, Pliny (35. 94) mentions a 'Hercules turning round' (*Hercules aversus*) that he had seen in Rome in the temple of Diana on the Aventine.[61] The meticulous copy executed in fresco shortly before the eruption of Vesuvius to decorate the apse of the basilica of Herculaneum reveals that the hero, seen three-quarters on from behind, was turning round to discover his son Telephus being suckled by a hind (figs. 15, 45).[62] This picture has already been mentioned because the way in which the heads are aligned in it is comparable to that in the battle scene (fig. 14). As happened with the painting of Gaugamela, the idyllic subject appears to have left implicit traces in literary tradition, both in Pliny's reference to Hercules alone and in the possible mention of the female fawn. In any case, the presence of the hind in the wall-painting makes it even more likely that this is a copy of Apelles' *Hercules aversus*. The subsequent display of the picture in the temple of Diana was determined by the mythical interpretation of Telephus's saviour as the hind sacred to the goddess.

In the painting from Herculaneum — which was removed when it was still in excellent condition and is now in the Museo Archeologico in Naples — the geometrical

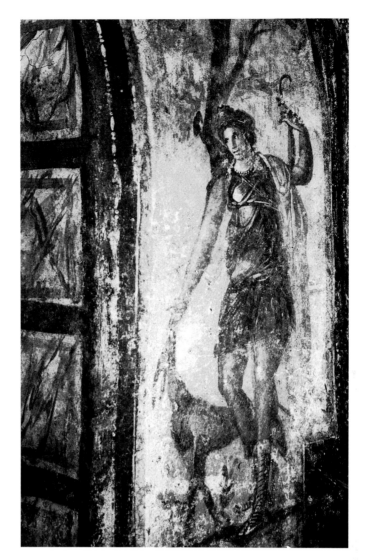

44. Nymph. Detail of Artemis hunting and a nymph. Fresco deriving from a painting by Apelles. Nymphaeum of Via Lavenza, Rome

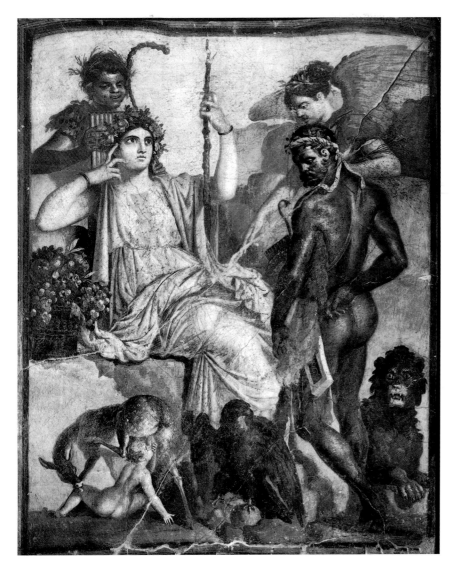

45. Heracles discovering Telephus, suckled by a hind, in the presence of Demeter, Pan and Parthenos, the personification of Mount Parthenion in Arcadia. Fresco, copy of a painting by Apelles displayed in the temple of Diana in Rome. From the basilica, Herculaneum. Museo Archeologico Nazionale, Naples

46. Heracles resting from his labours. Detail of the discovery of Telephus. Fragment of a moulded bowl from Puteoli. Albertinum, Dresden

schema of Sicyon may be recognized in the way the whole picture is divided into squares with their related diagonals. Thus it comprises a network of horizontal, vertical and oblique lines establishing links and contrasts between the animals, the child, the hero, the goddess and a figure that may be Parthenos, the winged personification of Mount Parthenion, where the story takes place. The axes of the disposition of the different elements on the picture plane guide the linear perspective. In the composition, which consists of eight subjects — without counting the Caravaggesque basket, symbolizing the fertility of the earth — the rocky ledges and the sequence of personages surrounding the seated figure of Demeter intervene in order to give credibility and breathing space to an assorted group. The horizontal division of this picture by means of steps of rock foreshadows the tripartition of the allegorical paintings devoted to Alexander. The lower band metaphorically illustrates the topography of the legend. It comprises, from the left, Telephus, being fed by the hind on Mount Parthenion, located on the southern edge of Arcadia; the eagle of Zeus, Heracles' father, symbolizing the god's Panhellenic sanctuary in Elis, on the western border of the region; the lion, associated with Nemea in the Argolid, the eastern neighbour. The animals and the infant are all situated on this rock platform. Heracles and Demeter occupy the lower register and the central one with their bodies, while their heads reach the upper band, which contains the heads and shoulders of Pan and Parthenos. This masterly disposition ensures that hero's head is on the same level as the goddess's, despite the different heights of the figures (fig. 15) — in accordance with the convention of isocephaly — thus allowing the relationship between the more distant elements to be highlighted. With an ear of corn, the winged girl draws Heracles' attention to the miracle of the hind in the lower left corner; the other diagonal aligns Pan's head with that of the goddess, then continues through her right leg and Heracles' left leg to the opposite corner of the picture. Every face and gesture is reflected in another area, either through close resemblance or because it is a mirror image, or else because of a simple gesture. Thus the different colours match or contrast with each other within the geometrical structure.

Heracles leaning on his club was also one of the subjects treated by Lysippus, who was active at the same time in Sicyon and was compared to Apelles by Synesius of Cyrene (*Epistles* 1). This Christian Neoplatonist, who became bishop of Ptolemais, referred to the rivalry between the two artists as an example of brotherly correction, as a

result of which the painter and Lysippus exchanged critical opinions about their respective drawings that were useful to both of them: 'It is, therefore, necessary to allow others to examine what we produce. Excessive goodwill towards a person prevents one from being objective in one's judgement of their work. So Lysippus took Apelles before his drawings and Apelles took Lysippus before his'.

In particular, *Hercules aversus* resembles the first representations of Heracles resting from his labours attributable to the sculptor: the Argos type[63] and the one known as Antikythera-Sulmona.[64] The chronology of the pictorial archetype is confirmed by the weary Heracles appearing on a Lucanian vase by the Primato Painter in the Museo Archeologico, Naples (fig. 47),[65] datable to around 345 B.C.: the hero faces a winged female figure (perhaps Nike) who has a similar hairstyle to the Parthenos in the fresco. The popularity of Apelles' picture after it was brought to Italy is attested by a fragment of moulded pottery produced at Puteoli (modern Pozzuoli) in the early Imperial age, now in the Albertinum in Dresden, with a view of Heracles from behind (fig. 46).[66] Lastly, the motif of Demeter in a pensive mood, her head supported by the fingers of her right hand, in the fresco from Herculaneum (figs. 15, 45), inspired Ingres — whose admiration of Apelles deriving from literary sources I have already mentioned — when he painted his portrait of Inès Moitessier seated, now in the National Gallery in London.[67]

A work that both excited Pliny's admiration and perplexed him (35. 96) may be related to a rare cult practised in a Peloponnesian sanctuary: 'He also painted things it is not possible to paint — thunder, lightning, thunderbolts — which are called Bronte, Astrape, Keraunobolia.'[68] Pliny's translation — *tonitrua, fulgetra fulguraque* — does not render the complete meaning of the Greek terms, which are feminine singular; in particular, *keraunobolia* means a 'storm of thunderbolts' taken as a whole. In Apelles' case they are the numina that were honoured at Trapezus in Arcadia — Astrapai, Thyellai, Brontai (Pausanias 8. 29. 2)[69] — where *thyella* (storm) is a suitable synonym for *keraunobolia*. On the other hand, it is quite possible that these meteorological personifications were merely part of a more complex composition and were considered in isolation from the predominant theme of a picture due to the fascination of the ideas, as happened regarding certain details of Telephus's infancy or in the battle of Gaugamela, which were apparently independent themes in Apelles' oeuvre. In this regard, the description of a painting (the artist is not specified)

47. Heracles resting from his labours and Nike. Lucanian red-figured nestoris. Primato Painter. Museo Archeologico Nazionale, Naples

showing the death of Semele, the daughter of Cadmus, is significant; it comprises not only anthropomorphic representations of Astrape 'flames flashing from her eyes' and Bronte 'in a strong image' (*en eidei skleroi*), but also 'fire blazing from the sky' (*pyr te rhagdaion ex ouranou*), the latter corresponding to Pliny's *keraunobolia*. Such were the manifestations of Zeus's majesty in the lost painting, and these were fatal to who was about to become the mother of Dionysus (Philostratus, *Imagines* 1. 14).[70]

Macedonia

The society that sustained the artistic production of Sicyon was not merely a community of citizens, but a vaster one that united with other the Greeks under the rule of a monarch. Painting was at the service of the sovereign and the support given by Philip to the aristocracy led to the accentuation of the allegorical tendencies that were intended to exalt the local rulers. In 343 B.C., when Philip invited Aristotle to become tutor to Alexander, Apelles was also at court thanks to the excellent relations he had with the native land of his teacher Pamphilus, who was born in Amphipolis and was a 'Macedonian by nationality' (Pliny 35. 76). Apelles thus played an important role in the transition from the system of schools linked to cities with ancient cultural traditions to that of artists working for king. Much more than Lysippus, who on this occasion maintained his own intellectual independence, Apelles helped to promote the art of the court and painted a large number of portraits of monarchs, as we have already seen in Pliny's comment (35. 93): 'It is superfluous to list the number of times Apelles painted Alexander and Philip.'

The salient features of Sicyonian painting at the court of the Argeads may be seen in the stag-hunt with a youthful Alexander and Hephaestion, reproduced in a pebble mosaic in the floor of one of the houses built around courts with peristyles at Pella (figs. 48, 49).[71] The *petasus* flying off the prince's head as a result of the violence of his gestures helps to reveal his identity by baring the characteristic *anastole* (hair thrown back from a central parting) and turning the hat, which in Macedonia was considered to be fit for kings, into a sort of halo behind his head. On the left is Hephaestion, armed with a double axe, the weapon used by Hephaestus, the god after whom the young man was named. Due to the effect of perspective, he appears to be taller than Alexander: although their heads are on the same level, Hephaestion is a little further away, making him appear to be well-built. A number of features distinguish this work from

48. Stag-hunt with Alexander and Hephaestion, copy of a painting by Melanthius or Apelles. Pebble mosaic. House with a peristyle at Pella

49. Stag-hunt with Alexander and Hephaestion, copy of a painting by Melanthius or Apelles, with a frame of acanthus scrolls attributable in the original to Pausias. Pebble mosaic. House with a peristyle at Pella

the output of the contemporary artists of the Attic school: the geometric control of the composition; sparing use of colour in the classical manner, with a range limited to white, yellow, red and black; the refined shading of tones in the *sfumato*; the attention paid to the organic articulation of each muscle and sinew. The Attic artists were less interested in the stereometric construction and formal theory, tending instead to hatch the shadows and use a wider variety of colours, and preferring landscape and narrative scenes.

Further proof that this is the work of a Sicyonian artist — also confirming the heroic character imparted to Alexander's hunting activity — is to be found in the schema of the two hunters and the stag used by Lysippus in three adjacent groups of Heracles' labours created subsequently at Alyzeia, in Acarnania, for Cassander. This is attested by the copy of Lysippus's bronzes in the frieze on the Corsini sarcophagus:[72] Alexander in the mosaic at Pella becomes the Lernaean Hydra's opponent; Hephaestion, his arms raised behind his head, has the same pose as the victor over the Erymanthian Boar; the stag itself is reproduced as a mirror image to represent the resistance of the Ceryneian hind.

The attribution to Melanthius of the hunt, a superb polyhedral structure, is based on the statement by Pliny (35. 80) that the painter was better than his fellow artist Apelles at composition (*dispositio*).[73] The existence of an archetype in the form of a panel painting is confirmed by a copy in Alexandria of the same subject in a mosaic showing Erotes hunting (fig. 50).[74] The fact that Aratus of Sicyon gave Ptolemy III numerous drawings and paintings by Melanthius (Plutarch, *Aratus* 12. 3) is another reason for assuming that the mosaic floor in Pella is based on a composition by this artist.

A different conclusion may be reached, however, by observing the inscription at the top of the mosaic: '*gnosis epoesen*' (fig. 48). It is generally believed that 'Gnosis' is the name of the maker of the floor; if this is correct, he is the first mosaicist known to us by name. A difficulty remains, nevertheless, with regard to the use of an abstract feminine term — 'knowledge' or 'skill' — as a personal, presumably masculine name. Moreover, the inscription is the only asymmetrical feature in the perfect equilibrium of the scene; it is not clear why such a skilled craftsman should have placed the verb so far to the right, making it necessary to interrupt it with Alexander's *petasus*. At the time of the discovery of the mosaics in Pella, the lacunae were partially filled in with pebbles of the same shape and colour as those used in antiquity, without this being mentioned when the works

50. Erotes hunting a stag. Mosaic deriving from the stag-hunt with Alexander and Hephaestion. From Shatbi. Graeco-Roman Museum, Alexandria

were published. It is, therefore, quite possible that the area at top left is a modern patch repairing damage that deprived us of the artist's name in the genitive case. In this case, although there would not be room for 'Melanthiou', there would be sufficient space for 'Apellou' (this could be shortened to 'Apelo'), a hypothesis that is favoured by the artist's presence at Philip's court.

Hence '[Apellou] gnosis epoesen' (made by Apelles' skill) would help us to explain the occurrence of the term gnome in anecdotes regarding Lysippus, an exponent of the same artistic milieu (Himerius, Exercises and Speeches 13. 1). The term gnosis is the first expression of one of the typical concepts of Apelles' aesthetic that Quintilian (12. 10. 6) translated as ingenium. The opposite term — apognosis (incapacity) — is used deliberately by Apelles for the limit to his ability, in the cases where 'fortune' compensates for the gnosis (Dio Chrysostom, Orationes, 63. 5). At this point, the hypothesis, advanced on various occasions, that it was Pausias who was responsible for the fantastic scroll decoration surrounding the scene (fig. 49), would be given credence by a fragment of an epigram on papyrus. Describing one of Apelles' paintings, this adds — with reference to a similar floral frame — that 'the painter of the flowers also deserves to be praised'.[75] Together with the acanthus scrolls, the mosaic is the same size as the original, a square 3.1 metres (about ten feet) across: the internal square is half the exterior one. The floral motif was clearly designed to accompany a vertical wall-painting: the plant sprouting from the lower left is leafier and thicker that the one growing out from above. The statuesqueness of the group of figures is created by the pose of the hunters at the moment of greatest tension as they prepare to strike their prey: having raised their arms, they are both about to deal the deadly blow. The stag itself is depicted as it instinctively draws back from the dog's attack. The secret that combines the vivid realism of the scene with the highest form of abstraction lies in the simultaneity of the actions and the choice of the propitious moment for the representation — the kairos — which was common to the aesthetic of Apelles and Lysippus,[76] and was represented by both artists with magic personifications, as we shall see in the painter's case (figs. 68, 69).

Ephesus

From the romantic discovery of Laïs, the painter proceeded to the privilege of the courtesan. When Alexander became king (336 B.C.), he ceded his mistress Pancaste of Larissa, his first companion, to Apelles who had desired her when portraying her nude (Aelian, Varia Historia 12. 34). Information regarding this work is supplied by Lucian (Imagines 7), when he refers to the ideal colouring for a woman: 'As far as the body is concerned, Apelles represents it — especially in the manner of Pancaste — not excessively white, but simply brightened by the blood (enaimos)'. The other side of the coin was to be found in the palace intrigues, with the hostility of the young Ptolemy, the son of Lagus (Pliny 35. 89), leading to the crisis that spurred the artist into painting 'Calumny' in Alexandria.

The Asian campaign (334–323 B.C.) gave Apelles ample opportunity to depict the historical effects that he had begun to illustrate in Macedonia with the portraits of Alexander before he ascended the throne. Like Lysippus, Apelles is mentioned by Plutarch (de Alexandri fortuna aut virtute II. 2) as being at Alexander's side at the beginning of the enterprise. He went to live in Ephesus, where he had begun his artistic career on his arrival from the nearby town of Colophon. He returned as the king's painter. This was a solemn investiture, unheard of in the city states of mainland Greece until the patronage of the Macedonians, but more usual in the cities of the Ionian coast, which were frequented by artists employed by the satraps.[77]

Cleitus the Black saved Alexander's life at the battle of the Granicus (May 334) and was portrayed, according to Pliny (35. 93), 'with his horse while he hastened to battle, and his armour-bearer handed him the helmet that he requested' (Clitum cum equo ad bellum festinantem galeam poscenti armigerum porrigentum). I have already referred to the probable presence of the nobleman in the picture of the battle of Gaugamela. Among the other Companions who distinguished themselves during the crossing of the Granicus was Neoptolemus, a prince of Epirus who died in 321 and was represented by Apelles 'on horseback against the Persians' (Pliny 35. 96).

After the victory, Alexander personally led the operations for the entry into Ephesus and took part in the 'procession (pompa in Latin, from the Greek pompe) of Megabyzus, a priest of Artemis in Ephesus'. This is the subject of a painting by Apelles (Pliny 35. 93) representing the allegory of the advance of the Greeks to the East, in accordance with Isocrates' presage (Philippus 182), which I have already quoted: 'resembling a holy mission (theoria) rather than a military expedition (strateia)'. Arrian (Anabasis 1. 18. 2) explains that, when sacrificing to the goddess, Alexander 'participated in the procession with all his troops under arms and in battle array'.

The king was also the subject of other paintings executed by Apelles in Ephesus. In one of these he was portrayed on horseback (Aelian, *Varia Historia* 2. 3): 'On seeing his portrait painted by Apelles in Ephesus, Alexander did not appreciate it, even though the painting was worthy of praise, but the king's horse, when brought before the picture, neighed at the horse depicted in it as if were real. Then Apelles exclaimed: "Sire, this horse seems to be much more expert than you in painting"'.

Without mentioning the participation of the king, Pliny (35. 95) refers to an 'experiment' that was carried out before the steed painted by Apelles when competing with other artists. Over the centuries, the work appeared to have kept and renewed its power to excite the horses that saw it. Apelles, however, only accepted the view that his works were true to nature when this regarded his pictures of animals. In the human figure, the aspiration after 'grace' led the painter's 'skill' — *gnome* or *gnosis*, as mentioned previously — to a mode of execution that was subjective in the Aristotelian sense, which Alexander did not always find convincing. The work in question may be the one depicting a horseman described eloquently by Dio Chrysostom (*Orationes*, 63. 4–5), the conclusion of which I shall examine later when returning to the detail of the horse's foam: '[Apelles] painted a horse that was not intended for work but rather for war; its neck erect, it reared with its ears pricked up and its eyes alight as it returned from battle. In its eyes it had the ardour of the gallop: its front legs were raised in the air, while the others only just touched the ground. And the rider reined in the horse, curbing its bellicose fury'.

The painter's influence is clearly perceptible in this heroic vision of the horseman, a theme that was treated at the same time by Lysippus in his bronze group commemorating the fallen at the Granicus. Once again the exchange of ideas between the two artists of the Sicyonian school led to similar results: in both the sculpture and the painting the combatant was riding a rearing horse.

No less famous is the painting in which Alexander is *keraunophoros*, 'bearing a thunderbolt' (Plutarch, *de Alexandri fortuna aut virtute* II. 2). This is a reminder of Apelles' ability to represent celestial phenomena, and directly corresponds to Callisthenes' admission that the thunderbolt could be related to Alexander (Eustathius, *Commentary on Homer's Iliad* 13. 26–30; Polybius 12. 12b. 2–3). Callisthenes, however, limited the concept to Alexander's divine descent, subsequently rejecting — at the cost of his life — full apotheosis with the consequence of *proskynesis*

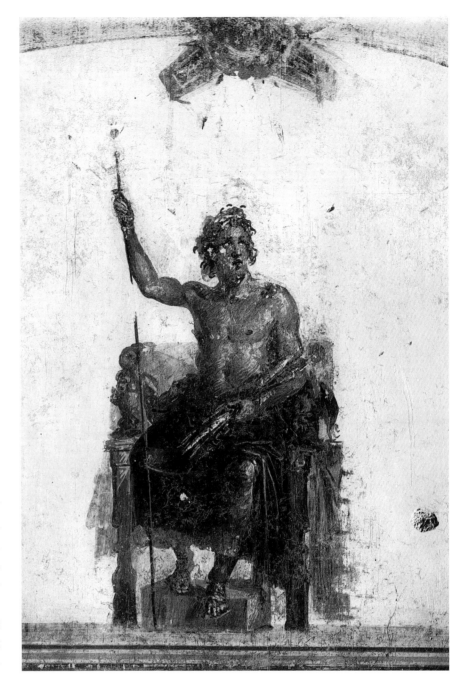

51. Alexander as Zeus enthroned. Fresco, copy of a painting by Apelles in Ephesus. House of the Vettii, Pompeii

52. Bust of Alexander in a tondo.
Repoussé silver. From Marengo.
Museo di Antichità, Turin

53. Wedding of Alexander and
Stateira as Ares and Aphrodite.
Fresco from the House of the Golden
Armlet, Pompeii. Antiquarium,
Pompeii

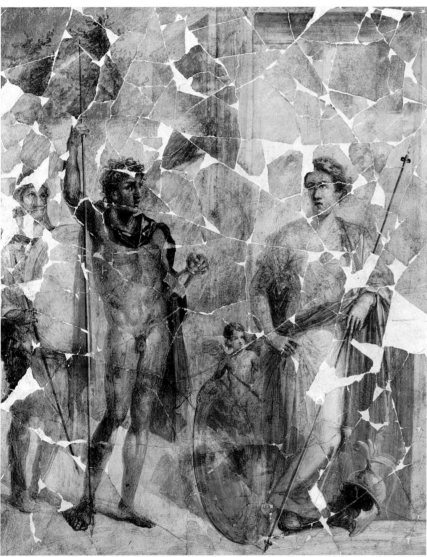

(hierarchical prostration before a superior), imposed not on-
ly on those who had practised it before the king under Per-
sian rule, but also on the Greeks.[78] Evidently Apelles care-
fully selected the aspects of Alexander that he wished to
portray: he did not represent 'his virility and leonine char-
acter' but rather 'the inclination of his neck and the charm
and liquidity of his gaze'. In particular, 'depicting him hold-
ing a thunderbolt, he did not reproduce his colouring, but
made him darker and more sunburnt' (Plutarch, *Alexan-
der* 4. 3). The effect was certainly not the result of the artist's
lack of skill, but was produced by the glaring light: 'The
toes seem to protrude, and the thunderbolt appears to pro-
ject from the picture' (Pliny 35. 92). Apelles' intentional dis-
tance from the sitter is stressed by Plutarch: 'He painted
Alexander holding a thunderbolt so forcefully and vividly
that one could say that, of the two Alexanders, Philip's son
was invincible, but Apelles' was inimitable' (*de Alexandri
fortuna aut virtute* II. 2).

This masterpiece, dedicated in the temple of Artemis
in Ephesus, is known to us thanks to a small copy discov-
ered in the House of the Vettii in Pompeii; the picture is
surmounted by a trophy of arms suspended from the curved
frame (fig. 51).[79] Seated on a foreshortened throne, the fig-
ure is not perfectly frontal. The distribution of the planes
gives emphasis to Alexander's youthful impatience: his left
leg is brought forward, the other is bent, so that, under his
cloak, his knees are seen to be divaricated; his torso is turned
towards his right and his right hand is holding up the scep-
tre, which rests on the floor in the foreground; his lowered
left hand grips the thunderbolt, which extends the diago-
nal of his forearm to the centre, while his head is tilted up-
wards, his gaze projecting the disquieting composition in-
to the distance. This apotheosis is the result of the fusion
of elements characteristic of the king inspired by Zeus —
as Lysippus portrayed him on the same occasion — with
those of his self-identification with the god. Symbols that
are both regal and divine include the footstool, the throne,
the sceptre, the purple cloak and the crown of oak leaves.
The thunderbolt held in his hand is a godly attribute, while
the tilting of his head and the upward gaze represent the
conjunction between human and celestial power. With 'skill'
and 'grace' Apelles has made use of the deformity of Alexan-
der's neck to express his attraction towards the heavens and
allowed the flash of lightning to disguise the excessively light
colouring of his skin, which 'reddened above all on his chest
and face'. The touch of the Pompeian fresco-painter, ex-
ploiting the white of the plaster to obtain the transparen-

cy of the colours, reproduces, down to the king's clear eyes, the fascination of the original. Pliny's observation are confirmed by the thunderbolt placed obliquely on his lap, projecting from his knees, rendered with the white and yellow contrasting with the purple — 'fulmen extra tabula esse' (the thunderbolt appears to project from the picture) — and by the toes of the left foot reflecting the flash from above, which immediately attract the spectator's attention with highlights causing them to stand out against the sandal: 'digiti eminere videntur' (the toes seem to protrude). The classical organicity is jeopardized by the emphasis placed on the illuminated detail. The highlights (*splendor*), which Pliny (35. 29) describes as being the latest revolution in painting, have been added to the plastic function of perspective and of the colour and light perfected in Sicyon by Melanthius and Pausias. Thus the source of light is represented in the picture together with its reflection on objects and in the figure. The equivalent Greek terms — *lampron* or *stilbon* — are associated with the lustre of gold in a technical treatise by Aristotle or Theophrastus (*De coloribus* 3. 793a. 13–15, 5. 794b. 19–795a. 28). This innovation was introduced despite the sparing use of colour that has already been mentioned in connection with the stag-hunt in a mosaic in Pella (fig. 48) and was a distinctive feature of the Sicyonian school. With regard to Alexander and the thunderbolt, it is worth repeating Pliny's comment: 'The reader should bear in mind that all those works were painted by Apelles with just four colours.'

The skilled techniques to which I referred when discussing the original painting on which the Alexander mosaic is based (plate I) — colour glazes and the transparency of the final coat of varnish — allowed the artist to express every nuance of Alexander's inner life and interpret his remarkable character in those troubled times (fig. 51). The papyrus that I quoted with regard to the frame of the stag-hunt in Pella (fig. 49) contains an interesting reference to a 'daimon' in the main picture: this is the power that captivates the spectator with the representation of the utmost potentialities of the human spirit. It was for the *keraunophoros* that Apelles asked for, and obtained, the payment of twenty talents 'in gold coins, sufficient to cover the surface of the picture, not by number' (Pliny 35. 92). This price vividly illustrates the economic power of Alexander's dominion and the investment that political propaganda through persuasive images demanded.

It is difficult for us to imagine a world in which the artist is required to deify his patron in his portraits, and,

54–55. Warrior and his bride as Ares and Aphrodite with Eros. Apulian red-figured lekythos, by the Lampas Painter. Private collection, Berlin

at the same time, be on friendly terms with him. The relationship between Titian and Charles V — and, because of its similarity to the picture of Alexander on horseback mentioned previously, how can we ignore the glittering equestrian portrait of the emperor in the Prado? — helps to explain the origin of an anecdote still recounted in the Renaissance: the visit to the studio of which popes and princes were the protagonists. The lives of the artists as a literary genre originated in the Peripatetic school, which was not well-disposed towards Alexander, who was responsible for the death of Callisthenes, a relative of Aristotle's. The king's reputation was hardly improved by such episodes as the previously mentioned one in which his artistic expertise was compared unfavourably with that of Bucephalas. But, while it is useless to try to verify their historical veracity, they retain the authenticity of the Ionian spirit, the grace (*charis*) perceived by Apelles not only as an aesthetic ideal (Pliny 35. 79), but rather as a way of life, in contrast to Melanthius's severity, but probably closer to Pausias's amiability: 'Apelles also had grace, which was why Alexander, who frequently came to his studio, was fond of him [...] but when the king began to show his ignorance about painting, Apelles persuaded him to keep quiet, saying that otherwise he would make the boys who ground the colours laugh' (Pliny 35. 85).

The Orient

In my reconstruction, I have hypothesized that the picture of the battle of Gaugamela was executed soon after the event (1 October 331 B.C.) and in correspondence with the height of Apelles' career, which Pliny (35. 79) dated to the period 332–329. In addition to the portraits the artist had already painted, there was the picture of himself inserted in the battle, according to the epigram quoted previously (*Greek Anthology* 9. 595). I have already investigated the intriguing psychological, historical and poetic implications of the first known self-portrait of an artist (see p. 38 and plate XII). For similar reasons, in antiquity importance was given to the portrait of a contemporary artist, Habron (whose works also comprised allegories and pictures of deities), painted by Apelles; the picture was kept on Samos (Pliny 35. 93) in the sanctuary of Hera, which Strabo (14. 1. 14) considered to be a splendid 'picture gallery'.

Another member of Alexander's circle was the Menander that Pliny (35. 93) indicated as the 'king of Caria' — he was, in fact, the satrap of the neighbouring region of Lydia — and about whom we only have information relating to the period from 327 to 321. Apelles' painting of Menan-

der was in Rhodes, where it is recounted that the artist stayed for a brief period and made contact with Protogenes. 'Archelaus with his wife and daughter' may be identified as the *strategos* who was the son of Theodorus and governor of Susa under Alexander, and then became the satrap of Mesopotamia (Pliny 35. 96). Antaeus was the father of Leonnatus, who distinguished himself in India at Alexander's service and died in 322 (Pliny 35. 93). Echoes of this portraiture are to be found in the varied quest for a social, psychological and moral identity in which contemporary Apulian vase-painters, such as the Darius Painter and his followers, were engaged with an array of figures typical of large-scale painting: dynasts, princes, warriors, family members, messengers, guards and servants.

I have already referred to the affinities with regard to Gaugamela in the iconography of the battle on the Hydaspes (326 B.C.) attested shortly afterwards on the decadrachms (fig. 16). We are also familiar with the scenes of Alexander's second and third weddings in Susa in 324: the copies of the two paintings were detached from the walls of one of the triclinia in the House of the Golden Armlet in Pompeii (figs. 53, 58). The room was decorated in Nero's reign by painters close to those who had worked in the House of the Vettii, where the Alexander as Zeus was found.

As in the battle of Gaugamela (plate I), the natural setting of Alexander's marriage to Stateira[80] is indicated by a tree behind the king (fig. 53). The dramatic physiognomy, framed by a tiara, of the guard in Oriental costume is similar to that of the warrior, facing in the other direction, who is curbing the frightened horse in the centre of the battle scene: they both belong to the corps of the *melophoroi*, the guards of the Achaemenid sovereigns, reconstituted in Susa by Alexander (Phylarchus, in Athenaeus 12. 539e; Aelian, *Varia Storia* 9. 3; Polyaenus, *Strategemata* 4. 3. 24). In this festive painting, the artist has adopted the theatrical convention of following the king with a lance-bearer, a silent supernumerary indicating the bridegroom's rank. Alexander has the long sideburns that are visible in the battle with Darius. His gilded helmet of the Chalcidian type, adorned with a plume, is lying on the ground, as it was on the field of Gaugamela. The contrast between a sunburnt face and a pale one (in this case, between the faces of Alexander and the Oriental), occurred twice in the picture of the discovery of Telephus (Pan and Demeter; Heracles and Parthenos), so that it may be regarded as one of the artist's stylistic effects (figs. 15, 45). Lastly, as regards the pose, the drapery and the way the head is turned, the upper part of the fig-

ure of Stateira resembles a portrait of Kairos in a mosaic from Baalbek (fig. 69), while the pillars and architraves suggest the pavilion built at Susa for the ceremony with which ninety-two Macedonian nobles married Persian women, according to Chares of Mytilene's account (Athenaeus 12. 538b–539a).

The king stands self-assuredly, his raised right arm holding his lance with its ferrule downwards. His purple cloak leaves the front of his barefoot body naked, exalting the monumentality of his physique, as if it were in a niche: Apelles was renowned for a 'naked hero, a painting with which he challenged nature itself' (Pliny 35. 94). The effect of the drapery behind his back may also be admired in the image of Alexander as Zeus — although he is wearing a cuirass — on the obverse of the decadrachms issued by Alexander in Mesopotamia (fig. 57),[81] the reverse of which we have already examined with regard to the duel with Porus (fig. 16).

By contrast, Stateira leans relaxedly against a pillar, echoing the Aphrodite of the Gardens sculpted by Alcamenes. Looking towards the bridegroom, she returns his passionate gaze. Above her yellow chiton, so thin that it is almost transparent, her himation falls over her left arm and, on the other side, is drawn up around her waist. Diverging from the verticality of the lance gripped by the bridegroom, Stateira holds obliquely her father's sceptre, the symbol of Persian rule that the princess is about to consign to the monarch who has conquered it with the lance. This is the wish her father had previously expressed in a vain attempt at conciliation: at the end of the siege of Tyre (July 332), Darius had offered Stateira in marriage to Alexander together with the cession of the lands already occupied (Quintus Curtius Rufus 4. 5. 1). In accordance with Oriental tradition, the woman plays an important role in the family and dynasty by transforming the inheritance into natural succession, resolving the conflict of power with a bond legitimated by blood and keeping the sovereignty alive after the defeat and death of the king. As in Herodotus's account (1. 7–14) of how Gyges succeeded King Candaules, the power passes through the woman together with her person: the kingdom and femininity are inseparably linked. It is the Persian world that the artist reconstructs — as he did in the picture of the battle of Gaugamela to a certain degree — giving the historical event a fantastic setting. The light blue of the himation, a splendid complement to Alexander's purple, recalls Aphrodite's epithet 'Uranian', crowning the earthly rule of the lance with the celestial di-

mension of the bride elect. Between bride and bridegroom, Eros holds his bow in his left hand, while with his right hand he holds up the shield that completes the panoply of Ares pacified.

Like the battle of Gaugamela (figs. 17–20), the hierogamy of Susa immediately became a source of inspiration for the Apulian vase-painters. A lekythos by the Lampas Painter (private collection, Berlin), shows a warrior as Ares in the pose of Alexander opposite his bride in the guise of Aphrodite, with Eros in the middle (figs. 54, 55).[82] The schema of the standing sovereign with the same position of the legs, gestures, fall of the cloak and turn of the head is found in the cuirassed figure of Titus next to his brother Domitian on the sestertii of Vespasian (fig. 56).[83] Alexander is portrayed as himself with a hint of his sideburns in a piece of the Marengo Treasure (North Italy), datable to the reign of Lucius Verus, in the Museo di Antichità in Turin: worked by the repoussé method, the silver bust fits into a tondo.[84]

Returning to the triclinium of the House of the Golden Armlet, opposite the painting of the wedding of Alexander and Stateira is another one representing the wedding of the king as Dionysus to Parysatis as Ariadne set in a rocky landscape in accordance with the rites of the *thiasos* (fig. 58).[85] The small construction in the foreground recalls the labyrinth of Crete, while the ship setting sail in the distant harbour is a reminder that Ariadne was abandoned by Theseus on the island of Naxos. Instead of the Oriental who appears in the background of the wedding with Stateira (fig. 53), the couple are watched by Silenus, who is holding a thyrsus (wand) and tympanum (hand drum) just as if they were a lance and shield, thus confirming the original similarity of the subjects. Among the first manifestations of Alexander's divine character there was a Dionysian component, linked to the Argeads' descent from the god himself (according to a myth regarding the origins of Heracles' wife, Deianira) and accentuated by the orgiastic practices of the king's mother, Olympias. In this final period of his reign, Alexander king held a Bacchanal after he had survived the march across the desert of Gedrosia and Carmania, in imitation of the god's return from India; this was the subject of a posthumous painting by Apelles.

In this fresco, Alexander as Dionysus reclines languidly, his right arm folded behind his head. His thyrsus — tilting in the opposite direction to Silenus's — dominates the centre of the picture (like Stateira's sceptre in the other painting). The king has just put it down in order to give vent to

58. Wedding of Alexander and Parysatis as Dionysus and Ariadne. Fresco from the House of the Golden Armlet, Pompeii. Antiquarium, Pompeii

59. Dionysus and Ariadne. Terracotta figurine from Myrina. Louvre, Paris

60. Reclining Dionysus. Detail of an initiatory scene. Fresco. Villa of the Mysteries, Pompeii

his amorous instincts: with his left hand he fondles his bride's right breast. He has a crown of vine leaves in his tousled hair, his mouth is half-open with full lips and his watery eyes roll drunkenly: Apelles was well able to represent the 'liquidity' of Alexander's gaze (Plutarch, *de Alexandri fortuna aut virtute* II. 2), as may be seen in the painting in the House of the Vettii (fig. 51). The king's purple cloak, spread out abundantly over the rock seat, covers his left leg and hips and envelops his raised forearm, thus forming a screen against Silenus's penetrating gaze (fig. 58).

In these amatory circumstances the princess has the grace of an *Aphrodite Pudica*: her right hand grips her wooer's wrist, offering weak resistance to his advances and, in effect, showing her acceptance. Blown open by the wind buffeting this epiphanic prodigy, the himation conceals only her pubic area with a hem held in the woman's left hand. This is evidently a derivation from the drapery of an Aphrodite in Attic painting, reproduced on a lekythos dating from around 400 B.C. in the Antikensammlung in Berlin,[86] and corresponding to the statue type known as the *Venus Felix*.[87] The success of the new standing figure of Ariadne may, in its turn, be judged by the resulting innovation in Athenian vase-painting: a calyx-krater in Berlin shows her nude behind Dionysus.[88] Alexander's pose is also found in a Hellenistic terracotta figurine from Myrina, now in the Louvre (fig. 59),[89] and in the frieze of the Villa of the Mysteries, painted around 60 B.C., when the resemblance of Ariadne to Aphrodite fuelled in private the exaltation of a mortal: the lady of the house was an initiate into Bacchic rites (fig. 60).[90]

In the wedding of Alexander and Stateira human joy is kept in check by the ceremonial nature of the occasion, while love is contained by reasons of state; the equilibrium of the composition enunciates the solemnity of the rite, where Ares and Aphrodite are joined in matrimony by Eros (fig. 53). In the nuptials with Parysatis, the combination of elements peculiar to Ariadne with those typical of Aphrodite is indicative of the artist's desire to intensify the metaphor and go beyond the conventions of the myth thanks to the unprecedented nobility of his style (p. 58). Parysatis, Ariadne and Aphrodite rolled into one is the acme of 'divine agreement' (*homoiesis thoi theoi*) and, since it is perfect, it has no future. It is the supreme consummation of time, the tension on the final crest. Susa marks the conclusion of earthly and mythological symbols, the fulfilment of an inimitable life, the final festivity that leaves nothing behind and cannot return.

After Hephaestion's death, in Babylon the excessiveness of Alexander's tasks manifested itself, especially as they were now swollen by the extent of his dominions and the immense economic power accumulated with the treasures of the Orient. The art of Apelles, Lysippus and Pyrgoteles appears to have been overwhelmed by these exorbitant plans. Stasicrates, a native of Bithynia, 'showed his contempt for the portraits of Alexander, whether they be painted, sculpted or engraved, considering them to be the work of petty, mean-spirited artists' (Plutarch, *de Alexandri fortuna aut virtute* II. 2). And it was Stasicrates who, 'when he met Alexander on a previous occasion, told him that, more than any other mountain, Mount Athos in Thrace was suitable for modelling in a human form [...]. Alexander did not agree to this proposal, but having devised more extraordinary and costly projects than this, he spent hours making plans with the artists' (Plutarch, *Alexander* 72. 8). Alexander rejected Stasicrates' original project with the apparently moderate suggestion that he should 'leave Athos where it is; it would be sufficient as a monument to an arrogant king'. Then his remarks regarded very different horizons: 'I, on the other hand, shall be represented by the Caucasus, the Hamodos range, the Tanaïs and the Caspian Sea; these are the images (*eikones*) of my exploits' (Plutarch, *de Alexandri fortuna aut virtute* II. 2). He was now confident that he could give a rational mould to the inhabited world: the oecumene became Alexander's image. This was a bold vision, interpreted by Apelles in a portrait of Alexander as Zeus in which the throne and the sovereign's feet rest on the globe. This work is known to us thanks to a stucco dating from the Flavian era, now in the Vatican Museums, that was detached from a columbarium beyond the Porta San Sebastiano (fig. 61).[91] The longhaired young man with a sceptre and thunderbolt resembles the sitter in the portrait originally in Ephesus (fig. 51). The arrangement of the legs is the same, while the position of the arms and the tilted head is inverted; in the lower part of the composition are seated Poseidon and Heracles. The former resembles the seated Poseidon appearing on Roman coins minted in Corinth, possibly deriving from the image of the god fashioned by Lysippus in that city;[92] the latter is the pensive hero that the Sicyonian sculptor executed as a colossal statue for Tarentum.[93] These are arguments in favour of assigning the original painting on which this work is based to Apelles, especially in view of the exchange of ideas between the two artists belonging to the Sicyonian school that has already been mentioned with regard to the finding of Telephus (figs.

61. Alexander as Zeus on the globe, between Heracles and Poseidon. Stucco. From the columbarium beyond the Porta San Sebastiano, Rome. Antiquarium Romano, Museo Gregoriano Etrusco, Vatican

62. War-elephant. Detail of the interior of an earthenware dish, made in Latium. From Capena. Museo Nazionale di Villa Giulia, Rome

15, 45), the stag-hunt (figs. 48, 49) and the battle of the Granicus.

The exaltation of world power is a feature that the allegory in the Vatican Museums has in common with the statue of Alexander holding a lance that Lysippus made in Ephesus as a challenge to Apelles' first *keraunophoros* ('bearing a thunderbolt').[94] In an epigram written not long after the events, Asclepiades has the bronze sovereign say 'I place the earth under me' (*Greek Anthology* 16. 130. 4). The globe revives, in Alexander's ideology, Aristotle's demonstration of the sphericity of the earth (fig. 61). We know that the king intended to circumnavigate Africa: thus, while the rule over the Ocean implies the control of the continents embraced by those waters, Poseidon and Heracles symbolize, in their attitude of meditative subordination, Alexander's dominion over sea and land respectively.

That the influence of the art of Alexander's court was extremely widespread is demonstrated by the mythological and allegorical compositions accompanying the reproductions of the battle of Gaugamela on Apulian vases (figs. 17, 18), while the reasons that have already been discussed in this respect concerning the earlier Persian Wars (figs. 20, 21) are also pertinent here. Between Alexander's return from India in 324 and his death in 323, the subjects chosen by the Darius Painter manifest the adhesion of the Tarentine government to the king's western programme: the fact that the two vases in the Museo Archeologico in Naples showing the battle come from a tomb at Ruvo di Puglia, in the Peucetian hinterland, proves that this vision was accepted in the dominions adjoining Tarentum, which had now sided with the Greeks as a result of the prudent diplomatic missions sent by the Mediterranean peoples to Babylon shortly before Alexander's death in June 323.

On Alexander's Death
In the winter of 322 B.C., Philip III Arrhidaeus, Alexander's half-brother and heir, had concluded the preparation of the magnificent funeral carriage to be used for the transport of his predecessor's body in Egypt. According to Diodorus Siculus (18. 26–27), around the catafalque there were: 'four painted panels, parallel and equal to the sides. Of these, the first represented a chariot in embossed metal where Alexander was seated, a singular sceptre in his hand. Around the king was an armed guard of Macedonians and another of Persians, their lances adorned with a pommel (*melophoroi*); in front of these were the bearers of Alexander's weapons. The second panel showed the war-elephants

following the escort as they advanced carrying, at the front, Indian mahouts and, behind them, Macedonians armed in their usual manner. The third panel depicted troops of cavalry drawing up in battle order. Finally, on the fourth one were ships ready for battle'.

The lure of the exotic, which I have already touched on when describing the Alexander mosaic, has been added to the victory procession painted by Apelles in Ephesus. After Alexander's death, the story becomes a mystery. The singularity of the 'sceptre' suggests that it may be a thyrsus. The elephants are an important element in the allegory of Alexander as Dionysus returning from India; there is one, surmounted by a turreted howdah, in a tondo painted on the bottom of a shallow dish (in the class known as *pocola*), produced in Latium shortly afterwards, now in the Museo Nazionale di Villa Giulia, Rome (fig. 62).[95] Making use of four colours, the vase-painter gives free rein to his imagination by showing the female elephant followed by her calf, which is attached to her tail with its trunk. This detail suggests that this scene is inspired by Apelles' military procession rather than a battle. The cavalry drawing up are part of the *theoria*, as in the Panathenaic processions in the frieze of the Parthenon. The ships allude to the conquest of the Ocean, when the fleet parted from the army in the Indus delta and sailed to Mesopotamia under the command of Nearchus of Crete.

When the king's body reached Egypt, a precious legacy for the future dynasty of the Ptolemy, the theme of the 'return' of Alexander across the desert of Gedrosia and Carmania — represented as the triumphal progress of Dionysus's *thiasos* after his victory over the Indians — met the favour of the inhabitants of Alexandria, who venerated the founder of the city as if he were a young god. Thus Alexander's journey back from India was to become the model for the procession that each of the Ptolomies staged when acceding to the throne. Elements of this splendid display were then absorbed by the Roman triumph of the Republican era. In 29 B.C., after the death of Cleopatra, the paintings were brought to Rome by Octavian. The figures of Polemos (War)[96] and Oistros (Furor), who appeared pacified by Alexander in his chariot, inspired Virgil (*Aeneid* 1. 293–296) in his presage of the Augustan peace: 'The terrible doors of *Bellum* (War) will be shut tightly with bars of iron and, confined within, cruel Furor sitting on barbarous weapons, his arms bound behind his back by a hundred bronze fetters, will fret horribly with his bloody mouth.' The last detail suggests that Apelles — as in the picture of

Artemis the huntress (figs. 43, 44) — is interpreting Homer: 'the great mouth of bitter Polemos' (*Iliad* 10. 8); 'lowered himself into Polemos's bloody mouth' (*Iliad* 19. 313). Nor should we forget the motif of the ruddy foam that the painter had treated both in the case of the dying horse in the battle of Gaugamela (plate X) and in that of the steed wearied by battle on which Alexander or one of his valiants rode.

The Latin *Furor* may be translated by the Greek *Oistros* (literally, the gadfly, which stings man, driving him into a frenzy) according to the equivalence explicit in the literary tradition: in the words of Paulus Diaconus (*Epitome of Festus* 213. 1), 'Oestrum furor Graeco vocabulo' (*Oistros* is the Greek word for *furor*). Contemporary with Apelles' work, is a striking image, accompanied by the inscription *Oistros*, on an Apulian vase, now in Munich, by the Underworld Painter.[97] Partially wrapped in a cloak, with long wavy hair and torches in his hands, he rides in the chariot drawn by dragons that will allow Medea to flee after the killing of her children; dominating the whole scene, this image confirms the immediate impact of Apelles' motifs on the South Italian vase-painters.

After Virgil's death in 19 B.C., the paintings that had decorated Alexander's catafalque were used to adorn the forum of Augustus (completed 2 B.C.), 'in the busiest part' of this complex (Pliny 35. 94). Servius (*Commentary on the Aeneid* 1. 294) illustrates Virgil's poem with a visual experience: 'For those entering the forum of Augustus, on the left is the personification of Bellum, and Furor sitting vanquished on the weapons in the attitude described by the poet'. Like the early painting showing Aristratus at Sicyon, also this eulogistic work of Apelles' maturity was destined to be modified. During his principate, Octavian had avoided behaving like a monarch, and the frequent references to Alexander concerned, above all, the ideology of dominion over the known world. After the process of apotheosis of the emperors and the consolidation of the Julian dynasty, the identification of the lord of Rome with the deified sovereign seems to have been justified. Claudius, in fact, had Alexander's head in the paintings replaced with that of Augustus. Next to the temple of Mars Ultor, which dominated the square, in the hall formerly housing the colossal statue of the emperor there are still today the marble frames that surrounded the huge square paintings.[98]

That it was Apelles who immortalized the sovereign's last pomp and splendour may be deduced from the fact that Pliny (35. 27) referred explicitly to 'Alexander triumphant in his chariot', a work by Apelles in the forum

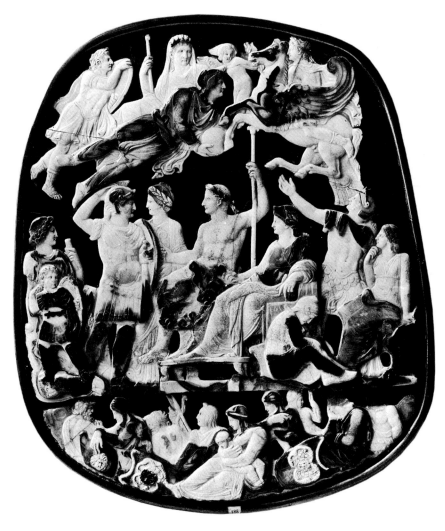

63. Grand Camée de France showing the apotheosis of the Julio-Claudian dynasty. Sardonyx cameo. Cabinet des Médailles, Bibliothèque Nationale, Paris.

of Augustus, which was the first of the panels mentioned by Diodorus Siculus. In this forum, the writer had, moreover, seen a picture by the same artist portraying Alexander as the son of Zeus with the Dioscuri (Pliny 35. 93). In this case, when the sovereign's face was changed into that of Augustus, the citizens of Rome decided that the two divine brothers were, in reality, Gaius and Lucius Caesar, the grandsons designated as heirs to the throne, but who died before the emperor.

Apelles' paintings for Alexander's funeral had a decisive role in the iconography of the apotheosis. In this respect, it is worth observing the Grand Camée de France, in the Bibliothèque Nationale in Paris; this is sardonyx carved with a scene glorifying the Julio-Claudian dynasty (fig. 63).[99] At the bottom, in the rounded area — as in the exergue of a medallion — is the crowd of prisoners, prostrate and sorrowful. In the central area Tiberius is seated with other members of his family. At the top the genius of the *gens Iulia* accompanies Augustus and the deified personages. The schema is the one inspiring the principal scene on the volute-krater of the Persians (fig. 64),[100] from which the Darius Painter derives his conventional name; reference has been made to him on various occasions for his vase-paintings deriving from large-scale works of art. Here, too, there are three registers, as in the cameo (fig. 63) and the kraters reproducing the battle of Gaugamela (figs. 17, 18). In the lower band are the subjects paying a tribute; in the middle one, Darius the Great on the throne with his son Xerxes and other historical figures standing or sitting; at the top, deities and personifications, including Apate (fig. 65), who will be compared later with Apelles' Calumny. Despite the intervening centuries, the Tarentine vase-painter and the Roman engraver were inspired by the same models: the large celebratory paintings devised by Apelles at Alexander's and Philip III Arrhidaeus's courts.

Alexandria

After his paintings had reached Egypt together with the royal coffin, Apelles himself landed there involuntarily as the result of a violent storm (Pliny 35. 89). In the biographical tradition, the whole of the artist's visit to Alexandria was characterized by danger and misunderstanding, as if the painter had conveyed to his first biographers, in the circle of Antigonus Monophthalmos, his dislike for Ptolemy I, which had been deep-rooted since they were all at Alexander's court. The artist turned up at the palace with an invitation that had been artfully sent to him by his 'imitators'

through the court jester, without previously consulting the king. Such was the fame of the animosity between Apelles and Ptolemy that the courtiers counted on an incident that would be deleterious for the guest. Apelles 'came to dinner, and when faced with the anger of Ptolemy, who showed him his stewards so he could identify the one who had invited him, he took a piece of spent charcoal from the brazier and drew his picture on the wall, and the king recognized the jester's face at once' (Pliny 35. 89). This is certainly not a marginal episode in such an illustrious career. In fact, Apelles' ability to obtain accurate likenesses through caricature places him at the origin of the grotesque production (*grylloi*) that established itself at Alexandria with Antiphilus, the rival to whom Pliny was really referring when he used the generic expression 'imitators' (*aemuli*).

Antiphilus was responsible for the subsequent manoeuvre that endangered Apelles' life: this was the accusation of having participated in a conspiracy, which is thought to be why the artist then painted the famous allegory of Calumny (*Diabole*, 'false accusation'). Lucian (*Calumniae non temere credendum* 2–3) mistakenly associated this picture with an episode that took place a century after Apelles disembarked in Egypt, the betrayal of Theodotus at Tyre in 219 B.C. Although the confusion derived from the siege of Tyre in 315 B.C., in which the Egyptian garrison defended the city against Antigonus (Diodorus Siculus 19. 61. 5), we have, nonetheless, a useful chronological reference for the artist's activity at Ptolemy's court, and also the sensation that Apelles' well-known preference for the Syrian king helped to make the insinuation more credible.

Apelles' need to achieve a certain degree of independence from the established order of the court caused him to elevate his tried and tested realism to creations that were to become legendary, but which had their origins in the human sphere. Lucian's description (*Calumniae* 5)[101] informs us that the ample judicial scene was enriched with nuances, refinements and psychological accents, reversing the convention that confined personifications to myths. Thus was born a splendid profane allegory, that, thanks to Lucian's account, centuries later stimulated the emulation of Sandro Botticelli, Andrea Mantegna, Raphael and Albrecht Dürer:[102] 'On the right is seated a man with long ears, rather like those of Midas, and he is holding out his hand to Calumny who is coming towards him from afar. Beside him are two women, Ignorance (Agnoia), I believe, and Suspicion (Hypolepsis). On the other side, Calumny is approaching; a remarkably beautiful woman, she is, however, passionately

64. Darius the Great in council in the presence of the gods protecting the Greeks. Apulian red-figured volute-krater, by the Darius Painter. From Canosa. Museo Archeologico Nazionale, Naples

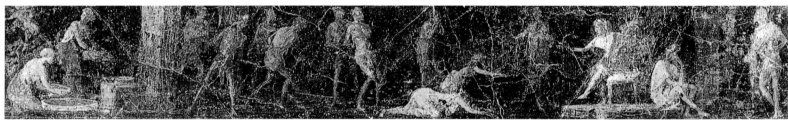

65. Personification of Deceit (Apate). Detail of the assembly of gods present at the council of Darius the Great. Apulian red-figured volute-krater, by the Darius Painter. From Canosa. Museo Archeologico Nazionale, Naples

66. Judicial scene. Fresco inspired by Apelles' Calumny in Alexandria. From the Farnesina House, Rome. Museo Nazionale Romano, Rome

67. Tragic actor. Fresco, possibly a copy of Apelles' painting of Gorgosthenes in Alexandria. From Herculaneum. Museo Archeologico Nazionale, Naples

excited, as if she were unable to contain her wrath and fury. In her left hand she holds a burning torch; with the other she is dragging by the hair a young man who is raising his hands to heaven, calling on the gods as witnesses. She is guided by an ugly pale man with a penetrating gaze, who seems to be emaciated by a long illness. It is easy to imagine that this is Envy (Phthonos). But another two women accompany Calumny, encouraging her and tidying up her clothes and hair. As the guide who showed me the picture explained, one is Intrigue (Epiboule), the other is Deceit (Apate). Behind them was a woman dressed in mourning, her black clothes in tatters. I think her name was Repentance (Metanoia); in any case, she looked behind, weeping and peering in great confusion at Truth (Aletheia), who was arriving. It was thus that Apelles managed to represent the risk that he himself had run'.

Individual personifications correspond to figures in literature and vase-painting. In the fable of Heracles at the crossroads, as recounted by Prodicus, Truth is a virgin 'of genuine, archaic beauty, like the statues in the Archaic style […] wearing a white tunic through which the forms of her body may be discerned […] her gaze is frank and noble, her smile steady, not fickle' (Themistius, *Orationes* 22. 281 a–c).[103] Thus she appears 'clad in white' in a picture described by Philostratus (*Imagines* 1. 27. 3).[104]

The figure of Deceit appears on the volute-krater of the Persians, mentioned previously: in the upper register on the obverse, between the deities and the symbolic images (fig. 64), the name 'Apate' is inscribed above this woman, a bad counsellor in the preliminaries to the war against the Greeks (fig. 65).[105] She is wearing richly decorated boots, a full chiton with close-fitting sleeves and an animal skin hanging over her shoulders, knotted at the front below her neck. The different colours highlight the contrast between the fur exterior of this skin and the dressed interior, a 'double-face' as ambiguous as its wearer. On her head she has a diadem of snakes. Particular striking is the way she holds out the torches: in Apelles' picture, Calumny held the torch is just the same way.

Phthonos,[106] together with the caricature of Ptolemy's jester, is among the incunabula of Alexandrian verism, which was mentioned when referring to Antiphilus: the thinness and emaciation of the figure, as if due to disease, are at the origin of the pitiless pictorial representation of pathology, which made notable progress with the scientific research of the Museum of Alexandria. Generally speaking, in the Greek world the personification of Envy devised by the painter became a small amulet in terracotta or bronze commonly worn to ward off the evil eye.[107]

Agnoia[108] has left traces in Egypt. Accompanied by an inscription, she is seen on a papyrus from Oxyrhynchus in Oxford,[109] and in a painting from Hermopolis Magna in the Egyptian Museum in Cairo.[110] On the basis of the distinctive drapery repeated in the two pictures, it may be deduced that in Apelles' painting Agnoia wore her mantle rolled up around her waist and tied with a knot in front from which the hem fell, symbolizing the clumsiness of Ignorance, although this is involuntary. The sketch on the papyrus is frontal and rigid, while the figure in the scene of the murder of Laius by Oedipus — who is ignorant of his victim's identity — gesticulates desperately, probably echoing the pose of Apelles' archetype.

Metanoia[111] as a doleful woman is also present in Christian art — for example, in an eleventh-century relief on the island of Torcello, in the Venetian Lagoon (fragments are in the cathedral and in the Museo di Torcello).[112]

In order to get an overall idea of the picture, it is worth taking a look at the friezes from the triclinium of the Farnesina House in Rome, now in the Museo Nazionale Romano in Rome. Representing judicial dramas, these paintings, datable to around 19 B.C., are inspired by Alexandrian models, in accordance with the fashion introduced by Octavian. The second compartment on the left wall (fig. 66)[113] depicts a small crowd before a sovereign acting a judge, who is seated with his right arm outstretched like Calumny's interlocutor. The various ways the figures lose their composure as they are dragged and pushed or prostrate themselves at the king's feet echoes Apelles' painting. The rapid touches of light derive ultimately from the *splendor* (highlights) used lavishly in his paintings; the nocturne formed by the dark background is indicated in the original by the presence of a torch.

In Alexandria there was a portrait of Gorgosthenes, a tragic actor, a possible copy of which is a painting from Herculaneum, now in the Museo Archeologico in Naples, showing the dedication of a tragic mask on the part of a seated actor in royal raiment (fig. 67).[114] The geometric structure of this fresco is similar to that of the picture of Heracles and Telephus (figs. 15, 45), and the seated figure resembles that of Alexander as Zeus in Ephesus (fig. 51) and the one of Akme that we shall see later (figs. 68, 70).

That the portraits left by Apelles were well known in Egypt is confirmed by Apion, of whom Pliny became a pupil. Under the guidance of his Alexandrian teacher, Pliny

68. Personifications of Kairos
(Opportunity), Akme (Flowering)
and Charis (Grace). Mosaic deriving
from a painting by Apelles in Smyrna.
From Byblos. Archaeological
Museum, Beirut

(35. 88) gives an account of the soothsayers who were able to read a man's past and future on his face. In the extraordinary series of portraits of kings, courtiers and artists painted by Apelles, the bold introspection and the high degree of individualization allowed one of these physiognomists to exercise his skills as a clairvoyant as if he had living people before him: 'He painted portraits that were so lifelike that, incredible as it may seem, the grammarian Apion wrote that one of those who predict a man's future from his face — known as *metoposcopoi* — was able to say not only how old the sitter was but also how many years he had had left before his death'.

Rhodes

After Apelles left Egypt and Ptolemy's perfidious court, he produced numerous masterpieces. In Rhodes he met Protogenes, who had moved to the island when he was of advanced years after a period in Athens. His biographers have embroidered on the encounter between the very different artists — rivals who admired and respected each other — recounting contrasting episodes and aspects of a story that seems to have got out of control. We have seen that Apelles had accepted the logic of monarchical power, in the context of an economy that drew on the resources of the eastern countries, to the extent that he insisted on being paid in gold. Protogenes, still attached to his origins as a craftsman, lived in the last Aegean city to maintain a certain degree of independence: the inhabitants of democratic Rhodes acquired his pictures at prices so low that Apelles became concerned (Pliny 35. 88).

Apelles' visit to Rhodes was still remembered in Roman times, as may be seen in Pliny's delightful account (35. 81–83), in which the artist is recognized by his 'line' (*ductus* in Latin): 'What took place between Protogenes and Apelles is well known. Protogenes lived in Rhodes, and Apelles landed there eager to see the works of a painter whom he only knew by reputation. He went straight to his studio. Protogenes was not there, but an old woman was watching over a large white panel resting on an easel. The woman told Apelles that Protogenes was out and asked him who it was who wanted to see the artist. 'This person,' replied Apelles and, taking a brush, he painted a very thin line across the panel. When Protogenes returned, the old woman showed him the line. It is said that that artist, after gazing at the fineness of the line for a long time, exclaimed that Apelles must have been there because nobody else was capable of producing such perfect work. Howev-

er, with another colour he then painted an even thinner line on top of the first one and then went out again, telling the old woman that if the stranger were to return she should show him the line and inform him that this was what he was looking for. And so it was. Apelles came back and, ashamed that he had been surpassed, with a third colour managed to divide the previous lines, without leaving room for any thinner ones. Protogenes, admitting defeat, rushed to the harbour in search of the guest. And this panel remained for posterity, astonishing all those who saw it, especially artists. I am told that it was destroyed in the first fire in the House of the Caesars on the Palatine. But I had already seen this large panel on which there was nothing but those imperceptible lines, displayed amidst the most outstanding works of many other artists. It seemed to be bare, and it was for this very reason that it was so fascinating and more famous than all the others'.

Smyrna

The disquieting power of Apelles' painting was sublimated by allegory. In Smyrna there was a picture of Charis (Pausanias 9. 35. 6), in reality the personification of the painter's aesthetic ideal. Pausanias stated that the figure was single (compared to the trio of the mythical sisters) and draped, contrary to the widespread custom of representing the group of the Three Graces naked. The picture was located in the odeum, which was used for musical auditions and poetry recitals, where the 'Grace' was displayed with other symbols of the Greek ideology of beauty.

Fragments of two mosaics found in Lebanon exemplify the essential features of this painting. The one from Byblos, in the Archaeological Museum of Beirut, depicts, from the left, the figures of Kairos (Opportunity), Akme (Flowering) and Charis (Grace, fig. 68).[115] The standing male figure is adolescent; poorly preserved in this mosaic, he is represented in a head and shoulders portrait in a mosaic from Baalbek in the Museo Capitolino in Rome (fig. 70).[116] This is variation on the theme of the young Alexander in which Apelles had been involved from the period he spent in Macedonia. The myth of Kairos was, in fact, linked to Alexander's exploits and the incredible speed of his advance, and I have already mentioned that Lysippus had dedicated an allegory in bronze of the same subject to the king. In both mosaics Akme is seated. In the one from Beirut the figure is almost complete (fig. 68), in a pose similar to that of Alexander as Zeus in Ephesus (fig. 51) and the presumed actor Gorgosthenes (fig. 67), as seen in the copies from Pom-

69. Personification of Kairos (Opportunity) in an octagon. Mosaic deriving from a painting by Apelles in Smyrna. From Baalbek. Museo Capitolino, Rome

70. Personification of Akme (Flowering) in a tondo. Mosaic deriving from a painting by Apelles in Smyrna. From Baalbek. Museo Capitolino, Rome

peii and Herculaneum respectively. Like in the apotheosis of Alexander, the head — here crowned with flowers — is tilted upwards, looking to the figure's left. The mosaic from the Museo Capitolino offers greater detail in the flowing hair and the liquid gaze (fig. 69). The face is clean-cut and the chin is rounded, as in the figure of Demeter in the discovery of Telephus (fig. 45). Charis is a young girl wearing a peplos with two girdles hidden by the overfalls and she has a garland of flowers on her head (fig. 68). The weight of her body is shared by her right leg and the support formed by a column on her left, producing the sinuous posture of her body, with a hand placed, palm outwards, on her hips.

The mosaic from Byblos, the only one containing this image, preserves a motif that is essential for its attribution — namely, the shadow cast by the girl onto the marble column. This is the phase of the discovery of optics to which I have already referred with regard to the Alexander mosaic when examining the reflections in the mercenaries' shields of two of Darius's warriors, one of whom may have given the artist a chance to insert his self-portrait (plate XII). In this case, the distortion is due to the fact that the shadow is cast onto a convex surface.

In both rhetoric and the figurative arts it was of fundamental importance to seize the opportunity for a successful outcome; this alluded to selection, the intuitive choice made in the mimesis. In painting, the logical sequence became perceptible through the harmonious crescendo of the images. The progression beginning with the figure of Kairos and continuing with Akme seated, culminates in the standing image of Charis: Grace may be rendered by the artist by seizing the propitious moment, but only when he is at the height of his career.

Cos

In the last part of his life, Apelles moved to Cos, where he obtained citizenship. Strabo's assertion (14, 2. 19) that in the sanctuary of Asclepius there were various works by Apelles, including a portrait of Antigonus Monophthalmos, allows this period to be dated to between 306 and 301 B.C., when the island was under Macedonian rule. This is Antigonus 'riding a horse', who in Pliny (35. 90) concludes the list of portraits; connoisseurs regarded this work, and also the picture of Artemis described previously among the artist's early works (figs. 43, 44), as the height of excellence (Pliny 35. 96). When discussing the sarcophagus of Abdalonymus, it was, in fact, suggested that the horseman on the extreme right of the battle scene was Antigonus (fig. 26).

Cos was a literary centre thanks to Philitas, who was born here around 340 B.C. Philitas, whose father was called Telephus, wrote a poem entitled *Telephus* on the myth of Arcadia, which was illustrated by Apelles when he was working in the Peloponnese (figs. 15, 45). One of Philitas's pupils was Herodas, who expressed the popular enthusiasm for the painter. In the sanctuary of Asclepius in Cos, the interior of a building was decorated by Apelles with the paintings that astonished the protagonists of one of Herodas's poems. The apparent naivety of the dialogue between Coccale and Cynno inaugurates the eulogistic tradition with regard to Apelles' use of line, the results of which became proverbial in imperial Rome, as I have already mentioned when describing the quality of the draughtsmanship in the painting on which the Alexander mosaic is based (Pliny 35. 84). The punishment desired for the artist's denigrator alludes to the rivalry between Apelles and Antiphilus in Alexandria: 'Truth, my dear, is in the hands of the Ephesian, in every one of Apelles' lines [...] those who have seen him or his works without being astounded, as they ought to be, deserve to be hung by one leg in a dyer's workshop.'

Leonidas of Tarentum (*Greek Anthology* 16. 182), on joining Theocritus in Cos, saw Aphrodite Anadyomene as depicted by Apelles at the moment she rose from the sea, which many authors attempted to describe without attaining the vividness of the Italiot poet: 'I saw the nuptial goddess of Cyprus as Apelles portrayed her, rising from her mother's womb, still streaming with foam, a most lovable beauty, not painted but animate. Gently, with the tips of her fingers she wrings her hair; gently, bright desire shines from her eyes, and her breasts, the heralds of her blossoming, swell like apples'.

It is thought that the artist intended the goddess to reflect the youthful beauty of Pancaste, the woman that Alexander gave him (Pliny 35. 87). In contrast to the statues of this type, of which various Roman copies still exist,[117] in the painting the goddess had only emerged from the sea as far as her bosom.[118]

A different image of Aphrodite is suggested in Petronius (*Satyricon* 83). In a Campanian city (Neapolis or Puteoli) the protagonist of the novel sees the works of famous artists: 'I came to a picture gallery in which a remarkable variety of paintings were displayed. In fact, I saw the works of Zeuxis not yet ruined by the ravages of time and touched, not without reverence, Protogenes' drawings, which vied with the truth of Nature herself. And soon I adored also what the Greeks call the *monoknemos* of Apelles. The out-

lines of the figure were drawn with such delicacy that you would believe the painting was alive'.

In this passage, the Greek term is incorrect: 'iam vero Apellis quam Graeci monocremon appellant etiam adoravi'. Compared to other suggestions, the correction *monocnemon* is the most convincing:[119] followed by the feminine relative pronoun, it recalls the Aphrodite 'who stands on one leg', known from statues, where the goddess is about to undo a sandal.[120]

The artist's last work, a third Aphrodite, which was unfinished due to his death, was also brought from Cos to Rome.[121] Although, in this case, she was to have been portrayed full-length, only the goddess's face and the upper part of her body had been completed (Cicero, *Epistulae ad familiares* 1. 9. 15): the rest had just been sketched in. Cicero (*De officiis* 3. 2. 10) and Pliny (35. 92) stressed the reverence with which, over the centuries, experts had observed this sketch, without daring to complete the picture 'because the beauty of the face was enough to make them abandon any hope of obtaining the same result in the rest of the body'.

From Genius to Success

According to the critics of antiquity, the process of 'discovery' (*inventio*) in classical painting reached its height in Apelles' output — in other words, everything already exists, it is only necessary to find it. Apparently the artist did not mean to break with the past; he expressed his admiration for exponents of different schools and revived previous styles in an original synthesis. On a theoretical level, however, he took the innovations of the Sicyonian school to a daring threshold: together with Lysippus and Aristotle, he was aware of the relativity and subjectivity of mimesis. The reasons why he was believed to have surpassed 'all those born before him and those destined to follow him' (Pliny 35. 79) are not at all consistent with the previous 'inventions'. The last of those mentioned by Pliny (35. 29), the *splendor* (highlights), although it was familiar to the artist — at least from the time he painted Alexander as Zeus in Ephesus (fig. 51) — was not explicitly attributed to him.[122]

On the other hand, Quintilian states that Apelles was superior to the others in his 'skill' and 'grace', and the artist himself was proud of this. The fragments deriving from Apelles' writings on the 'theory of painting' leave no doubt as to the fact that *gnome* and *charis* were natural gifts that had little to do with the foundations of classical aesthetics. Apelles himself admitted that he was surpassed not only by Melanthius in composition — as has already been mentioned

with regard to the doubtful attribution of the stag-hunt (figs. 48, 49) — but also by Asclepiodorus in proportions and Protogenes in diligence (Pliny 35. 80). It is the contrast with Protogenes' famous portrait of Ialysus that illustrates the unique, unrepeatable value of *charis*: 'It is said that Protogenes took seven years to complete his painting. And it is also said that, when he saw this work, Apelles was so impressed that he was lost for words, then he said, 'A lot of hard work and a splendid achievement,' but added that it did not have the grace thanks to which his own paintings were raised to the heavens' (Plutarch, *Demetrius* 22. 5–6).

Apelles had fully comprehended the contemporary aspects of his work, a conclusion that, from an artistic point of view, could be different from the classical preoccupation with completeness: 'He obtained further prestige when he admired a painting by Protogenes that involved a lot of work and great attention to detail. In fact, he said that Protogenes' works were equal to or even superior to his, but that he was better in just one aspect — namely, that he knew when he had done enough, thus illustrating the memorable precept that excessive diligence is often harmful' (Pliny 35. 80).

As I have already mentioned with regard to the wounded horse in the battle of Gaugamela (plate X), the painter even resorted to throwing a sponge at one of his paintings, and believed in the felicity of the moment inspired by Hermes and the *kairos* of his aesthetic, which we can admire in the mosaics discovered in the Lebanon (figs. 68-70). This approach may be linked to the descriptions of Tyche (Fortune), whom we know to have been seated,[123] like Akme in the allegory mentioned previously: 'Asked why he painted Tyche sitting down, Apelles the painter replied "Because she is never still"' (Stobaeus, *Anthology* 105. 60). The explanation offered by the artist excludes the possibility that this Tyche is the solemn personification of a city. She is portrayed as an example of female charm and she is the reason for the artist's success in a competition: 'Today I saw a girl looking out of a window [...]. Who could paint her beauty? Who could render it in the drawing? Who could give her form with colours? Bravo Apelles, such is his fame. But bravo only to her beauty! However, he has put his name under Fortune and for this reason he has received the greatest recognition. And he revealed himself to be the most expert in painting' (Libanius, *Descriptiones* 69).

Apelles' faith in what he produced himself (*automaton*) also corresponds to the belief of a contemporary politician who, in his private house in Sicily, dedicated an altar to the improbable Automatia (Plutarch, *Timoleon* 36. 6).

As for other aspects mentioned previously — the 'diaphane' of the atmosphere, the transparency of the colours and the artist's capacity to create freely — his vision coincides with a formula dear to Aristotle (*Ethica Nicomachea* 1140a. 8), who was quoting the tragic poet Agathon: 'Art loves fortune and fortune art'. And also in this way the conventional merit of the painting is prejudiced, as may be deduced from the reflection on the picture representing a rider on a rearing horse returning from battle (Dio Chrysostom, *Orationes*, 63. 4–5), which is quoted here for the descriptive part relating to the celebrations for Alexander and his Companions: 'It is also worth mentioning the success that fortune bestowed on Apelles the painter [...] when he had made the image totally realistic, it still lacked the colour of the foam; this is produced by blood completely mixed with slaver, since the breath drives the saliva out of the mouth and the heavy breathing causes it to froth, while the violence of the bit sprinkles it with blood. In short, Apelles was not able to paint the foam of the horse tormented by the battle. In increasing difficulty, he eventually flung the sponge at the picture in the direction of the bit. And, since it was soaked in many colours it created an effect on the picture that turned out to be the desired one of the foam. On seeing this, Apelles rejoiced — despite his incapacity (*apognosis*) — in the intervention of fortune (*tyche*) and completed the picture not through art (*techne*) but rather through fortune'.

It is, therefore, a formula that allows Apelles' aesthetic to be paralleled with Aristotle (*Poetica*, 1454a, 10–12) as regards the tragic poets, who, 'in their quest find [dramatic requirements] in the myths not through art but through fortune'.

'Grace' was not a rule valid for objective reasons; it could not be imparted by teaching, like the precepts of the Sicyonian school, but it was committed to a personal quality, the artist's 'genius', which resolved the difficulties of the model. No longer chosen according to the classical criterion of beauty, this was offered by circumstances extraneous to the aesthetic choice, and imposed by the exigencies of a policy that was ever less controlled by the citizens, as Apelles revealed by placing his own oppressed image in the thick of the battle of Gaugamela (plate XII).

Through the list of portraits and a number of anecdotes we have seen that the output was determined by the prodigality of the vastly expanded kingdom. In his frequent moves from one place to another, the painter, like Lysippus, remained in contact with those having power together with immense wealth. The problem was that of resolving the iconography and the requirements of the special patrons with 'skill' and 'grace': for instance, the malformation of Alexander's neck that served to express his attraction towards the gods; the reddening on his chest disguised by the flash of the lightning; Antigonus Monophthalmos's wound concealed by the use of perspective, in which the critics of antiquity recognized the independence of the artist from the ideal: 'in painting the whole face has its beauty; however, Apelles only showed Antigonus's face from one side, so that the deformity of the missing eye was hidden' (Quintilian, *Institutio Oratoria* 2. 13. 12).

The success of his work was not based on quantity, but rather on intellectual criteria. Regarding the discovery of Telephus (figs. 15, 45), Pliny (35. 94) observed that 'Heracles is turning in such a way that his face is visible more fully than one might expect, which is a very difficult thing to do'. Leaving aside the unfinished Aphrodite, also in the Aphrodite Anadyomene the artist had limited the representation of the nude: the goddess rose from the waves 'showing only her bosom, as is appropriate (*Greek Anthology* 16. 180. 5). As Parrhasius and Timanthes had intuited in the previous generations, what the artist omits is more important that what he represents.[124]

Having abandoned Plato's presumption that pure form was necessarily associated with noble contents, Apelles accepted Aristotle's proposition (*Poetica* 1448b. 10–12) that painting is endowed with poetic truth: 'We derive pleasure from looking at exact reproductions of things that we would normally observe with disgust, such as loathsome beasts and the dead.' When discussing the battle of Gaugamela, I mentioned that two different sources — together conforming to Aristotle's maxim — praised Apelles' images of both the 'dying' (Pliny 35. 90) and humble subjects: 'If Apelles had painted a monkey or a fox, thanks to his artistic skill he would have ennobled the painted beast, even though it was of no value' (Marcus Cornelius Fronto, *Letters to Marcus Aurelius* 1. 7).

All the more reason why, in the images of the gods, the harmony of the picture allows elementary imitation — the natural mimesis from which the Sicyonian school started with Eupompus — to be abandoned. Animated by 'grace', the artist's work, as we have heard from Apelles himself, was 'raised to the heavens' (Plutarch, *Demetrius* 22. 6). Thanks to the supreme gift of art, the mortal frees himself of physical encumbrance, he distinguishes himself from the mass and goes towards the solitude of the sublime: 'Even

if he joined the gods, Apelles would get the better of them,' is the conclusion of the women that Herodas (*Mimiambi*, 4. 75–76) shows round the marvels of the sanctuary of Cos.

[56] Wustmann 1870; A. Reinach 1921 (reprint 1985), pp. 314–360, nos. 400–486; Pfuhl, II, pp. 735–746; Berve 1926, II, pp. 53–55, no. 99; Swindler 1929, pp. 269–272; Della Seta 1930, pp. 414–416; Borrelli 1950, p. 56; Rumpf 1950–51; Rumpf 1953, pp. 146–147; Robertson 1959, pp. 14–15, 168–169; Lepik-Kopaczynska 1962; Pollitt 1965, pp. 163–169; Robertson 1975, pp. 492–496, 787; Moreno 1979, pp. 492–502; Croisille 1985, pp. 69–78, 196–209, 325; Pollitt 1986, pp. 22, 23, 31, 325; Giuliano 1987, pp. 1061–1064; Moreno 1987, pp. 140–145, 147–161, 164–167, 203; Rouveret 1989, pp. 421–423, 473–475, 486–489, 492–494, 559; Scheibler 1994, pp. 10–12, 18–19, 58–59, 61–62, 74–76, 118, 216; Robert 1999, pp. 236, 237, 240. See note 124. For the personages mentioned with reference to the painter see Berve 1926, II, pp. 42–44, no. 87, Antigonus; p. 255, no. 501, Menander; p. 273, no. 548, Neoptolemus; p. 297, no. 600, Pancaste; pp. 329–335, no. 668, Ptolemy, son of Lagus.

[57] Radius 1968, p. 115, no. 154, plate 53.

[58] A. Goulaki-Voutira, in Moustaka 1992, p. 877, no. 328.

[59] Dilthey 1870; Schwarz 1968–71.

[60] Usai 1972, pp. 386–398, figs. 5–6, plates 8–11; Simon 1984, p. 280, no. 151, plate 608; Moreno 1999, pp. 197–201, figs. 245–247.

[61] Boardman 1988, p. 788, no. 1256.

[62] Hermann, Herbig, Bruckmann 1904–31, I, pp. 104–106, plates 78–80; Elia 1932, pp. 18–19, no. 19, plate 1; Moreno 1982, pp. 415–419, fig. 31; Simon 'Arkadia' 1984, p. 608, no. 1, plate 437; Hannah 1986: identification of the seated goddess as Demeter rather than Arcadia; M. Strauss, in Heres, Strauss 1994, p. 863, no. 19. For the myth see Jost 1992, pp. 251–253.

[63] Moreno 'Ercoli' 1994, p. 490, fig. 548, no. B.1.

[64] Moreno 'Ercoli' 1994, pp. 490–491, fig. 548, no. B.2.

[65] Trendall 1967, p. 170, no. 963, plate 75.5; Schneider-Herrmann 1980, pp. 43, 46, 61, 70; Moreno 1984, pp. 420–422, figs. 27, 29.

[66] Hermann, Herbig, Bruckmann 1904–31, I, p. 105, note 9, fig. 27.

[67] Rosenblum 1973, pp. 164–165, plate 46.

[68] Queyrel 1984, p. 928, no. 1; Fernández Castro 1986, p. 170, no. 1; Müller 1992, p. 23, no. 1.

[69] Kroll 1937; Queyrel 1984, p. 928; Fernández Castro 1986, p. 170.

[70] Queyrel 1984, p. 928, no. 2; Fernández Castro 1986, p. 170, no. 2; Kossatz-Deissmann 1994, p. 720, no. 5, pp. 720–721, no. 7, plate 530: Apulian vase, Museum of Art, Tampa Bay, Florida.

[71] Petzas 1978, pp. 99–102, figs. 12–15; Salzmann 1982, pp. 107–108, no. 103, plates 29, 99.2, 101.2–6, 102.1–2; Prestianni Giallombardo 1986, plate III, fig. 5; Moreno 1987, pp. 134–136, figs. 31, 175; Makaronas, Giouri 1989, pp. 142–143, plates 18–22; Rouveret 1989, pp. 237, 245–247, 286–287, plate XXI.1; A.-M. Guimier-Sorbets, in Ginouvès 1993, pp. 121–136, fig. on p. 9 and figs. 106, 121; Moreno 1993, pp. 102–103, figs. 1, 3, 14; Moreno *Scultura* 1994, I, pp. 46–48, fig. 29; P. Moreno in *Lisippo* 1995, p. 266, fig. on p. 267; Siganidou, Lilibaki-Akamati 1996, pp. 24–25, figs. 1, 11, 50; Moreno 1998, pp. 13–17, figs. 5–6.

[72] Moreno 1993, p. 103, fig. 2; Moreno 1998, p. 16, fig. 7.

[73] Moreno 1987, pp. 134–136, figs. 31, 175; Rouveret 1989, pp. 237, 245–247, 286–287, plate XXI.1; Moreno 1993, pp. 102–103, figs. 1, 3, 14; Moreno 'Melanthios' 1995, fig. 737.

[74] Daszewski 1985, pp. 103–110, no. 2, plates 4–5; Moreno 1987, p. 134, fig. 29; Guimier-Sorbets 1998, p. 227, ill. 6.

[75] Roberts 1950.

[76] Moreno 1990; Tredé 1992; Moreno 'Kairos' 1995, fig. 186; P. Moreno in *Lisippo* 1995, pp. 190–195, no. 4.28.1–5; Antonopoulos 1998, pp. 247–251, plate 55a.

[77] Literary sources are unanimous with regard to a formal privilege granted by Alexander for the representation of his portrait in painting, bronze sculpture and gem engraving to Apelles, Lysippus and Pyrgoteles respectively (Horace, *Epistlulae* 2. 1. 237–244; Pliny 7. 125, 35. 85; Apuleius, *Florida* 7; Himerius, *Exercises and Speeches* 31. 5; Choricus, *Speeches* 43. 1). There is a lack of explicit evidence before Horace, but the poet is believed to have obtained the information from Hellenistic sources: Moreno 1973, pp. 97–99.

[78] Berve 1926, II, pp. 191–199, no. 408; Levi 1984, pp. 56–57; Prandi 1985, pp. 99–100.

[79] De Lorenzo 1900; Petersen 1900; Mingazzini 1961; Schefold 1979, plate I. 3; Moreno 1993, pp. 109–110, fig. 46; V. Sampaolo, in *Pompei*, V, 1994, pp. 492–493, no. 35; Canciani 1997, p. 426, no. 25.

[80] Moreno 1987, pp. 160–162, fig. 154; Lagi De Caro 1988, pp. 75–88; Mack 1991; Moreno 1993, p. 126, fig. 48; Stewart 1993, pp. 20, 47–48, 186–190, 429–431, figs. 59, 61, plates 6–7a; Moreno 1994, I, pp. 422–423, fig. 532; V. Sampaolo, in *Pompei*, VI, 1996, pp. 92–93, no. 104a–c; Walter-Karydi 1997, fig. 6; M. Mastroroberto, in *Pompeii, Picta fragmenta* 1998, pp. 130–131, no. 82. For Stateira see Berve 1926, II, pp. 363–364, no. 722.

[81] Hölscher 1973, pp. 172–173, plate 15.1; Price 1982, plate IX.1r and 3r, X.2r (the winged and bearded genius crowning Alexander is visible), XI.4; Levi 1984, p. 55; Pfrommer 1997, p. 398, no. 253, plate 257. See note 35.

[82] Hermary 1986, p. 892, no. 492, plate 636.

[83] Mattingly, Sydenham II, 1926, p. 66, no. 413; Alteri 1996, p. 89, no. 45.

[84] Carducci 1961, fig. 1007; Baratte 1998, pp. 375–376, fig. 382.

[85] Stewart 1993, pp. 187–188, fig. 60, plate 7b; V. Sampaolo, in *Pompei*, VI, 1996, pp. 80–84; M. Mastroroberto, in *Pompeii, Picta fragmenta* 1998, pp. 132–133, no. 83. For Parysatis see Berve 1926, II, p. 306, no. 607.

[86] I. Wehgartner, in *Die Antikensammlung* 1992, pp. 278–280, no. 151.

[87] H. von Heintze, in *Führer* I 1963, p. 186, no. 241; Delivorrias 1984, pp. 78–79, no. 696, plate 69.

[88] Gasparri 1986, p. 484, no. 734, plate 384.

[89] Mollard-Besques 1963, p. 78, plate 84.b, 84.f; Gasparri 1986, p. 486, no. 754, plate 386.

[90] Maiuri 1947, pp. 152–155, plate 8; Simon 1961, pp. 118, 130–131; Brendel 1966, pp. 246–248, figs. 1, 10, 24; Gasparri 'Dionysos', 'Bacchus' 1986, p. 555, no. 195, plate 447; Guarducci 1993, fig. 1; Sauron 1998, pp. 59–72, figs. 4–6, fig. on p. 10.

[91] Gabrici 1946, fig. 6; E. Simon, in *Führer* I 1963, pp. 615–616, no. 843; Mielsch 1975, p. 160, no. 88. 2; Moreno 1993, pp. 110–111, fig. 47; Simon, Bauchhenss 1994, p. 490, no. 82, plate 385. The current interpretation of the enthroned figure as Veiovis (rather than Alexander) is

not taken into consideration in the most recent study of this Roman deity: Simon 1997.

[92] Lippold 1950, p. 283, plate 136. 23; Amandry 1988, pp. 5–12, 32–33, 123–124, no. II, plate 2, R.1–R.6, plate 3, R.7–R.16: a bronze as of the Caesarian colony (43–44 B.C.).

[93] Gabrici 1946; P. Moreno, in *Lisippo* 1995, pp. 157–165, no. 4. 19. 3.

[94] P. Moreno, in *Lisippo* 1995, pp. 157–165, no. 4. 19. 3.

[95] Bianchi Bandinelli 1969, p. 25, fig. 28; another example is in the Musée J. Carcopino, Aleria (Corsica): Bianchi Bandinelli, Giuliano 1973, pp. 349–350, fig. 402.

[96] Schmaltz 1990; Zanovello 1994, pp. 423–424, no. 1.

[97] Müller-Huber 1994, pp. 28–29, no. 1, plate 21.

[98] For Apelles' painting representing Alexander, Nike and the Dioscuri see Bulle p. 348; Hamdorf p. 114; A. Goulaki-Voutira 1992, p. 877, no. 328; Schmaltz 1990. For the frames in the forum of Augustus pertaining to Apelles' paintings see Moreno 1993, p. 131, fig. 56; Moreno 'Apelle' 1994, fig. 326; Kockel 1995, p. 292.

[99] Rocchetti 1959, figs. 432–433; Zazoff 1983, p. 319, note 82; Oberleitner 1992, plate XXVIII. 2; M.E. Micheli, in *L'Idea* 2000, II, p. 558, no. 44.

[100] Hölscher 1973, pp. 60, 177–180, 220, plate 14. 2; Trendall, Cambitoglou 1982, p. 495, no. 8.38, plate 176. 1; Balty 1984, pp. 857–858, no. 1; Gabelmann 1984, pp. 76–78, no. 29; Moreno 1987, pp. 194–196, fig. 190; Palagia 1988, p. 626, no. 5, plate 385; Villanueva Puig 1989; R. Cassano, in *Principi* 1992, pp. 177–180, no. 1; Aellen 1993, pp. 202, 213, no. 4; Scheibler 1994, p. 163, fig. 81; R. Cassano, in *I Greci in Occidente, Napoli* 1996, pp. 152–153, no. 11.15, plate on p. 135; M. Lista, in *Alexandros* 1997, pp. 87–89, no. 2.

[101] Engelmann 1904; Hinks 1939, p. 117; Krenkel 1968, pp. 689–690; Settis 1981; Gabelmann 1984; Gilser 'Diabole' 1986, p. 386, no. 1; Gisler 'Epiboule' 1986, p. 803, no. 1; Massing 1990, pp. 15–28.

[102] Gombrich 1976; Cast 1981; Faedo 1985; Massing 1990; Faedo 1994.

[103] Settis 1981, p. 487.

[104] Ibid.

[105] Moreno 1987, pp. 151, 152, 154, 194, 196, fig. 180; Belloni 1981, p. 875, no. 1, plate 698; Schmidt 1982, pp. 505–506, plate 142; Aellen 1994, p. 202, no. 4.

[106] Aellen 1994, p. 174, note 5; Gisler 1997, p. 992, 995, no. 25.

[107] Gisler 1997, p. 993, nos. 1–12, plate 658.

[108] Canciani 1981, p. 303, no. 3.

[109] Ibid., p. 302, no. 1, plate 221.

[110] Ibid., p. 303, no. 2, plate 222.

[111] Polito 1992, p. 561, no. 1.

[112] Polacco 1984, pp. 25–27, fig. 38; Moreno 1990, p. 923, no. 14, plate 598.

[113] Bragantini, de Vos 1982, p. 236, inv. no. 1080, C.5, plate 154; Gabelmann 1984, pp. 151–152, no. 63, plates 17–18; Moreno 1987, p. 125, fig. 179; Massing 1990, plate 56; *La Villa* 1998, p. 47, fig. 60.

[114] Rizzo 1929, pp. 31–32, plate 50; Bianchi Bandinelli 1965, plate on p. 216; V. Sampaolo, in *Le Collezioni* 1986, p. 138, no. 103; De Caro 1994, fig. on p. 167.

[115] Moreno 1985, pp. 253–256; Moreno 1987, p. 150, fig. 157; Moreno 1990, p. 924–925, no. 20; Moreno 'Akme' 1994; Moreno 'Apelle' 1994, fig. 325; Moreno 'Kairos' 1995, p. 159.

[116] Moreno 1985, pp. 253–256; Moreno 1990, p. 925, no. 21, plate 598; Moreno 'Akme' 1994, plate on p. 156; Moreno 'Kairos' 1995, p. 159.

[117] Delivorrias 1984, p. 55, nos. 424–438, plates 40, 41; M.G. Picozzi, in *Catalogo* 1990, pp. 205–208, no. 111; D. Candilio, in *Rotunda* 1991, p. 76, no. 9; Schmidt 1997, pp. 206–207, nos. 133–146.

[118] Rumpf 1950–51, pp. 173–174; Delivorrias 1984, p. 54, n. 423.

[119] Blümner 1884. For the reinstatement of Aphrodite Monoknemos see Dilthey 1870; Rumpf 1950–51, p. 173; Krenkel 1968, p. 694; Bröker 1996, p. 694.

[120] Delivorrias 1984, pp. 57–59, nos. 462–481, plates 44–46; Schmidt 1997, pp. 210–211, nos. 182–191, plates 144, 145.

[121] Rumpf 1950–51, pp. 173–174.

[122] Moreno 1966; Pollitt 1974, pp. 439–441.

[123] Villard 1997, pp. 116, 124.

[124] For Apelles' technique and style see S. Reinach 1917; Swindler 1929, p. 272; Borrelli 1950, pp. 56–57; Gage 1981; Lecoq 1974, p. 46; Scheibler 1974; Moreno 'Apelle' 1994; Scheibler 1994, pp. 102–103; Scognamillo 1994. See note 56.

Bibliography, List of Locations of Works, Index

Bibliography

Publications relating to the Alexander mosaic and/or Apelles are followed by an asterisk

Actes du XII Congrès international d'Archéologie classique, Athènes 1983, I, Athens, 1985; II–IV, 1988.
Chr. Aellen, *À la recherche de l'ordre cosmique, Forme et fonction des personnifications dans la céramique italiote*, Kilchberg, Zurich, 1994.
Akten des XIII. internationalen Kongresses für klassische Archäologie, Berlin 1988, Mainz, 1990.
Alessandro Magno, Storia e mito, Roma, 1995-1996, exh. cat. edited by C. Alfano, Milan, 1995.*
Alexander the Great, Reality and Myth, edited by J. Carlsen, B. Due, O. Steen Due, B. Poulsen, Rome, 1993 (*Analecta Romana Instituti Danici, Supplementum 20*).*
Alexandre le Grand: image et réalité, edited by E. Badian, Geneva, 1976 (*Fondation Hardt, Entretiens*, 22).*
Alexandros kai Anatoli, edited by D. Pandermalis, Salonica, 1997.*
G. Alteri, *I Sesterzi dei Dodici Cesari dal Medagliere della Biblioteca Apostolica Vaticana*, exh. cat. (Vicenza 1996), Rome, 1996.
M. Amandry, *Le Monnayage des duovirs corinthiens*, Paris, 1988 (*Bulletin de Correspondance Hellénique*, Supplément 15).
B. Andreae, 'Zermalmt vom Wagen des Grosskönigs', in *Bonner Jahrbücher*, 161, 1956, pp. 1–5.*
B. Andreae, 'Zum Relief Ruesch', in *Marburger Winckelmann-Programm*, 1956, pp. 7–11.*
B. Andreae, *Das Alexandermosaik*, Bremen, 1959 (*Opus nobile*, 14).*
B. Andreae, *Das Alexandermosaik aus Pompeji*, Recklinghausen, 1977.*
B. Andreae, 'L'osservazione goethiana dell'arte antica', in *Finalmente in questa capitale del mondo! Goethe a Roma*, edited by K. Scheuermann and U. Bongaerts-Schomer, I, Rome (n.d. but 1997), pp. 132–139.
B. Andreae, *Schönheit des Realismus,*

Auftraggäber, Schöpfer, Betrachter hellenistischer Plastik, Mainz, 1998.
M. Andronikos, *Vergina, The Royal Tombs*, Athens, 1984.
M. Andronikos, 'I zographiki stin archaia Makedonia', in *Archaiologiki Ephemeris*, 126, 1987, pp. 361–382.
M. Andronikos, *Vergina*, II, *The 'Tomb of Persephone'*, Athens, 1994.
Die Antikensammlung im Pergamonmuseum und in Charlottenburg, edited by Staatliche Museen zu Berlin, Berlin, 1992.
I. Antonopoulos, 'Kairos kai Bios: i christianiki epilogi anamesa stin eukairia kai ti sotiria', in *Archaiologikon Deltion*, 48–49, 1994–95, *Meletes*, pp. 247–266.

E. Badian, 'A Note on the "Alexander Mosaic"', in *The Eye Expanded, Life and the Arts in Greco-Roman Antiquity*, edited by Fr. B. Tichener and R. F. Moorton, Berkeley, Los Angeles and London, 1999, pp. 75–92.*
J. Baltrusaitis, *Lo specchio, Rivelazioni, inganni e science-fiction*, Milan, 1981.
J. Ch. Balty, 'Asia' I, in *Lexicon Iconographicum Mythologiae Classicae*, II, Zurich and Munich, 1984, pp. 857–858.
F. Baratte, 'Il Tesoro di Marengo', in *Archeologia in Piemonte*, II, *L'età romana*, edited by L. Mercando, Turin, 1998, pp. 369–380.
L. Baumer, U. Weber, 'Zum Fries des Philippgrabes von Vergina', in *Hefte des Archäologischen Seminars der Universität Bern*, 14, 1991, pp. 27–41.
H. Berve, *Das Alexanderreich auf prosopographischer Grundlage*, I–II, Munich, 1926.
L. Beschi, 'Demeter', in *Lexicon Iconographicum Mythologiae Classicae*, IV, Zurich and Munich, 1988, pp. 844–892.
R. Bianchi Bandinelli, 'Pittura', in *Enciclopedia dell'arte antica classica e orientale*, VI, Rome, 1965, p. 207–222.*
R. Bianchi Bandinelli, *Roma, L'arte romana nel centro del potere*, Milan, 1969.
R. Bianchi Bandinelli, 'La pittura', in *Storia e civiltà dei Greci*, 10, *La cultura*

ellenistica, Le arti figurative, edited by R. Bianchi Bandinelli, Milan, 1979 (reprint 1991), pp. 461–513.*
R. Bianchi Bandinelli, A. Giuliano, *Etruschi e Italici prima del dominio di Roma*, Milan, 1973.
Bildkatalog des Skulpturen des Vatikanischen Museums, II, *Museo Pio Clementino, Cortile Ottagono*, edited by B. Andreae, Berlin and New York, 1998.
O. Binghöl, *Malerei und Mosaik der Antike in der Türkei*, Mainz, 1997.
H. J. Bloesch, *Antike Kunst in der Schweiz*, Erlenbach, Zurich, 1943.
H. Blümner, 'Noch einmal die "Monoknemos" des Apelles', in *Archäologische Zeitung*, 42, 1884, pp. 133–138.*
J. Boardman, 'Herakles', in *Lexicon Iconographicum Mythologiae Classicae*, IV, Zurich and Munich, 1988, pp. 728–838.
J. Boardman, *Storia Oxford dell'arte classica*, Rome and Bari, 1995.*
A. Bonito Oliva, *L'ideologia del traditore, Arte, maniera, manierismo*, Milan, 1988.
L. Borrelli, 'Qualche scheda sulla tecnica della pittura greca', in *Bollettino dell'Istituto Centrale del Restauro*, 1, 1950, pp. 55–57.*
I. Bragantini, M. de Vos, *Museo Nazionale Romano, Le pitture*, II, 1, *La decorazione della Villa romana della Farnesina*, Rome, 1982.
O. J. Brendel, 'Der Grosse Fries in der Villa dei Misteri', in *Jahrbuch des Deutschen Archäologischen Instituts*, 81, 1966, pp. 206–260.
P. Briant, 'Chasses royales macédoniennes et chasses royales perses, Le thème de la chasse au lion sur la Chasse de Vergina', in *Dialogues d'Histoire Ancienne*, 17, 1991, pp. 211–255.
G. Bröker, 'Apelles', 1, in *Allgemeines Künstlerlexikon, Die Bildenden Künstler*, III, Lepizig, 1880, pp. 695–696.*
Bl. B. Brown, 'Alexander the Great as Patron of the Arts', in *The Fire of Hephaistos, Large Classical Bronzes from North American Collections*, Cambridge (Mass.), 1996, pp. 86–103.*
R. R. Brown, *Ptolemaic Paintings and*

Mosaics and the Alexandrian Style, Cambridge (Mass.), 1957.
V. Bruno, *Form and Color in Greek Painting*, New York, 1977.*
W. Byvanck, 'La bataille d'Alexandre', in *Bulletin van de Vereening tot Bevordering der Kennis van de Antieke Beschaving*, 30, 1955, pp. 28–34.*

G. Calcani, *Cavalieri di bronzo, La Torma di Alessandro Magno opera di Lisippo*, Rome, 1989.
G. Calcani, 'L'immagine di Alessandro Magno nel gruppo equestre del Granico', in *Alexander* 1993, pp. 29–39.
G. Calcani, 'Arte di guerra', in *Alessandro* 1995, pp. 145–151.*
F. Canciani, 'Agnoia', in *Lexicon Iconographicum Mythologiae Classicae*, I, Zurich and Munich, 1981, pp. 302–303*; 'Zeus', 'Juppiter', ibid., VIII, Zurich and Düsseldorf, 1997, pp. 421–470.
A. Capodiferro, 'Arcus Constantini', in *Lexicon Topographicum Urbis Romae*, I, Rome, 1993, pp. 86–91.
C. Carducci, 'Tesoro di Marengo', in *Enciclopedia dell'arte antica classica e orientale*, IV, Rome, 1961, p. 831.
D. Cast, *The Calumny of Apelles: A Study in the Humanist Tradition*, New Haven, 1981.*
Catalogo della Galleria Colonna in Roma, Sculture, edited by F. Carinci, H. Keutner, L. Musso, M. G. Picozzi, Rome and Busto Arsizio, 1990.
M. Catapano, 'La fortuna del mosaico di Alessandro', in *Apollo*, 12, 1996, pp. 129–149.*
A. Ciancio, 'Lo stile lucano', in *I Greci in Occidente, Arte e artigianato nella Magna Grecia*, edited by E. Lippolis, Milan, 1996, pp. 395–399.
A. Cohen, *The Alexander Mosaic, Stories of Victory and Defeat*, Cambridge, 1997.*
Le Collezioni del Museo Nazionale di Napoli, I, 1, *I Mosaici, le Pitture*, edited by Archivio Fotografico Pedicini, Rome, 1986; I, 2, *La Scultura*, 1989.
H. Comfort, 'Terra sigillata', in *Enciclopedia dell'arte antica classica e ori-*

entale, *Supplemento 1970*, Rome, 1973, pp. 803–835.

A. Conze, 'Laokoon und Alexanderschlacht', in *Commentationes philologae in honorem Theodori Mommseni scripserunt amici*, Berlin, 1877, pp. 448–450.*

A. Conze (review of), J. Overbeck, 'Geschichte der Griechischen Plastik', IV, Leipzig, 1882, in *Göttingische Gelehrte Anzeigen*, 1882, no. 29, pp. 897–914.

J. Croisille, *Pline l'Ancien, Histoire naturelle, XXXV*, Paris, 1985.*

I. E. Curtius, J. E. Reade, *Art and Empire, Treasures from Assyria in the British Museum*, London, 1995.

L. Curtius, *Die Wandmalerei Pompejis, Eine Einführung in ihr Verständnis*, Leipzig, 1929.*

W. Daszewski, *Corpus of Mosaics from Egypt*, I, *Hellenistic and Early Roman Period*, Mainz, 1985.

A. Delivorrias, 'Aphrodite', in *Lexicon Iconographicum Mythologiae Classicae*, II, Zurich and Munich, 1984, pp. 2–131.*

A. Della Seta, *Il nudo nell'arte*, Milan, Rome, 1930.*

G. De Lorenzo, *Una probabile copia pompeiana del ritratto di Alessandro Magno dipinto da Apelle*, Naples, 1900.*

S. De Maria, 'Arco onorario e trionfale', in *Enciclopedia dell'arte antica classica e orientale, Secondo Supplemento 1971-1994*, I, Rome, 1994, pp. 354–377.

G. D'Henry, 'La romanizzazione del Sannio', in *La Romanisation du Samnium aux IIe et Ier siècles av. J.-Chr., Actes du Colloque, Napoli 1988*, Naples, 1991, pp. 9–19.

A. M. Devine, 'The Battle of Gaugamela: A Tactical and Source-critical Study', in *Ancient World*, 13, 1986, pp. 87–115.

S. Diebner, *Aesernia-Venafrum*, Rome, 1979.

W. Dilthey, 'Die Artemis des Apelles und die wilde Jagd', in *Rheinisches Museum*, 25, 1870, pp. 321–336.*

M. Donderer, 'Das pompejanische Alexandermosaik, Ein östliches Importstück?', in *Das antike Rom und der Osten, Festschrift für Klaus Parlasca*, edited by Chr. Börker and M. Donderer, Erlangen, 1990, pp. 19–31.*

St. Drougou, Chr. Saatsoglou-Paliadeli, *Vergina, Wandering through the Archaeological Site*, Athens, 1999.

Th. Eberhard, 'Nikomachos in Vergina?', in *Archäologischer Anzeiger*, 1989, pp. 219–226.

O. Elia, *Pitture murali e mosaici nel Museo Nazionale di Napoli*, Rome, 1932.*

L. Faedo, 'L'impronta delle parole, Due momenti della pittura di ricostruzione', in *Memoria dell'antico*, edited by S. Settis, II, Turin, 1985, pp. 3–42.*

L. Faedo, 'Le immagini dal testo', in Maffei 1994, pp. 127–142.*

B. Fehr, 'Zwei Lesungen des Alexandermosaik', in *Bathron, Beiträge zur Architektur und verwandten Künsten für Heinrich Drerup*, edited by H. Büsing and F. Hiller, Saarbrücken, 1988, pp. 121–134.*

M. C. Fernández Castro, 'Bronte', in *Lexicon Iconographicum Mythologiae Classicae*, III, Zurich and Munich, 1986, pp. 170–171.*

Führer durch die öffentlichen Sammlungen klassischer Altertümer in Rom, I–IV, edited by W. Helbig and H. Speier, Tübingen, 1963–72.

H. Fuhrmann, *Philoxenos von Eretria, Untersuchungen über zwei Alexandermosaike*, Göttingen, 1931.*

I. Furlan, *Codici greci illustrati della Biblioteca Marciana*, VI, Padua, 1997.

H. Gabelmann, *Antike Audienz- und Tribunalszenen*, Darmstadt, 1984.

E. Gabrici, 'L'Eracle di Lisippo a Taranto', in *Atti dell'Accademia Nazionale dei Lincei, Rendiconti, Classe di Scienze morali, storiche e filologiche*, series VIII, 1, 1946, pp. 18–36.

H. Gaebler, *Die antiken Münzen Nord-Griechenlands*, III, *Die antiken Münzen von Makedonia und Paionia*, 1–2, Berlin, 1906–35.

J. Gage, 'A Locus Classicus of Color Theory: the Fortunes of Apelles', in *Journal of Warburg and Courtauld Institutes*, 44, 1981, pp. 1–26.*

H. von Gall, 'Die Kopfbedeckung des medischen Ornats in achämenidischer und hellenistischer Zeit', in *Akten 1990*, pp. 320–323.

C. Gasparri, 'Dionysos', in *Lexicon Iconographicum Mythologiae Classicae*, III, Zurich and Munich, 1986, pp. 414–514; 'Dionysos', 'Bacchus', ibid., pp. 540–566.

A. Geyer, 'Alexander in Apulien', in *Kotinos, Festschrift für Erika Simon*, edited by H. Froning, T. Hölscher and H. Mielsch, Mainz, 1992, pp. 312–316.*

A. Geyer, 'Geschichte als Mythos, Zu Alexanders "Perserschlacht" auf apulischen Vasenbilder', in *Jahrbuch des Deutschen Archäologischen Instituts*, 108, 1993, pp. 443–455.*

R. Ginouvès, *I Macedoni, Da Filippo alla conquista romana*, Milan, 1993.

J.-R. Gisler, 'Diabole', in *Lexicon Iconographicum Mythologiae Classicae*, III, Zurich and Munich, 1986, p. 386*; 'Epiboule', ibid., p. 803*; 'Hypolepsis', ibid., V, 1990, p. 609*; 'Phthonos', ibid., VIII, 1997, pp. 992–996.*

L. Giuliani, 'Alexander in Ruvo, Eretria und Sidon', in *Antike Kunst*, 20, 1977, pp. 26–42.*

L. Giuliani, 'L'iconografia della vittoria di Alessandro: versione triviale e versione colta', in *Ricerche di pittura ellenistica*, Rome, 1985, pp. 199–202.*

La Gloire d'Alexandrie, Exposition des Musées de la ville de Paris, 1998, Paris, 1998.

B. Goldman, 'Darius III, the Alexander mosaic, and the "thiara ortho"', in *Mesopotamia*, 28, 1993, pp. 51–69.*

E. H. Gombrich, *The Heritage of Apelles*, Oxford, 1976.*

V. von Graeve, *Der Alexandersarkophag und seine Werkstatt*, Berlin, 1970.

I Greci in Occidente, exh. cat. (Venice, 1996) edited by G. Pugliese Carratelli, Milan, 1996 (Eng. ed. *The Western Greeks*, Milan, 1996).

I Greci in Occidente, La Magna Grecia nelle collezioni del Museo Archeologico di Napoli, exh. cat. edited by S. De Caro and M. Borriello, Naples, 1996.

M. Guarducci, 'Dioniso e la cosiddetta Villa dei Misteri', in *Atti dell'Accademia Nazionale dei Lincei, Rendiconti, Classe di Scienze morali, storiche e filologiche*, series IX, 4, 1993, pp. 521–533.

A.-M. Guimier-Sorbets, 'Les Mosaïques', in *La Gloire 1998*, pp. 227–231.

G. Güntner, 'Persephone', in *Lexicon Iconographicum Mythologiae Classicae*, VIII, Zurich and Düsseldorf, 1997, pp. 956–978.

N. G. L. Hammonds, *The Genius of Alexander the Great*, London, 1997.

R. Hannah, 'Et in Arcadia ego? The Finding of Thelephos', in *Antichthon*, 20, 1986, pp. 86–104.*

N. Hannestad, 'Imitatio Alexandri in Roman Art', in *Alexander 1993*, pp. 61–69.

P. Hartwig, 'Ein Tongefäss des C. Popilius mit Szenen der Alexanderschlacht', in *Mitteilungen des Deutschen Archäologischen Instituts, Römische Abteilung*, 13, 1898, pp. 399–408.*

H. Heres, M. Strauss, 'Telephos', in *Lexicon Iconographicum Mythologiae*

Classicae, VII, Zurich and Munich, 1994, pp. 856–870.*

P. Hermann, R. Herbig, F. Bruckmann, *Denkmäler der Malerei des Altertums*, I, Munich, 1904–31.*

A. Hermary, 'Eros', in *Lexicon Iconographicum Mythologiae Classicae*, III, Zurich and Munich, 1986, pp. 850–942.

R. Hinks, *Myth and allegory in ancient art*, London, 1939 (*Studies of the Warburg Institute*, 6).*

N. Hoesch, 'Alexandermosaik', in *Der Neue Pauly*, I, Stuttgart and Weimar, 1996, cc. 454–457; 'Apelles', 4, ibid., c. 829.*

T. Hölscher, *Griechische Historienbilder des 5. und des 4. Jahrhunderts v. Chr.*, Würzburg, 1973.*

T. Hölscher, 'Zur Deutung des Alexandermosaik', in *Festschrift Ekrem Akurgal*, Ankara, 1989 (*Anadolu*, 22, 1981–1983), pp. 297–303.*

L'Idea del Bello, Viaggio per Roma nel Seicento con Giovan Pietro Bellori, I–II, exh. cat. (Rome, 2000) edited by E. Borea and L. de Lachenal, Rome, 2000.

M. Jost, 'Héraklès en Arcadie', in *Héraclès, Roma 1989*, Brussels and Rome, 1992, pp. 245–261.

H. M. von Kaenel, *Münzprägung und Münzbildnis des Claudius*, Berlin, 1986.

V. Kockel, 'Forum Augusti', in *Lexicon Topographicum Urbis Romae*, II, Rome, 1995, pp. 289–295.

Fr. Koepp (review of), H. Fuhrmann, 'Philoxenos von Eretria' (Göttingen, 1931), in *Göttingische Gelehrte Anzeigen*, 1932, no. 3, pp. 89–104.*

G. Körte, 'Das Alexander-Mosaik aus Pompeji', in *Mitteilungen des Deutschen Archäologischen Instituts, Römische Abteilung*, 22, 1907, pp. 1–24.*

G. Körte, *I rilievi delle urne etrusche*, III, Rome, 1890.

A. Kossatz-Deissmann, 'Hera', in *Lexicon Iconographicum Mythologiae Classicae*, IV, Zurich and Munich, 1988, pp. 659–719; 'Iris I', ibid., V, 1990, pp. 741–760; 'Semele', ibid., VII, 1994, pp. 718–726.

W. Krenkel, 'Apelles bei Petron und Lucilius', in *Festschrift Gottfried von Rücken*, Rostock, 1968 (*Wissenschaftliche Zeitschrift der Universität Rostock, Gesellschaft- und Sprachwissenschaftliche Reihe*, 7–8, 1968), pp. 689–695.*

W. Kroll, 'Tonitrualia', in *Realencyclopädie der klassischen Altertumswis-*

senschaft, VI, A, 2, 1937, cc. 1711–1714.

A. Lagi De Caro, 'Alessandro e Rossane come Ares e Afrodite in un dipinto della Casa Regio VI, Insula occidentalis', 39, in Classica et Pompeiana, Studies in Honor of Wilhelmina F. Jashemski, I, New Rochelle, New York, 1988, pp. 75–88.*

A.-M. Lecoq, 'Apelle et Protogène: la signature-ductus', in Revue de l'Art, 26, 1974, pp. 46–47.*

W. Lepik-Kopaczynska, Apelles der berühmste Maler der Antike, Berlin, 1962.*

M. A. Levi, 'Theòs aniketos, Aspetti cultuali della legittimità di Alessandro', in Alessandro Magno tra storia e mito, edited by M. Sordi, Milan, 1984, pp. 55–57.

R. Lindner, 'Hades', in Lexicon Iconographicum Mythologiae Classicae, IV, Zurich and Munich, 1988, pp. 367–394; 'Kouretes', 'Korybantes', ibid., VIII, 1997, pp. 736–741.

G. Lippold, Die Griechische Plastik, Munich, 1950 (Handbuch der Archäologie, III, 1).

Lisippo, L'arte e la fortuna, edited by P. Moreno (Rome, 1995), Milan, 1995.

R. Mack, Love and War and other Gender Conflicts: An Image of Alexander from Pompeii, Berkeley, 1991 (dissertation).*

S. Maffei, Luciano di Samosata, Descrizioni di opere d'arte, Turin, 1994.*

F. Magi, 'Laocoonte', in Enciclopedia dell'arte antica classica e orientale, IV, Rome, 1961, pp. 467–471.

A. Maiuri, La Villa dei Misteri, Rome, 1967.

Chr. Makaronas, E. Giouri, Oi Oikies Arpages tis Elenis kai Dionysou tis Pellas, Athens, 1989.

M. B. Marzani, 'Hippys', in Enciclopedia dell'arte antica classica e orientale, IV, Rome, 1961, pp. 40–41.

J. M. Massing, Du texte à l'image, La "Calomnie" d'Apelle et son iconographie, Strasbourg, 1990.*

S. B. Matheson, 'Apelles', in The Dictionary of Art, II, London and New York, 1996, pp. 217–218.*

P. Matthiae, Ninive, Milan, 1998.

H. Mattingly, E. A. Sydenham, The Roman Imperial Coinage, II, Vespasian to Adrian, London, 1926.

D. Mazzanti, 'I segni della sconfitta', in Archeologia Viva, 8, no. 5, May–June 1989, pp. 18–23.

A. Melucco Vaccaro, 'Chi costruì l'Arco di Costantino? Un interrogativo ancora attuale', in Rendiconti della Pon-

tificia Accademia di Archeologia, 66, 1993–94, pp. 1–60.

W. Messerschmidt, 'Historische und ikonographische Untersuchungen zum Alexandersarkophag', in Boreas, 12, 1989, pp. 64–92.

H. Mielsch, Römische Stuckreliefs, Berlin, 1975 (Mitteilungen des Deutschen Archäologischen Instituts, Römische Abteilung, Ergänzungsheft 21).

St. Miller-Collett, 'Iconographic Issues in Hellenistic Macedonia: the Tradition of Painting', in I temi figurativi 1997, pp. 85–88.

P. Mingazzini, 'Una copia dell'Alexandros keraunophoros di Apelle', in Jahrbuch der Berliner Museen, 3, 1961, pp. 7–17.*

S. Mollard-Besques, Musée National du Louvre, Catalogue raisonné des figurines et des reliefs en terre-cuite grecs, étrusques et romains, II, Myrina, Paris, 1963.

P. Moreno, 'Splendor', in Enciclopedia dell'arte antica classica e orientale, VII, Rome, 1966, pp. 455–456.

P. Moreno, Testimonianze per la teoria artistica di Lisippo, Treviso, 1973.

P. Moreno, 'La pittura tra classicità ed ellenismo', in Storia e civiltà dei Greci, 6, Milan, 1979 (reprint 1991), pp. 459–520.*

P. Moreno, 'Kairos, Akme e Charis da una pittura di Apelle', in Ricerche di pittura ellenistica, Rome, 1985, pp. 253–256.*

P. Moreno, Pittura greca, Da Polignoto ad Apelle, Milan, 1987.*

P. Moreno, 'Kairos', in Lexicon Iconographicum Mythologiae Classicae, V, Zurich and Munich, 1990, pp. 920–926.*

P. Moreno, 'Lysippic Types: Painting into Sculpture', in Festschrift für Jale Inan, Istanbul, 1991, pp. 147–152.*

P. Moreno, 'L'immagine di Alessandro Magno nell'opera di Lisippo e di altri artisti contemporanei', in Alexander 1993, pp. 101–136.*

P. Moreno, 'Akme', in Enciclopedia dell'arte antica classica e orientale, Secondo Supplemento, 1971-1994, I, Rome, 1994, p. 146*; 'Apelle', ibid., pp. 275–277*; 'Efestione', ibid., II, 1994, pp. 418–420; 'Ercoli Farnese', pp. 489–494.

P. Moreno, Scultura ellenistica, I–II, Rome, 1994.

P. Moreno, 'Kairos', in Enciclopedia dell'arte antica classica e orientale, Secondo Supplemento, 1971-1994, III, Rome, 1995, pp. 157–159*; 'Melanthios', ibid., pp. 592–593.

P. Moreno, 'Elementi di pittura ellenistica', in L'Italie méridionale et les premières expériences de la peinture

hellénistique, Actes de la table ronde organisée par l'École française de Rome, 18 février 1994, Rome, 1998, pp. 7–67.*

P. Moreno, Sabato in museo, Letture di arte ellenistica e romana, Milan, 1999.

A. Moustaka, A. Goulaki-Voutira, U. Grote, 'Nike', in Lexicon Iconographicum Mythologiae Classicae, VI, Zurich and Munich, 1992, pp. 850–904.

B. Müller-Huber, 'Oistros', in Lexicon Iconographicum Mythologiae Classicae, VII, Zurich and Munich, 1994, pp. 28–29.

P. Müller, 'Keraunobolia', in Lexicon Iconographicum Mythologiae Classicae, III, Zurich and Munich, 1986, p. 23.*

H. Niels, 'Das Alexander-Mosaik im Calidarium der Römischen Bäder zu Potsdam-Sansouci', in Jahrbuch für Brandenburgische Landgeschichte, 43, 1992, pp. 128–136.*

C. Nylander, 'Il milite ignoto: un problema nel mosaico di Alessandro', in La regione sotterrata dal Vesuvio, Studi e prospettive, Atti del convegno internazionale, Napoli 1979, Naples, 1982, pp. 689–695.*

C. Nylander, 'The Standard of the Great King, A Problem in the Alexandermosaik', in Opuscula Romana, 14, 1983, pp. 19–37.*

C. Nylander, 'Darius III, the Coward King: Point and Counterpoint', in Alexander 1993, pp. 145–159.*

W. Oberleitner, 'Das "Ptolemäer-Kameo" - doch ein Kameo der Ptolemäer!', in Mousikòs anér, Festschrift für Max Wegner, edited by O. Brehm and S. Klie, Bonn, 1992, pp. 329–338.

W. Oberleitner, Das Heroon von Trysa, Ein Lykisches Fürstengrab des 4. Jahrhunderts v. Chr., Mainz, 1994.

O. Palagia, 'Hellas', in Lexicon Iconographicum Mythologiae Classicae, IV, Zurich and Munich, 1988, pp. 626–627.

M. Pallottino, 'Arco onorario e trionfale', in Enciclopedia dell'arte antica classica e orientale, I, Rome, 1958, pp. 588–591.

E. Pernice, 'Nachträgliche Bemerkungen zum Alexandermosaik', in Mitteilungen des Deutschen Archäologischen Instituts, Römische Abteilung, 23, 1908, pp. 11–14.*

E. Petersen, 'Zeus oder Alexander mit dem Blitz?', in Mitteilungen des Deutschen Archäologischen Instituts, Römische Abteilung, 15, 1900, pp. 160–169.*

Ph. Petzas, Pella, Alexander the Great's Capital, Salonica, 1978.

M. Pfrommer, 'Zeus in peripheria ori-

entalis', in Lexicon Iconographicum Mythologiae Classicae, VIII, Zurich, Düsseldorf, 1997, pp. 375–399.

E. Pfuhl, Malerei und Zeichnung der Griechen, II, Munich, 1923.*

Chr. Phatourou, 'Archaiotites kai mnemeia Dodekanisou', in Archaiologikon Deltion, 19 (2.3), 1964, pp. 462–475.

H. Philipp, Der Grosse Traianische Fries, Überlegungen zur Darstellungsweise am Grossen Traianischen Fries und dem Alexandermosaik, Munich, 1991.*

G. Pisani Sartorio, 'Arcus Drusi (Via Appia)', in Lexicon Topographicum Urbis Romae, I, Rome, 1993, p. 93.

R. Polacco, La Cattedrale di Torcello, Venice, 1984.

E. Polito, 'Metanoia', in Lexicon Iconographicum Mythologiae Classicae, VI, Zurich and Munich, 1992, pp. 561–562.*

J. J. Pollitt, The Art of Greece, 1400-31 BC, Sources and Documents, Englewood Cliffs (New Jersey), 1965.*

J. J. Pollitt, Art and experience in classical Greece, Cambridge 1972.*

J. J. Pollitt, The Ancient View of Greek Art, Criticism, History and Terminology, New Haven and London, 1974.

J. J. Pollitt, Art in the Hellenistic Age, Cambridge, 1986.

Pompei, Pitture e mosaici, I–IX, Rome, 1990–99; La documentazione nell'opera di disegnatori e pittori dei secoli XVIII e XIX, Rome, 1995.*

Pompeii, Picta fragmenta, Decorazioni parietali delle città sepolte, exh. cat. edited by Soprintendenza Archeologica di Pompei, Turin, 1998.*

B. Poulsen, 'Alexander the Great in Italy during the Hellenistic period', in Alexander 1993, pp. 161–170.*

L. Prandi, Callistene, Uno storico tra Aristotele e i re macedoni, Milan, 1985.

A. M. Prestianni Giallombardo, 'Il diadema di Vergina e l'iconografia di Filippo II', in Ancient Macedonia, IV, Salonica, 1986, pp. 497–509.

A. M. Prestianni Giallombardo, 'Recenti testimonianze iconografiche sulla kausia in Macedonia e la datazione del fregio della Caccia della II Tomba reale di Vergina', in Dialogues d'Histoire Ancienne, 17, 1991, pp. 257–304.

M. J. Price, 'The "Porus" Coinage of Alexander the Great, A Symbol of Concord and Comunity', in Studia Paulo Naster oblata, I, Numismatica Antiqua, Louvain, 1982, pp. 75–88.

Principi imperatori vescovi, Duemila anni di storia a Canosa, exh. cat. edited by R. Cassano, Venice, 1992.

F. Queyrel, 'Astrape', in *Lexicon Iconographicum Mythologiae Classicae*, II, Zurich and Munich, 1984, p. 928.*

E. Radius, *L'opera completa di Ingres*, Milan, 1968.
Real Museo Borbonico, VIII, Naples, 1832.*
L. C. Reilly, 'The Hunting Frieze from Vergina', in *Journal of Hellenic Studies*, 113, 1993, pp. 160–162.
S. Reinach, 'Apelle et le cheval d'Alexandre', in *Revue Archéologique*, 1, 1917, pp. 189–197.*
A. Reinach, *Textes grecs et latins relatifs à l'histoire de la peinture ancienne*, Paris, 1921 (reprint 1985, edited by A. Rouveret).*
G. E. Rizzo, 'La battaglia di Alessandro nell'arte italica e romana', in *Bollettino d'Arte*, 1925–26, pp. 529-546.*
R. Robert, 'Apelle et Protogène', in *Céramique et peinture grecques, Modes d'emploi, Paris 1995*, edited by M.-Chr. Villanueva Puig et al., Paris, 1999, pp. 233–244.
C. H. Roberts, 'A Hellenistic Epigram Recovered', in *Journal of Juristic Papyrology*, 4, 1950, pp. 215–217.*
M. Robertson, *Greek Painting*, Geneva, 1959.*
M. Robertson, *A History of Greek Art*, Oxford, 1975.*
L. Rocchetti, 'Cammeo di Francia', in *Enciclopedia dell'arte antica classica e orientale*, II, Rome, 1959, pp. 295–298.
R. Rosenblum, *Jean Auguste Dominique Ingres*, Milan, 1973.
Rotunda Diocletiani, Sculture decorative delle terme nel Museo Nazionale Romano, edited by M. R. Di Mino, Rome, 1991.
A. Rouveret, *Histoire et imaginaire de la peinture ancienne*, Rome, 1989.*
A. Ruesch, *Il bassorilievo con motivo della battaglia di Alessandro*, Munich, 1927.*
A. Rumpf, 'Anadiomene', in *Jahrbuch des Deutschen Archäologischen Instituts*, 65–66, 1950–51, pp. 166–174.*
A. Rumpf, *Malerei und Zeichnung*, Munich 1953 (*Handbuch der Archäologie*, IV, 1).*
A. Rumpf, 'Zum Alexander-Mosaik', in *Mitteilungen des Deutschen Archäologischen Instituts, Athenische Abteilung*, 77, 1962, pp. 229–241.*

Chr. Saatsoglou-Paliadeli, 'Aspects on Ancient Macedonian Costume', in *Journal of Hellenic Studies*, 113, 1993, pp. 122–145.
Chr. Saatsoglou-Paliadeli, 'Oi maches tou Alexandrou', in *Alexandros* 1997, pp. 24–33.*

F. Salviat, 'Monuments figurés et tradition littéraire, Alexandre et Darius a Issos', in *Actes* III 1988, pp. 193–197.*
D. Salzmann, *Untersuchungen zu den antiken Kieselmosaiken*, Berlin, 1982.
H. Sarian, 'Eryns', in *Lexicon Iconographicum Mythologiae Classicae*, III, Zurich and Munich, 1986, pp. 825–843.
G. Sauron, *La grande fresque de la Villa des Mystères à Pompéi, Mémoires d'une dévote de Dionysos*, Paris, 1998.
K. Schefold, *Die Antwort der griechischen Kunst auf die Siege Alexanders des Grossen*, Munich, 1979 (*Bayerische Akademie der Wissenschaften, Philosophischhistorische Klasse, Sitzungsberichte*, 1979, Heft 4).*
K. Schefold, 'Die Stilgeschichte der Monumentalmalerei in der Zeit Alexanders des Grossen', in *Actes* I 1985, pp. 23–36.*
I. Scheibler, 'Die "Vier Farben" der griechischen Malerei', in *Antike Kunst*, 17, 1974, pp. 92–102.*
I. Scheibler, *Griechische Malerei der Antike*, Munich, 1994.*
B. Schmaltz, 'Ein triumphierender Alexander?', in *Mitteilungen des Deutschen Archäologischen Instituts, Römische Abteilung*, 101, 1994, pp. 121–129.*
M. Schmidt, 'Asia und Apate', in *Aparchaí, Nuove ricerche e studi sulla Magna Grecia e la Sicilia antica in onore di Paolo Enrico Arias*, edited by L. Gualandi and L. Massei, II, Pisa, 1982, pp. 505–520.*
M. Schmidt, 'Venus', in *Lexicon Iconographicum Mythologiae Classicae*, VI-II, Zurich and Düsseldorf, 1997, pp. 192–230.
G. Schneider-Herrmann, *Red-figure Lucanian and Apulian Nestorides and Their Ancestors*, Amsterdam, 1980 (*Allard Pierson Series*, 1).
R. Schöne, 'Das pompejanische Alexandermosaik', in *Neue Jahrbücher für Klassische Altertumswissenschaft*, 29, 1912, pp. 181–204.*
G. Schwarz, 'Zur Artemis des Apelles', in *Jahreshefte des Österreichischen Archäologischen Institutes in Wien*, 49, 1968–71, pp. 77–78.*
R. Scognamillo, 'La mescolanza dei colori nel trattato "Del senso e i sensibili" di Aristotele e la tecnica dei pittori greci', in *Da Aristotele alla Cina, Sei saggi di storia dell'arte universale*, edited by S. Marconi, Rome, 1994, pp. 5–34.*
The Search for Alexander, An Exhibition, New York, 1982.
S. Settis, 'Aletheia', in *Lexicon Iconographicum Mythologiae Classicae*, I, Zurich and Munich, 1981, pp. 486–487.*

G. Siebert, 'La Salle à la mosaïque', in *Fouilles de Xanthos*, IX, 1, edited by H. Metzger, Paris, 1992, pp. 57–73.
M. Siganidou, M. Lilibaki-Akamaati, *Pella, Proteousa ton Makedonon*, Athens, 1996.
E. Simon, 'Zum Fries der Mysterienvilla bei Pompeji', in *Jahrbuch des Deutschen Archölogischen Instituts*, 76, 1961, pp. 111–172.
E. Simon, 'Arkadia', in *Lexicon Iconographicum Mythologiae Classicae*, II, Zurich and Munich, 1984, pp. 607–608*; 'Artemis', 'Diana', ibid., pp. 792–855*; 'Laokoon', ibid., VI, 1992, pp. 196–201; 'Veiove', ibid., VIII, 1997, pp. 184–185.
E. Simon, G. Bauchhenss, 'Poseidon, Neptunus', in *Lexicon Iconographicum Mythologiae Classicae*, VII, Zurich and Munich, 1994, pp. 483–500.
K. Sismanidis, *Klines kai klinoeideis kataskeues ton makedonikon taphon*, Athens, 1997.
G. Spinola, *Il Museo Pio Clementino*, I, Vatican City, 1996.
A. Stewart, *Faces of Power, Alexander's Image and Hellenistic Politics*, Berkeley, Los Angeles, and Oxford, 1993.*
S. Stopponi, 'Perugia', in *Enciclopedia dell'arte antica classica e orientale, Secondo Supplemento 1971-1994*, IV, Rome, 1996, pp. 331–339.

I temi figurativi nella pittura parietale antica, Atti del VI Convegno internazionale sulla Pittura parietale antica, Bologna 1995, edited by D. Scagliarini Corlàita, Bologna, 1997.
I. Touratsoglou, *Makedonia, Istoria, mnimeia, mouseia*, Salonica, 1995.
M. Tredé, *Kairós, L'à-propos et l'occasion, Le mot et la notion d'Homère à la fin du IVe siècle avant J.-Chr.*, Paris, 1992.
A. D. Trendall, *The Red-Figured Vases of Lucania, Campania and Sicily*, Oxford, 1967.
A. D. Trendall, 'Pittore di Policoro', in *Enciclopedia dell'arte antica classica e orientale, Supplemento 1970*, Rome, 1973, pp. 633–634.
A. D. Trendall, A. Cambitoglou, *The Red-Figured Vases of Apulia*, I–II, Oxford, 1979–82.
I. Triantis, 'Myrtilos', in *Lexicon Iconographicum Mythologiae Classicae*, VI, Zurich and Munich, 1992, pp. 693–696; 'Oinomaos', ibid., VII, 1994, pp. 19–23; 'Pelops', ibid., pp. 282–287.
E. Trinkl, 'Ein Selbstporträt im Alexandermosaik?', in *Jahreshefte des Österreichischen Archäologischen Institutes in Wien*, 66, 1997, pp. 102–115.*

B. Tripodi, 'Il fregio della Caccia della II Tomba reale di Vergina e le cacce funerarie d'oriente', in *Dialogues d'Histoire Ancienne*, 17, 1991, pp. 143–209.

L. Usai, 'L'Ipogeo di Via Livenza', in *Dialoghi di Archeologia*, 6, 1972, pp. 363–412.

La Villa della Farnesina in Palazzo Massimo alle Terme, edited by M. R. Sanzi Di Mino, Milan, 1998.
M. C. Villanueva Puig, 'Le Vase des Perses', in *Revue des Études Anciennes*, 91, 1989, pp. 277–298.
L. Villard, 'Tyche', in *Lexicon Iconographicum Mythologiae Classicae*, VI-II, Zurich and Düsseldorf, 1997, pp. 115–125.*
I. Vokotopoulou, *Oi taphikoi tymboi tis Aineias*, Athens, 1990.

E. Walter-Karydi, 'Gamos Roxanis kai Alexandrou, O Megas Alexandros os erastis', in *Alexandros* 1997, pp. 34–39.*
Wealth of the Ancient Word, The Nelson Bunker Hunt und William Herbert Hunt Collections, Fort Worth, 1983.
K. Weitzmann, *Ancient Book Illumination*, Cambridge (Mass.), 1959.
F. Winter, *Das Alexandermosaik aus Pompeji*, Strasbourg, 1909.*
G. Wustmann, *Apelles' Leben und Werke*, Leipzig, 1870.*

N. Yalouris, 'Helios', in *Lexicon Iconographicum Mythologiae Classicae*, V, Zurich and Munich, 1990, pp. 1005–1032.

P. Zanker, *Pompei*, Turin, 1993.*
P. Zanovello, 'Polemos', in *Lexicon Iconographicum Mythologiae Classicae*, VII, 1994, pp. 423–424.*
P. Zazoff, *Die antiken Gemmen*, Munich, 1983.
F. Zevi, 'I ekstrateia tou Alexandrou sto eikonographiko programma tis "Oikias tou Phaunou" stin Pompeia', in *Alexandros* 1997, pp. 40–46.*
F. Zevi, 'Il Mosaico di Alessandro, Alessandro e i Romani', in *Ultra terminum vagari, Scritti in onore di Carl Nylander*, Rome, 1997, pp. 385–397.*
F. Zevi, 'Die Casa del Fauno in Pompeji und das Alexandermosaik', in *Mitteilungen des Deutschen Archäologischen Instituts, Römische Abteilung*, 105, 1998, pp. 21–65.*
F. Zevi, M. Jodice, *Pompei*, Naples, 1992.*
F. Zevi, L. Pedicini, *I mosaici della Casa del Fauno a Pompei*, Naples, 1998.*

List of Locations of Works

Alexandria
 Graeco-Roman Museum
 Mosaic showing Erotes hunting a stag, from Shatbi 103, fig. 50

Argos
 Museum
 Statue of Heracles resting, from the Hadrianic baths, Argos 101

Athens
 Agora
 Stoa of Zeus Eleutherios 32; Stoa Poecile 32, 86
 National Museum
 Bronze statue of boy on horseback, from the sea off Artemisium 22

Beirut
 Archaeological Museum
 Mosaic, from Byblos: personifications of Kairos (Opportunity), Akme (Flowering) and Charis (Grace) 38, 119–121, fig. 68

Berlin
 Private collection
 Apulian red-figured lekythos, Lampas Painter: Warrior and Bride 110, figs. 54–55

Berlin
 Staatliche Museen, Antikensammlung
 Attic calyx-krater, Kerch class, from Thebes: Dionysus and Ariadne 111; Attic lekythos, from Athens: Aphrodite and Eros 111
 Pergamonmuseum
 Marble relief, from Pergamum, terrace of Athena: frieze of arms 29

Boston
 Museum of Fine Arts
 Italo-Megarian bowl with moulded relief decoration, workshop of Caius Popilius: Battle between Alexander and Darius 20, 22, 93, 94, figs. 36, 37

Cairo
 Egyptian Museum
 Fresco, from Hermopolis Magna:

Laius, Oedipus and the personification of Ignorance 117

Chatsworth
 Ceramic tiles: detail deriving from the Alexander mosaic 21, fig. 8

Cos
 Sanctuary of Asclepius 120, 122

Copenhagen
 Nationalmuseet
 Fragment of an Apulian red-figured krater, Darius Painter: Battle between Alexander and Darius 85

Corinth
 Peirene fountain 97

Dresden
 Albertinum
 Fragment of a moulded bowl, made in Puteoli: Heracles resting 100, 101, fig. 46

Herculaneum
 Basilica, 99

Isernia
 Museo Archeologico Nazionale
 Limestone relief of the battle between Alexander and Darius 22, 91, 93, fig. 29

Istanbul
 Archaeological Museum
 Sarcophagus of Abdalonymus, Pentelic marble, from Sidon: a battle of Alexander 18, 22, 86, 88, 89, 120, figs. 25, 26

Location n.s.
 Private collection
 Macedonian bronze coin, reign of Gordian III, reverse: Alexander on horseback 95, fig. 40

Location n.s.
 Private collection
 Bronze sestertius of Vespasian, reverse: Titus and Domitian 110, fig. 56

London
 British Museum
 Gold aureus of Claudius, reverse showing the Arch of Drusus (cast in the Museo della Civiltà Romana, Rome) 94, fig. 38; silver decadrachm of Alexander, minted in Susa, obverse showing the battle between Alexander and Porus, reverse showing Alexander as Zeus 23, 83, 84, 109, figs. 16, 57; Panathenaic processions, Pentelic marble, sculpted by Phidias, from the Parthenon frieze, Athens 113; Bronze coin from Sagalassus, reign of Claudius Gothicus, reverse showing Alexander on horseback, galloping 23; limestone reliefs from Kuyunjik, Nineveh: south-west palace, Victory of the Assyrians over the Elamites 29, figs. 10, 11; northern palace, Departure of Ashurbanipal for the hunt 31, fig. 12.
 National Gallery
 Jean Auguste Dominique Ingres, *Portrait of Inès Moitessier Seated*, oil on canvas, 101

Madrid
 Museo del Prado
 Titian, *Equestrian Portrait of Charles V*, oil on canvas 108; Diego Velázquez, *Surrender of Breda*, also known as *Las lanzas*, oil on canvas 17.

La Valetta, Malta
 Cathedral
 Caravaggio, *Beheading of St John the Baptist*, oil on canvas, 37

Munich
 Antikensammlung
 Apulian red-figured volute-krater, Underworld Painter, from Canosa: Oistros and Medea 113

Naples (formerly)
 Hamilton Collection
 Apulian red-figured krater, Darius Painter: Battle between Alexander and Darius 85, 114, fig. 17

Naples
 Museo Archeologico Nazionale
 Fresco from Herculaneum: tragic actor 117, 119, fig. 67; fresco from the basilica, Herculaneum: Heracles and Telephus 35, 99, 100, 101, 108, 109, 112, 117, 122, figs. 15, 45; Apulian red-figured amphora, from Ruvo, Darius Painter: Battle between Alexander and Darius 85–87, 112, figs. 19, 20, 21; Apulian red-figured volute-krater from Canosa, Darius Painter: Darius the Great in council 114, figs. 64, 65; Apulian red-figured volute-krater from Ruvo, Darius Painter: Battle between Alexander and Darius 85–87, 89, 112, fig. 18; mosaic, from the House of the Faun, Pompeii: Battle between Alexander and Darius 9–38 passim, figs. 1, 2, 6, 7, 9, 14, 23, 28, plates I–XXII; mosaic, from the House of the Faun, Pompeii: Nilotic landscape 11; Lucanian red-figured nestoris, Primato Painter: Heracles resting and Nike 101, fig. 47; Bronze statuette of Alexander on horseback, from Herculaneum 18.

Paris
 Bibliothèque Nationale, Cabinet des Mèdailles
 Grand Camée de France, sardonyx cameo: Apotheosis of the Julio-Claudian dynasty 114, fig. 63
 Musée du Louvre
 Jean Auguste Dominique Ingres, *The Source*, oil on canvas, 97; terracotta figurine from Myrina: Dionysus and Ariadne 111, fig. 59

Pella
 House with a peristyle
 Pebble mosaic: Stag-hunt with Alexander and Hephaestion 11, 13, 102–104, 107, 112, figs. 48, 49
 Archaeological Museum
 Pebble mosaic: Lion-hunt with Alexander and Hephaestion 13, 87

Perugia
 Museo Archeologico Nazionale

Index

Picture Credits

Some of the photographs of the Alexander mosaic were obtained from the archive of Luciano Pedicini, Naples; others were taken specifically for this book by the photographer, following my instructions. This photography, and the gathering together of the other illustrations, was made possible by a grant provided by the Consiglio Nazionale delle Ricerche and the Ministero dell'Università e della Ricerca scientifica e tecnologica to the Università di Roma Tre, Dipartimento di Studi storico artistici archeologici e sulla conservazione.

I would like to express my gratitude to the numerous friends and colleagues whose invaluable assistance and advice facilitated the writing of this book: Giancarlo Alteri, Bernard Andreae, Flaminia Bartolini, Horst Blanck, Maria Rosaria Borriello, Francesco Buranelli, Giuliana Calcani, Vittorio Casale, Rosaria Ciardiello, Clotilde D'Amato, Stefano De Caro, Araldo De Luca, Sylvia Diebner, Michael Donderer, Anna Eugenia Feruglio, Pier Giovanni Guzzo, Wolf-Dieter Heilmeyer, Helmut Jung, Alexia Latini, Fernando Lombardi, Liliana Marcando, Nives Li Causi, Paolo Liverani, Susy Marcon, Antonio Martina, Giovanni Moreno, Eva Nardella, Carl Nylander, Wolfgang Oberleitner, Alain Pasquier, Luciano Pedicini, Aldo Reale, Filippo Reale, Claudio Rovai, Federica Smith, Brigitte Tailliez, Antonietta Viacava, Paul Zanker, Marino Zorzi.

I am particularly indebted to Donna Giulia Maria Crespi, who presented the text for publication to Skira editore, and to Skira's chairman, Massimo Vitta Zelman, for accepting it.

Fig. 1 Araldo De Luca, Rome.
Fig. 2 Alinari, Florence.
Fig. 3 Direction Générale des Affaires Culturelles, Commission des Fouilles et Missions Archéologiques, Paris.
Fig. 4 André Bourgarel, Paris.
Fig. 5 Ephoria ton Klassikon kai Proïstorikon Archaiotiton, Rhodes.
Figs. 6–7 Luciano Pedicini, Naples.
Fig. 8 Brian B. Shefton, Newcastle.
Fig. 9 Tonio Hölscher, Heidelberg, drawing by B. Otto.
Figs. 10–12 British Museum, London.
Fig. 13 Wolfgang Oberleitner, Kunsthistorisches Museum, Vienna.
Figs. 14–15 Drawings by Flaminia Bartolini, Rome.
Fig. 16 British Museum, London.
Fig. 17 Drawing by Johan Heinrich Wilhelm Tischbein (1751–1829).
Fig. 18 Luciano Pedicini, Naples.
Fig. 19 Fabrizio Parisio, Naples.
Fig. 20 Luciano Pedicini, Naples.
Fig. 21 Fabrizio Parisio, Naples.
Fig. 22 Makis Skiaderessis, Athens.
Figs. 23–24 Drawings by Olga Lo Russo, Bari.
Figs. 25–26 Hirmer Fotoarchiv, Munich, archive nos. 571.2084– 571.2086.
Fig. 27 Archivio Fotografico, Musei Vaticani, Vatican City, neg. XI-II.21.22.
Fig. 28 Anderson, Florence, n. 25749.
Fig. 29 Luciano Cristicini, Isernia.
Fig. 30 Soprintendenza Archeologica dell'Umbria, Perugia, neg. a.75.3302.03.
Fig. 31 Giunti Gruppo Editoriale, Florence.
Fig. 32 Bartolomeo Bartoccini, Rome.
Fig. 33 Soprintendenza Archeologica dell'Umbria, Perugia, neg. a.78.884.85.
Fig. 34 Bartolomeo Bartoccini, Rome.
Fig. 35 Soprintendenza Archeologica dell'Umbria, Perugia, neg. a.79.827.828.
Figs. 36–37 Museum of Fine Arts, Boston.
Fig. 38 Museo della Civiltà Romana, Rome.
Fig. 39 Deutsches Archäologisches Institut, Rome, neg. no. 37.1352.
Fig. 40 Federica Smith, Rome.
Fig. 41 Biblioteca Nazionale Marciana, Venice, Foto Toso.
Fig. 42 Deutsches Archäologisches Institut, Rome, neg. no. 68.1525.
Figs. 43–44 Ufficio Centrale per il Catalogo e la Documentazione, Ministero per i Beni e le Attività Culturali, Rome.
Fig. 45 Araldo De Luca, Rome.
Fig. 46 Staatliche Kunstsammlungen, Antikensammlung, Dresden, neg. no. Z.C.679.47.
Fig. 47 Araldo De Luca, Rome.
Fig. 48 Archive of the Archaeological Receipts Fund, Athens.
Fig. 49 Ephoria ton Klassikon kai Proïstorikon Archaiotiton, Salonica
Fig. 50 Deutsches Archäologisches Institut, Cairo, neg. no. F.17441.
Fig. 51 Alinari, Florence, Foto Brogi, no. 11221.
Fig. 52 Museo di Antichità, Turin.
Fig. 53 Luciano Pedicini, Naples.
Figs. 54–55 Endrik Lerch, Ascona.
Fig. 56 Giuseppe Bruno, Turin.
Fig. 57 British Museum, London.
Fig. 58 Luciano Pedicini, Naples.
Fig. 59 Musée du Louvre, Paris, negative M. and P. Chuzeville, Myr.180.
Fig. 60 Giacomo Pozzi Bellini, Rome.
Fig. 61 Archivio Fotografico, Musei Vaticani, Vatican City.
Fig. 62 Scala, Antella - Bagno a Ripoli, near Florence.
Fig. 63 A. Giraudon, Paris, no. 8388.
Figs. 64–65 Araldo De Luca, Rome.
Fig. 66 Soprintendenza Archeologica di Roma, Rome.
Fig. 67 Anderson, Florence, no. 23415.
Fig. 68 Archaeological Museum, Beirut.
Figs. 69–70 Paolo Moreno, Rome.